IN THE VICTORIAN STYLE

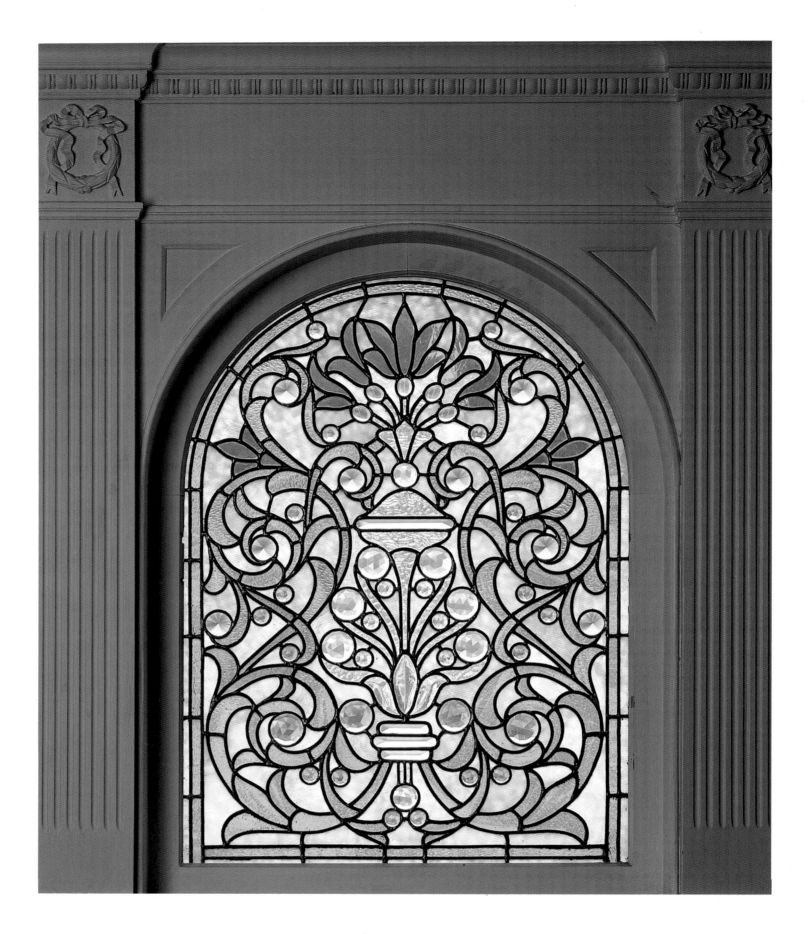

IN THE
VICTORIAN
STYLE

TEXT BY
RANDOLPH DELEHANTY
PHOTOGRAPHS BY
RICHARD SEXTON

Chronicle Books · San Francisco

Library of Congress Cataloging-in-Publication Data

Delehanty, Randolph.
 In the Victorian style / Randolph Delehanty; photography by
 Richard Sexton.
 p. cm.
 Includes bibliographical references.
 ISBN 0-87701-750-6 (hc)
 1. Architecture, Victorian—California—San Francisco.
 2. Architecture, Domestic—California—San Francisco.
 3. Architecture—California—San Francisco—Details. 4. San
 Francisco (Calif.)—Buildings, structures, etc. I. Sexton,
 Richard. II. Title.
 NA7238.S35D4 1991
 720′9794′6109034—dc20 91-4145
 CIP

Printed in Japan.

Editing: Sharon Silva
Book and cover design: Herman + Company
Composition: Mark Woodworth Typography & Porter Mortell

Distributed in Canada by Raincoast Books,
112 East Third Avenue, Vancouver, B.C. V5T 1C8

10 9 8 7 6 5 4 3 2 1

FRONT COVER
Detail of the golden oak entrance hall bench in the Spencer house,
in the Haight-Ashbury, designed by Frederick P. Raven in 1895.

ENDPAPERS
Ceiling paper in the Victorian style in a restored Western Addition
house designed and printed by Bradbury and Bradbury in Benicia,
California, in 1989.

FRONTISPIECE
A stained glass window with clear glass "jewels" in the front parlor
of the Spencer house built in 1895 in the Queen Anne style.

BACK COVER
A characteristic light colored, Italianate style, bay-windowed San
Francisco row house at 1825 Sutter Street, in the Western Addition,
built in 1878. In 1983 the boxwood-grid front garden was planted
and sculptor James Nestor's black steel Streetlight was installed.

Chronicle Books
275 Fifth Street
San Francisco, California 94103

DEDICATION

*In appreciation of those San Franciscans who have
conserved our Victorian architectural heritage, and
especially those who opened their homes to us.*

TABLE OF CONTENTS

THANKS AND ACKNOWLEDGMENTS

e would like first to thank the generous San Franciscans who permitted us to photograph and record the rare interiors that grace this book. The National Society of the Colonial Dames of America in California allowed us to photograph their Octagon house, and The Foundation for San Francisco's Architectural Heritage let us photograph the Haas-Lilienthal house. Both buildings are open to the public for tours. The Hamlin School permitted us to photograph in Stanwood Hall. Mr. and Mrs. Jack Chambers let us photograph the Spencer house, one of the city's finest bed-and-breakfast inns. The Victorian Alliance was very helpful in introducing us to various gracious and preservation-minded San Franciscans. Mr. Donald C. Beilke, Miss Janice Cline, Miss Anne Ellinwood, Mr. and Mrs. Gerald Levine, Dr. John Newmeyer, Mr. Gene Ramey, Mr. Richard D. Reutlinger, Mr. and Mrs. John Schmiedel, Dr. Albert Shumate, and Mr. Jim Tyler have our sincere thanks. Mr. J. Roger Jobson of The Society of California Pioneers permitted us to photograph treasures in that important collection. Mr. William Walters allowed use of some of his fine drawings, and Mr. Greg Gaar and Dr. Albert Shumate provided us with rare historical photographs. The San Francisco History Room of the Main Branch of the San Francisco Public Library is the source of many of the old engravings in this book. The San Francisco Department of City Planning created the map of the city in 1900, which we have adapted.

We owe scholarly debts to San Francisco historians Ms. Anne Bloomfield, whose work on The Real Estate Associates is basic, and Ms. Judith Lynch, whose research is another important link in the chain of knowledge. It is a particular pleasure to thank historian Mr. Gary Goss for his generosity in sharing his years of basic research with us.

We also wish to thank Mr. Mike Phillips and Nikon Professional Services for the generous loan of photographic equipment. We most especially want to acknowledge the contribution of Mr. Lai-Wen Huang, who ably assisted with the photography throughout this project.

The authors also wish to acknowledge the vital role of Mr. William LeBlond and Mr. Jack Jensen at Chronicle Books. Ms. Linda Herman of Linda Herman + Company designed this book, and Mr. Mark Woodworth and Mr. Porter Mortell of Mark Woodworth Typography set the type. Ms. Sharon Silva, Ms. Judith Dunham, Ms. Mary Farr, Mr. Tim Ferdun, and Ms. Callie Peet Bernhardt were the skilled "carpenters" and craftspeople who took our blueprints, words, and photographs and turned them into the handsome book that you hold in your hands and are about to explore.

For their encouragement of his work many years ago, Randolph Delehanty wishes to thank Mr. William M. Roth, Mr. Charles Hall Page and The Foundation for San Francisco's Architectural Heritage, and Mr. and Mrs. Albert J. Moorman. Mr. Randolph Riddle, Mrs. Richard S. Delehanty, and Dr. and Mrs. Ronald B. Delehanty have also watered the tree of which this is the flower.

INTRODUCTION

The San Francisco Victorian house was essentially *modern*. The key to understanding it lies not in its obvious facade but in its invisible plumbing. It was born out of a fascination with two things: new technologies and the architectural styles of the past. In how it was built, sold, financed, and served (by streetcars, municipal sewers, running water, gas, electricity, and even telephones), the San Francisco Victorian row house was radically new, not old-fashioned. While their facades delighted in recalling historical elements from the Gothic to the Neoclassical, Victorian houses perhaps reflected their era most accurately in up-to-date bathrooms with reliable utilities and porcelain fixtures. These advances made possible tremendous improvements in health, hygiene, and individual privacy. It is the tension between looking old and being new that makes Victorian houses so interesting.

This book seeks to elucidate both of these dimensions of San Francisco's much-loved Victorian houses. It gives a "deep" view of the buildings, a picture of how they look and what they mean. Its subject is the city's domestic architecture, explored through both individual structures and whole neighborhoods. Chapter 1 is a pictorial overview that introduces this rich topic. Chapter 2 considers the fundamental question of how the land was divided in San Francisco during the great "land rush" that followed on the heels of the more famous Gold Rush of 1849. The imposition of a grid plan on the hilly site, the quick selling off of unimproved blocks, and then the sporadic subdivision of the blocks into long, narrow house lots created the framework within which the Victorian house evolved. Ironically, it was the all-American standard grid that gave this city its strong, distinctive form. Chapter 3 is a brief history of the booms and busts that swept

over San Francisco and resulted in the waves of building that filled up the subdivided blocks. This was not a steady process, but rather a jerky and uneven one punctuated by panics and depressions. Each time building revived, it did so in a new style, which helps to explain the architectural heterogeneity of the Victorian metropolis.

Chapter 4 describes the rapid evolution of the row house in San Francisco from its introduction by London-born George Gordon at elite South Park in 1854 to its widespread adoption by such early tract builders as The Real Estate Associates and such prolific contractor-builders as Fernando Nelson. Although not all Victorian houses in San Francisco were row houses (there were always freestanding mansions and simple cottages as well), the row house served the great middle class and became the dominant house type in the nineteenth-century city.

Chapter 5 looks at the expressive exteriors of San Francisco's Victorian houses —their gaudy parade of architectural styles. The categories we impose on these wildly varied buildings, while imperfect to be sure, *are* helpful in understanding them. In Chapter 6 another great Victorian achievement is briefly considered: the city's rich legacy of parks that softened long stretches of private houses with public breathing spaces. San Francisco's Victorian neighborhoods are a tight-knit fabric woven from rows of varied redwood houses and islands of irrigated green parks.

With the exterior of the Victorian house examined, Chapter 7 enters the home and "walks through" it room by room, a feature unique to this book. A half dozen of San Francisco's best-preserved nineteenth-century house interiors are explored. There are very few of these relatively unchanged interiors left today. This book records them and shares these private places with the reader. From the formal rooms to the informal family and servant spaces, from the front

parlor and dining room to the bedroom, bathroom, and back stairs, this chapter reveals the interior life of Victorian buildings. The accompanying explanatory text sketches the meaning of these rooms to the Victorians, their "cult of the home."

Once we have studied these structures outside and in, Chapter 8 turns to the building and servicing of the San Francisco Victorian house. The different roles of architects and builders, the development of the distinctive San Francisco row house with its slot, and the changing shape of the city's trademark bay window over time are explained. Victorian plasterwork, painting, graining, stenciling, wallpaper, and hardware are touched upon. Exterior colors, fences, towers, cresting, and finials are examined. The utilities that "plugged in" the Victorian house are also covered: cable-car and streetcar lines, sewers and running water, gas for illumination and heat, and electricity.

A final section, Chapter 9, looks at how San Franciscans have adapted their nineteenth-century houses to meet the needs of modern life, from open floor plans to the addition of back decks, from new kitchens to inserted garages. This contemporary view includes the historically correct restorations of Victorian facades that have swept the city in the last decade. With each passing year, San Francisco is regaining many of its lost Victorian houses as the misimprovements of the past are pried off and new redwood facades are accurately reconstructed. Lastly, we glance at the greening of the barren, sandy Victorian city with gardens and street trees.

Throughout this architectural journey, period quotations are worked into the text so that the Victorians can speak for themselves. This is a sweeping panorama and there's much to see and enjoy. Let us begin.

1

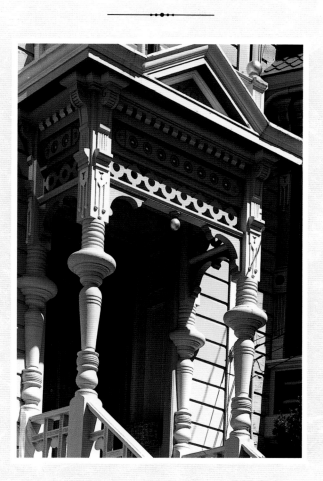

SAN FRANCISCO VICTORIAN HOUSES,
ROWS, AND NEIGHBORHOODS:
A PICTORIAL OVERVIEW

SAN FRANCISCO VICTORIAN HOUSES, ROWS, AND NEIGHBORHOODS: A PICTORIAL OVERVIEW

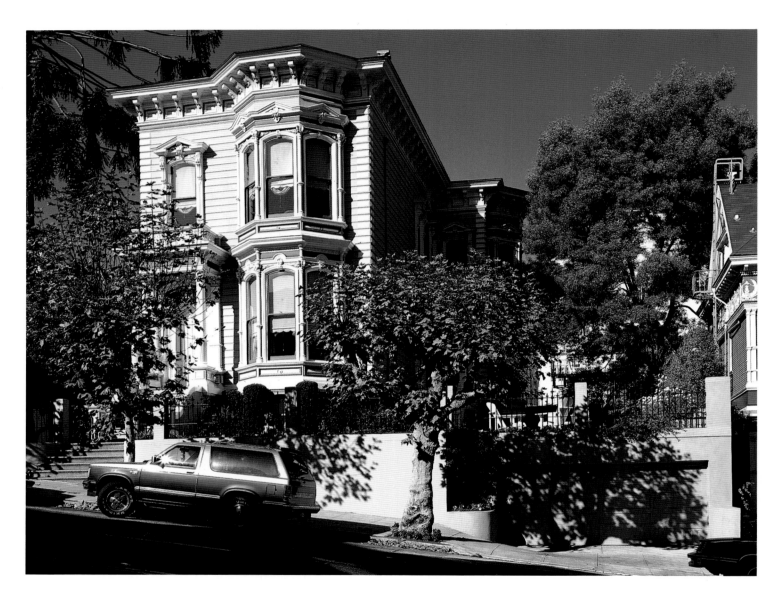

A SPLASHY ENTRANCE

San Francisco's Victorian houses face the street with great panache. The 1897 Eastlake-style porch of 725 Castro Street sports builder Fernando Nelson's signature columns of turned redwood. (Previous page)

A VICTORIAN WEDDING GIFT

The house at 1818 California Street, in Pacific Heights, was built in 1876 in the Italianate style. Bay windows, which became a San Francisco trademark, are seen here in the form of slant-sided bays. The commodious residence was a wedding gift from businessman Louis Sloss to his daughter and her husband. Today it is a bed-and-breakfast inn.

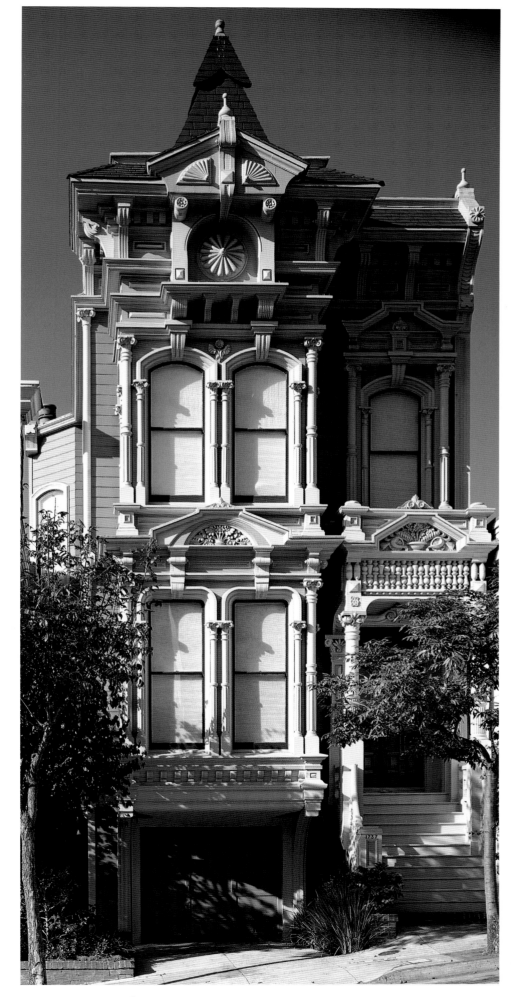

AN EASTLAKE HIGH POINT

The Vollmer house at 1735–37 Webster Street, in the Western Addition, was designed by the prolific firm of Samuel and Joseph Cather Newsom in 1885. It is the most elaborate surviving Eastlake-style Victorian row house in San Francisco. When its original Turk Street site was needed for more intensive development in 1975, the house was jacked up, put on wheels, and towed a dozen blocks west to its present Webster Street location. A garage was unobtrusively inserted underneath it, its interior was modernized, and its facade was carefully restored.

Hittell's Guide of 1888 observed that "the superior facility for shaping wood, and the abundance of machinery for planing and molding, has led to the adoption of more architectural ornament here than in any other city." "The visitor from the East," he dryly added, "is at once impressed by the rarity of plain exteriors in the dwellings of the wealthy."

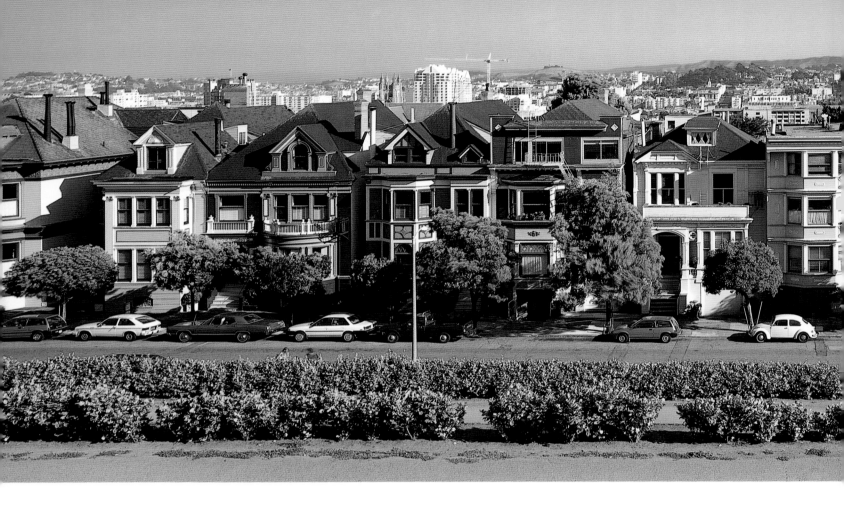

THE VICTORIAN CITYSCAPE: HOUSES AND PARKS

The panorama south from Alta Plaza, looking out over the Victorian-rich Western Addition, is punctuated by the dark green islands of Alamo Square (center left), Buena Vista Park, and eucalyptus-clad Mount Davidson (far right). The generous four-block-square parks on the hilltops and in the valley of the Western Addition were reserved by the city for the public in 1855.

Along the 2700 block of Clay Street, in the foreground, are (left) three peaked-roof Queen Anne houses designed in 1900 by Maxwell G. Bugbee, (center) a tall, white, bay-windowed, seven-unit apartment house built by Henry Feige in 1905, and (right) a group of flat-roofed houses built by David F. McGraw in 1890. (Above)

FRAMED BY GREENERY

San Francisco's nineteenth-century parks are as man-made as her houses are. Here Lafayette Park, in Pacific Heights, frames two great Queen Anne–style houses. To the left is 2004 Gough Street, designed by J. C. Matthews and Son in 1889; on the right is 2000 Gough Street, at Clay, designed by an unknown architect in 1885.

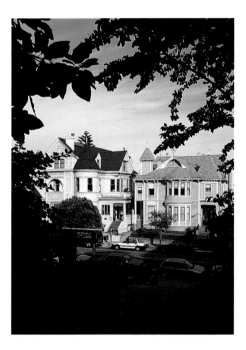

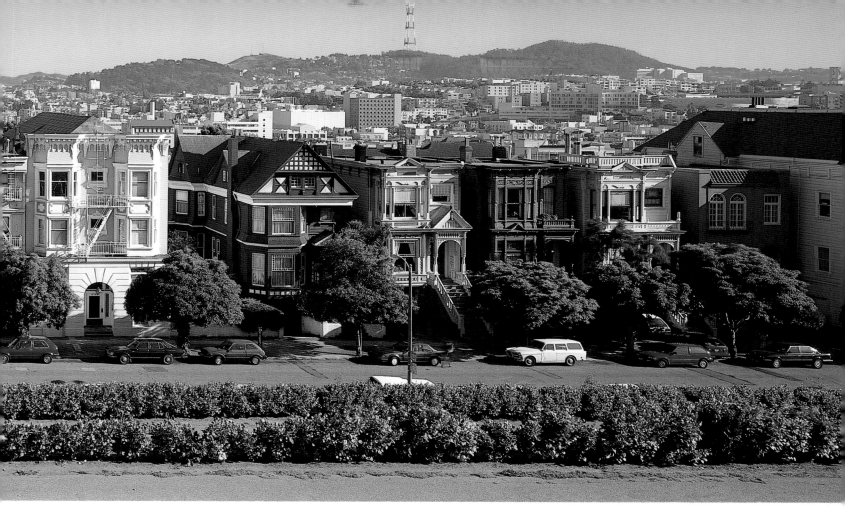

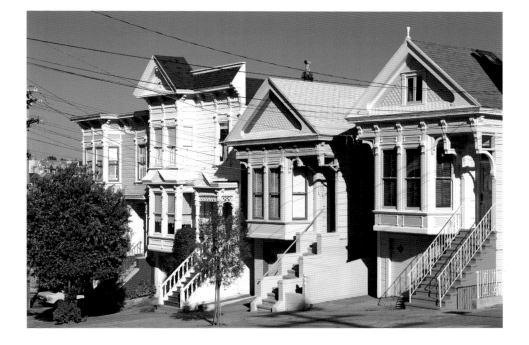

BAYS AND ROWS
*One- and two-story row houses,
punctuated by bay windows, spread
out along the city's cable-car lines
during the rapid growth of the Vic-
torian city. On Diamond Street near
Twenty-fifth Street, in Noe Valley, this
characteristic row of Eastlake-style
houses painted in traditional light-
reflecting colors produces a synco-
pated architectural rhythm that is
distinctly San Franciscan. The two
houses on the left were built by the
productive Fernando Nelson in 1893.*

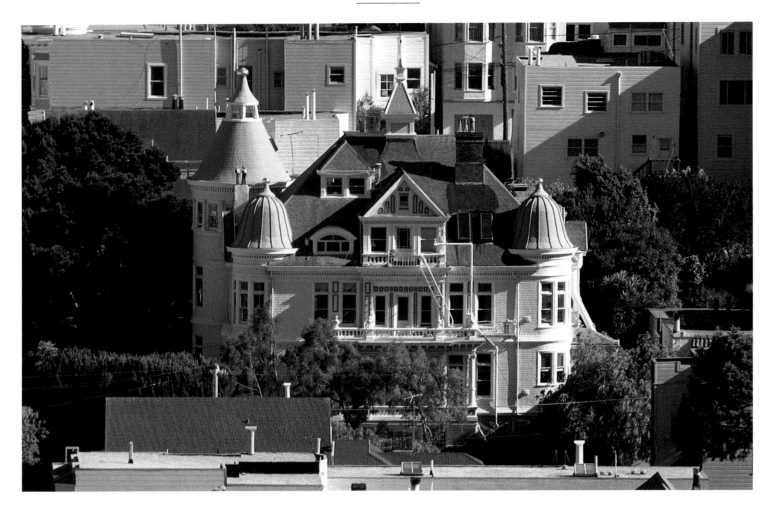

A GRAND HOUSE
The Alfred Clarke house, known as
Nobby Clarke's Folly, was designed by
Colley and Gould and built in 1890
at the head of Eureka Valley. It cost
$25,000, a considerable sum in those
days. This Baroque–Queen Anne pile
originally sat in a seventeen-acre
estate that was later subdivided.

PIECES IN AN
INTRICATE MOSAIC
The peak-roofed Queen Anne cottages
along Dolores Heights's Liberty Street,
built in the late 1890s, shelter mature
gardens at the heart of the block.
(Top)

Apartments and flats line Castro
Street in unbroken bay-windowed
ribbons along what was once the
Castro Street cable-car line. (Middle)

Gardens lie hidden at the center of
Noe Valley's Victorian blocks.
(Below)

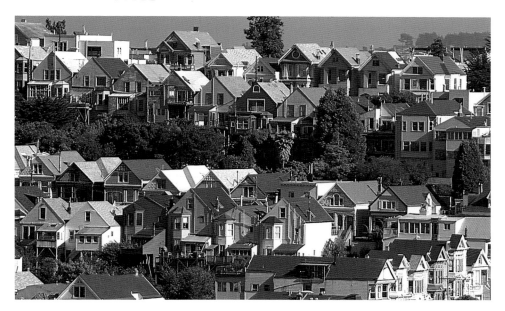

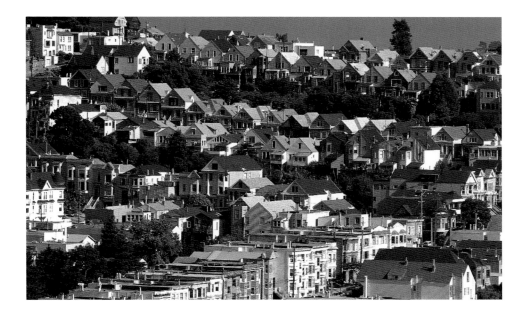

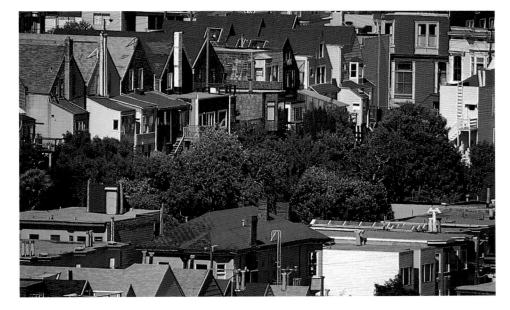

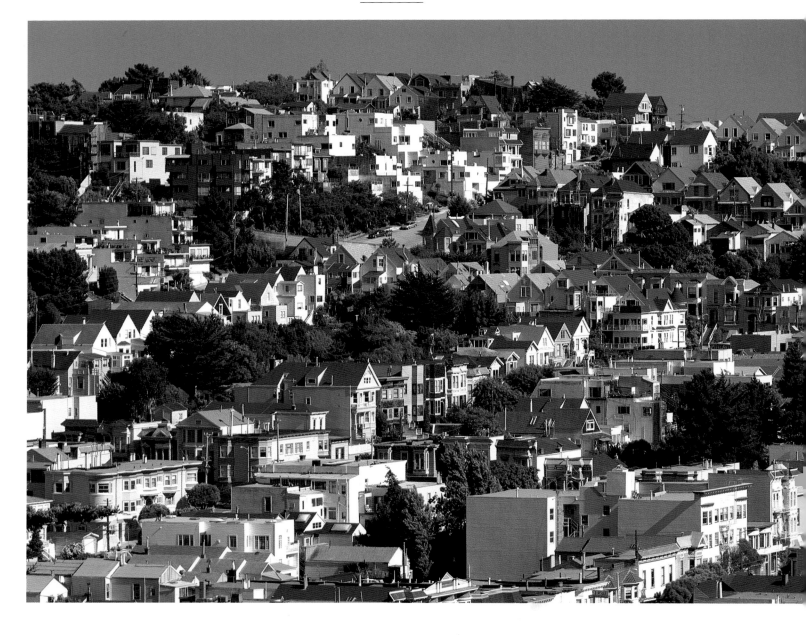

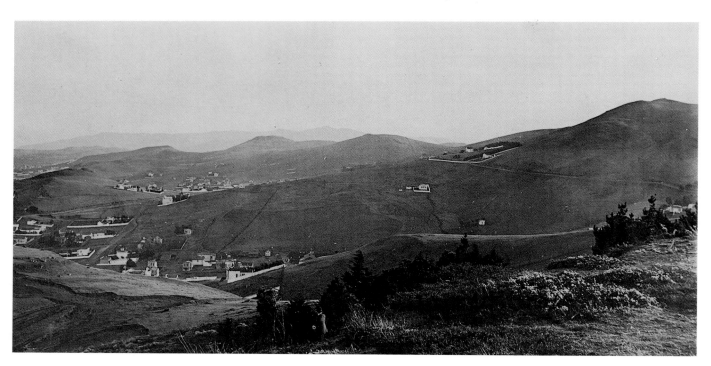

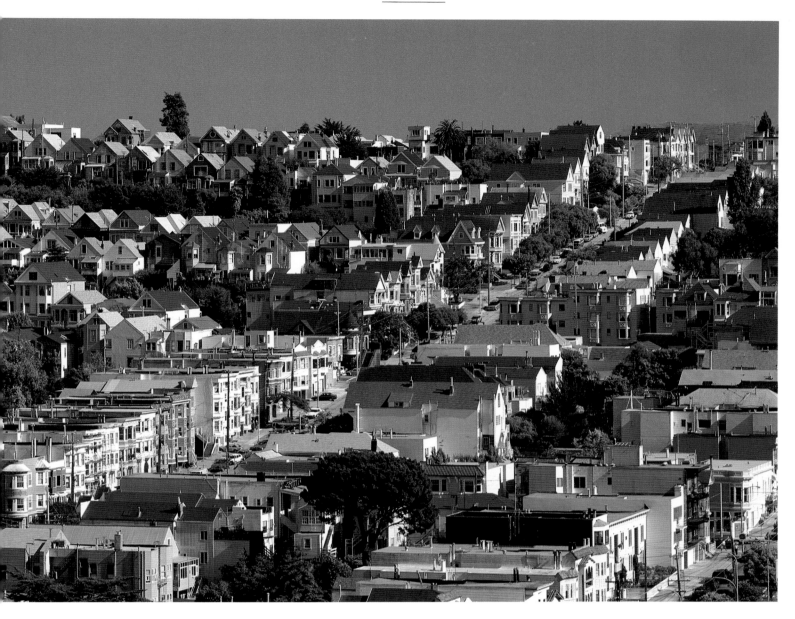

BEFORE AND AFTER:
THE VICTORIAN
ACHIEVEMENT
*This 1886 panorama, looking south
from Buena Vista Park, shows how
the Victorian city grew, with houses
appearing first in the accessible val-
leys. Eureka Valley and today's Cas-
tro District are to the near left; Noe
Valley appears in the middle distance.
All around are barren, undulating
hills dotted with dairies and small
truck gardens, the future Dolores
Heights.*
Greg Gaar Collection.

*Dolores Heights today, seen from
Corona Heights looking south, shows
the Victorian achievement at its best:
neat grids of graded blocks cast over
many hills and lined with light-
reflecting houses. Century-old back
gardens and trimmed street trees
soften the cityscape.*

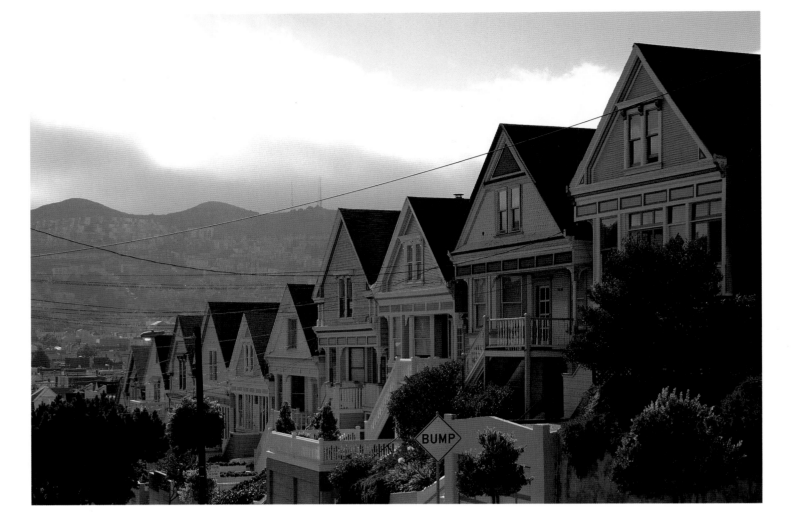

HILLS AND FOG

*San Francisco's always-changing
skies of bright sunlight and milky fogs
wash over her Victorian districts,
creating a distinctive atmosphere.
Here a landscaped row of Queen
Anne–style houses along Twenty-fifth
Street, between Dolores and Church
streets, awaits the fog that rolls in
over Twin Peaks from the west.*

2

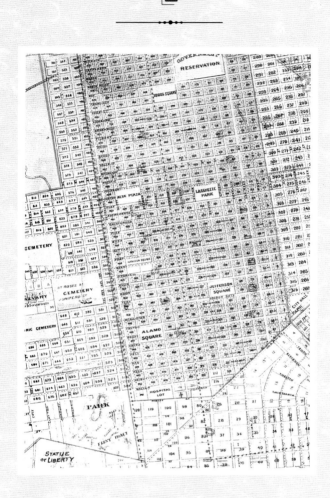

DIVIDING THE LAND:
FROM SAND DUNES TO HOUSE LOTS

DIVIDING THE LAND:
FROM SAND DUNES TO HOUSE LOTS

Arriving in Victorian
San Francisco

Travelers approaching Victorian San Francisco saw her first from across the ever-changing waters of San Francisco Bay. Rail passengers transferred to large, white, well-appointed ferries, which linked the Oakland mole with the Ferry Building at the foot of Market Street. The peninsular city with its tempered climate was approached from the water, its low horizon of undulating hills densely covered by the neat cubes of its buildings. Those who arrived by sea on the great sailing ships and modern steamers also debarked on Front Street, today's Embarcadero. In the nineteenth century, San Francisco was a major port crowded with ships from all seafaring nations.

Robert Louis Stevenson left a vivid description of the marine entrance to Victorian San Francisco in 1882:

A great city covers the sandhills to the west, a growing town [Oakland] lies along the muddy shallows to the east; steamboats pant continually between them from before sunrise till the small hours of the morning; lines of great sea-going ships lie ranged at anchor; colours fly upon the islands; and from all around the hum of corporate life, of beaten bells, and steam, and running carriages, goes cheer-

ily abroad in the sunshine. Choose a place on one of the huge throbbing ferry-boats, and, when you are midway between the city and the suburb; look around. The air is fresh and salt as if you were at sea. On the one hand is Oakland, gleaming white among its gardens. On the other, to seaward, hill after hill is crowded and crowned with the palaces of San Francisco.

From the great wooden shed of the old Ferry Building, the traveler walked out to Market Street, the city's main stem. From here cable-car lines radiated out over San Francisco like the ribs of a fan. The rush and bustle of a thriving commercial metropolis was everywhere apparent. What the stranger noticed first was the city's cosmopolitanism. There were Yankees and New Yorkers and southerners, Englishmen and Irish and Germans, Jews, Frenchmen and Italians, Mexicans and a few Indians. *The Annals of San Francisco* described the swirling scene as early as 1854:

You elbow South Americans, Australians, New Zealanders. You accost a man who was born in Brazil, who hails from Good Hope, who trades in Honolulu. One of the great Chinese merchants with an easy gait, an erect head and a boyish face, is coming around the corner. A man from Calcutta is behind you. . . . [There are] all

sorts of people from the outer edges of geographies and the far borders of atlases. . . . It is a tremendous polyglot. . . . Street life in San Francisco is a kaleidoscope that is never at rest.

Author Harriet Lane Levy evoked Saturday night on Market Street in Victorian San Francisco in her childhood memoir, *920 O'Farrell Street:*

Every quarter of the city discharged its residents into the broad procession. Ladies and gentlemen of imposing social repute; their German and Irish servant girls, arms held fast in the arms of their sweethearts; French, Spaniards, gaunt hard-working Portuguese; Mexicans, the Indian showing in reddened skin and high cheekbone—everybody, anybody, left home and shop, hotel, restaurant, and beer garden to empty into Market Street in a river of color. Sailors of every nation deserted their ships at the water front and, hurrying up Market Street in groups, joined the vibrating mass excited by the lights and stir and the gaiety of the throng. "This is San Francisco," their faces said.

And these San Franciscans were lively, too! Theodore Hittell sardonically noted in his 1888 guidebook for travelers that "her inhabitants are not marked by the staid habits, grave demeanor, and cautious reserve of older communities." Victorian San Francisco's exuberant

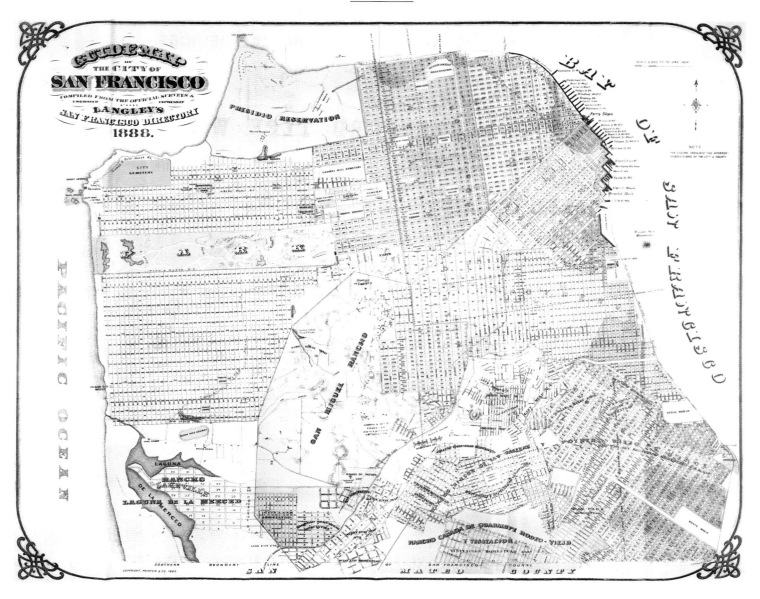

MUNICIPAL AND PRIVATE LAND SURVEYS IN VICTORIAN SAN FRANCISCO

San Francisco's complex street plan is the result of various municipal and private land surveys. The city surveyors laid out the even pattern of rectangular blocks in the northeastern areas (the downtown, South of Market, and Western Addition) and the far western neighborhoods, or Outside Lands (the Richmond and Sunset). The subsequent Anglo owners of the one-time Mexican ranchos in the center of the peninsula (Twin Peaks's San Miguel Rancho), the southeastern corner (Outer Mission and Bayview), and the southwestern section of the city (Lake Merced) laid out a patchwork of unrelated grids when those large holdings were subdivided over time. This informative map was published in 1888 as part of Langley's San Francisco Directory. The various (arbitrary) colors identify the earliest city surveys and private landholdings. Every block was given a number by the city or the private subdivider. The large rectangular park is Golden Gate Park.
Langley's San Francisco Directory, 1888.

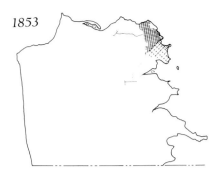

1853

THE GROWTH OF
SAN FRANCISCO

San Francisco grew from east to west, from Yerba Buena Cove on San Francisco Bay to the Pacific Ocean. The survey of 1847 drawn up by Irish-born civil engineer Jasper O'Farrell created the two different grids north and south of Market Street seen in the 1853 map.

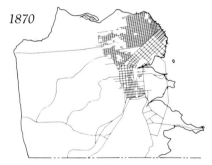

1870

By 1870 Yerba Buena Cove had been filled in for the expanding downtown. Both the middle-class Western Addition north of Market Street and the working-class Mission District south of Market Street were filling up with Victorian row houses.

architecture matched the expressiveness of her people.

Then, as now, the transforming effects of San Francisco's soft fogs and particular light made the city a constantly shifting image. George H. Sanders, one of the principals in the San Francisco architectural firm of Wright and Sanders, described the transforming sea fog in one long, undulating, most Victorian sentence in October 1884:

> While I write, on the upper levels of the California Street Hill [Nob Hill], overlooking the city, the fog has swept across the lower portions, revealing only the larger buildings, and the City Hall, the Synagogue, Trinity, St. Ignatius and other churches and the great hotels lift their domes, towers, spires and roofs, through its soft and swathing mantle and the rising sun gilds them with a glory of softly matutinal beauty which must be seen to be appreciated, while the Mission Hills beyond with their lovely waving lines of delicately shaded gray, with the blue mountains of San Mateo County towering beyond, all together present to the admiring gaze as pleasing a picture of quiet beauty as any often seen.

The Yankee Scramble for Real Estate

This dreamy view belied the more sordid beginnings of the great city on the bay. In 1846, immediately upon the United States naval conquest that took California and the Southwest from Mexico following a war triggered by a Texas border dispute, a mad scramble for land erupted in California. Yankee squatters built cabins and erected fences, acting as if all of California were in the public domain just waiting to be claimed by simple appropriation. But the 1848 Treaty of Guadalupe Hidalgo that ended the war and confirmed the vast Mexican Cession of more than 1 million square miles said otherwise. It declared that existing Mexican land titles were to be "inviolably respected."

The situation on the San Francisco peninsula was much more complicated

than it first appeared. The initial thirty years or so of the new city's life revolved around the vexed question of who held legal title to the land. Everyone could see that a great metropolis would rise on the narrow, sandy peninsula and that fortunes would be made when sand dunes became building sites. Americans were no strangers to land speculation. The very creation of the early eastern seaboard colonies was often an exercise in long-distance land speculation by those with connections to the British crown. The territorial expansion of the United States, so clean and majestic when seen in historical atlases—vast blocks of virgin land inscribed with neat dates of acquisition—was in reality usually a very messy process. There were conflicting claims of ownership, fraudulent land sales, contested public auctions, squatting, feuds, murders, political intrigues, and endless, costly court proceedings through layers of legal jurisdictions. *Thus* was born Victorian San Francisco.

The Mexican Heritage of Land Titles

During the Mexican era, from 1821 to 1846, the San Francisco peninsula had been parceled out in various ways. First was the military encampment at what is now the Presidio. Then there were the ex-mission lands surrounding Mission Dolores (formally, Mission San Francisco de Asis, founded in 1776 and "secularized," or dissolved, by the Republic of Mexico in the 1830s). Near the abandoned mission, along what is now Sixteenth Street, lots had been granted to, or simply taken by, Mexican settlers who built adobes there. In the center, south, and southwest of what is today the City and County of San Francisco, a dozen large and small tracts had been granted between 1833 and 1846 to individuals for cattle ranches. These ranchos, which had been awarded by the Mexican governor at Monterey, were extremely primitive affairs, often simply a rude adobe in a sandy hollow surrounded by unfenced

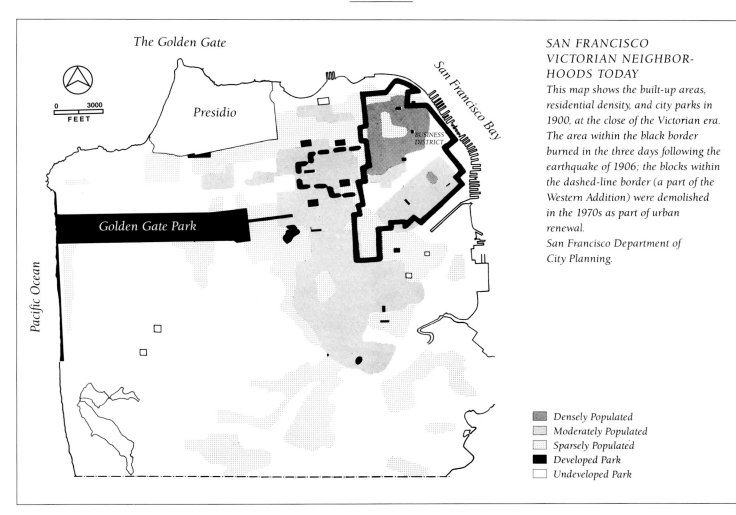

The Golden Gate

Presidio

Pacific Ocean

Golden Gate Park

San Francisco Bay

BUSINESS
DISTRICT

0 3000
FEET

SAN FRANCISCO
VICTORIAN NEIGHBOR-
HOODS TODAY
This map shows the built-up areas,
residential density, and city parks in
1900, at the close of the Victorian era.
The area within the black border
burned in the three days following the
earthquake of 1906; the blocks within
the dashed-line border (a part of the
Western Addition) were demolished
in the 1970s as part of urban
renewal.
San Francisco Department of
City Planning.

■ Densely Populated
▨ Moderately Populated
☐ Sparsely Populated
■ Developed Park
☐ Undeveloped Park

herds of almost-feral cattle.

José de Jesus Noe's San Miguel Ran-
cho included all of Twin Peaks and the
central hills. José Galindo's Rancho
Laguna de la Merced embraced one-
and-a-half leagues (about 6,642 acres) in
the far southwestern corner of the pen-
insula. Other ranchos were granted to
José Cornelio de Bernal, Benito Diaz,
José M. Andrade, and Ramon and Fran-
cisco de Haro. Some of the tracts granted
in the mid-1840s were given to English-
speaking naturalized Mexican citizens,
such as Ohio-born Jacob P. Leese, Henry
D. Fitch, and Peter Sherreback. Leese was
granted a two-square-league (about
8,856-acre) spread known as the Cañada
de Guadalupe Visitacion y Rodeo Viejo
in the southeast corner of what was to
become San Francisco. Some of these
men, in particular the syndicates of
speculators that quickly formed to buy
Mexican-held ranchos in the wake of the
United States conquest, were keenly

aware of future land values and fought
resourcefully for their empty, but prom-
ising, property.

At the shallow cove in the northeast
corner of the peninsula, where China-
town is today, an Anglo-Mexican pueblo
had sprouted in 1835. It was called Yerba
Buena, meaning "good herb" in Spanish,
because of the wild mint that grew there.
Four years later a crude grid of rectangu-
lar blocks with narrow streets was sur-
veyed by Swiss-born Jean Jacques
Vioget. Centered on a small, sandy plaza
(now Portsmouth Square in China-
town), this survey covered the twelve
blocks today bounded by Montgomery,
Grant, California, and Pacific. Near here
British and Yankee sea captains bartered
for the hides and tallow produced on
ranchos around San Francisco Bay. In
accordance with Mexican land law, the
municipality had granted a few lots to
those who promised to erect a dwelling
within one year. It was this complex

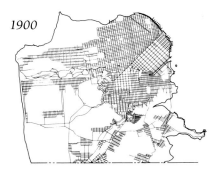

1900

When the Victorian era came to a
close in 1901, Golden Gate Park and
the sparsely settled Richmond District
reached out west to the Pacific Ocean.
South of the Mission District, a chain
of disconnected working-class "sub-
urbs" lay strung out in the valley
leading south to the city limit.
San Francisco Department of City
Planning.

THE ALL-AMERICAN GRID IN VICTORIAN SAN FRANCISCO: UNIFORMITY IN PLAN, INDIVIDUALITY IN SUBDIVISION

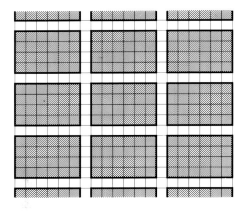

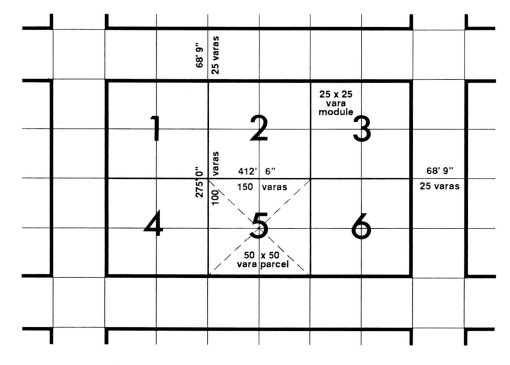

THE SIMPLE ABSTRACT SURVEY
Jasper O'Farrell's survey of 1847 created uniform rectangular blocks, oriented east to west, north of Market Street. Using a module based on twenty-five varas, or Spanish yards, streets and blocks were laid out. Each block was divided into six lots fifty varas square and the lots were auctioned off.
Anne Vernez Moudon

pattern of imprecisely surveyed private town lots, ranchos, and squatters that the United States inherited when it conquered California.

Complicating things further was the status of the ungranted land held in common by the Mexican municipality. These were the famous Pueblo Lands, or Outside Lands, a huge, undefined four square leagues (about 17,712 acres) of shifting sand hills west of the settlement at Yerba Buena, stretching from what is now Divisadero to the ocean, and from the Presidio south to Sloat Boulevard. In the immediate aftermath of the United States conquest, squatters had occupied all this unclaimed land and created a crazy quilt of individual spreads. Both state and local politics revolved around the troublesome question of land claims. As pioneer historian Theodore Hittell wrote, "There were squatter governors, squatter legislatures, and a squatter press." Into the 1860s there were endemic outbursts of squatter riots when legitimate owners sought to possess their land. The United States Army had to be called in to uphold property rights.

Although many of the squatters were poor men staking out their share of

the new El Dorado, others were wealthy speculators who hired landless straw men to occupy vacant land and erect hasty fences. No one knew the precise location of lots and claims. Lot jumping was easy. Squatting's earliest tools were the gun and the blanket. It was well known that five years' possession and, after April 1878, payment of state, county, and municipal taxes gave the squatter the foundation for legal title to land in the public domain. Essentially, the state's need for taxes was exchanged for clear titles. Or squatters could wait to be bought off by the legitimate title holder, who often found that route cheaper than costly court proceedings.

In many cases conflicting claims lay three, four, or more deep over the land. Land law instantly became one of the specialties of San Francisco lawyers. Historian Hubert Howe Bancroft records that the customary legal fee in a land claim case was one half of the land involved! And, he noted, "while figuring the affairs of the claimant the lawyer learned enough to enable him easily to cheat his client out of the other half." Many Spanish-speaking Mexican ranchers were illiterate and had never surveyed or properly recorded their

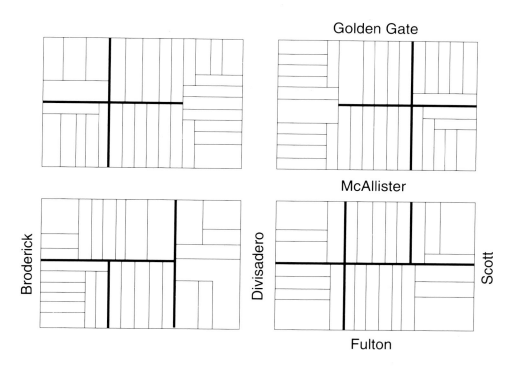

Golden Gate

McAllister

Broderick

Divisadero

Scott

Fulton

THE COMPLEX
SUBDIVIDED REALITY
*Owners of individual blocks and large
lots subdivided their property to cre-
ate house lots. These subdivisions
were never exactly the same on any
two blocks, creating individuality
within the uniform city grid. The four
blocks shown here at the edge of the
Western Addition are typical of the
results. The row house evolved to fit
these long, narrow lots. The standard
lot was twenty-five feet wide and one
hundred feet deep.*

holdings. Even those who had taken such steps were usually land-poor. When the American government was established, it levied county property taxes that had to be paid in coin, which the Mexican ranchers often did not have. County auctions soon transferred Mexican holdings to eager American land speculators.

The O'Farrell Survey of 1847 and Early Land Auctions

Among the very first things the Americans did when they assumed control over Yerba Buena was to engage Dublin-educated civil engineer and surveyor Jasper O'Farrell. It was his job to correct and extend the street plan of the Anglo-Mexican settlement at Yerba Buena Cove, to lay it out into blocks and lots that could be auctioned off. The town's earliest source of income was derived from selling off its "downtown" lands.

Jasper O'Farrell left an indelible imprint on San Francisco, one that significantly shaped the Victorian city. It was he who laid out broad Market Street. And he who established two different, and clashing, grids in the city. North of Market he preserved the small scale of Vioget's early blocks, but south of Mar-

ket he laid out much larger blocks unrelated to those to the north. The two grids did not match up evenly, making north-south connections across his city plan difficult. O'Farrell also projected his grid out into shallow Yerba Buena Cove (the so-called water lots), and over the peninsula's steep hills. Some of his projected "streets" ran straight up slopes impossible to pave; these later became public stairways. South of Market he laid his vast grid over swamps and small streams. In 1848 O'Farrell extended his survey from Front Street and the docks to the east to Larkin Street over Nob and Russian hills to the west. South of Market his survey extended to Townsend Street in the south and as far as Ninth Street to the west.

Another important feature of O'Farrell's plan was its parsimony in setting aside public spaces for parks and the complete absence of provisions for a city hall, police stations, schools, and other civic necessities. Laissez-faire nineteenth-century America had its stark monument in O'Farrell's flawed city plan. To preexisting Portsmouth Square, the original Mexican plaza, O'Farrell added only Washington Square to the north and Union Square to the south.

South of Market, only Columbia Square, covering just one third of one block, was reserved for public use (later built over for Bessie Carmichael Grammar School). In 1854 *The Annals of San Francisco* attacked O'Farrell's survey for its lack of parks:

> This is a strange mistake, and can only be attributed to the jealous avarice of the city projectors in turning every square vara [Spanish yard] of the site to an available building lot. Indeed the eye is wearied, and the imagination quite stupefied, in looking over the numberless square—all *square*—building blocks, and mathematically straight lines of streets, miles long, and every one crossing a host of others at right angles, stretching over sandy hill, chasm and plain, without the least regard to the natural inequalities of ground.

But O'Farrell's survey did accomplish its immediate goal, which was to create parcels of real estate that the municipality could auction off. In July 1847, W. Allan Bartlett, the *alcalde* (mayor) of the town, held a series of auctions. Each block north of Market Street measured 100 varas by 150 varas (275 feet by 412½ feet) and was divided into six lots each 50 varas square. Lots sold for $12.00 with an additional $3.62 recording fee. About 450 of the 700 lots were sold this way. Buyers were required to fence the lots and construct a dwelling within one year. The blocks south of Market Street were 200 varas by 300 varas, four times larger than the blocks near the plaza. They were divided into six lots each 100 varas square and sold for $25.00 plus the $3.62 recording fee. Some 70 of the 130 lots in the South of

Market were sold in August 1847.

For a short time these sales saved the infant municipality from the necessity of levying taxes. Early regulations limited purchasers to only one lot, but through straw men, speculators were able to assemble large holdings. The city, governed by men deeply involved in land speculation themselves, quickly did away with the regulations. In 1853, when the city sold water lots farther out in the cove that were less than half the size of the north of Market lots, they brought prices from $8,000 to $16,000. Such was the explosive growth of the post–Gold Rush port. Land speculation on this distant point of the western frontier now carried the promise of fantastic profits.

Extensions and Subdivisions of the Grid after O'Farrell

The full history of the laying out of Victorian San Francisco has yet to be written and is far beyond the scope of this book. There were several other important surveys after O'Farrell's that merit mentioning here, however. The city surveyor was instructed to carve out blocks in the Mission Addition, the Potrero, the Western Addition (the zone between Larkin Street and Divisadero, plus a part of the Potrero), the Haight-Ashbury, and later the Richmond and the Sunset. Generally speaking, where fairly regular extensions of the downtown grid exist today, the city laid out the land. In the Outer Mission, Excelsior, and Bayview, where there is a complex patchwork of various unrelated, small grids, or in the lee of Twin Peaks with its curving, ser-

pentine streets, private developers drawing up distinct subdivisions created the varied street plans. Victorian San Francisco was principally built on the city-surveyed grids shown on page 13.

The quilt of disconnected grids south of Army Street was designed in the late nineteenth century by individual developers and homestead associations (corporations that subdivided land) as early working-class "suburbs," but they were not heavily built up until the twentieth century. The Richmond and the Sunset, platted in the nineteenth century, and the objects of a burst of speculation mania in the mid-1860s, likewise did not develop until well after the Victorian era.

In the oldest parts of the city, such as today's Chinatown, the Financial District, and North Beach, and in the impractically large South of Market blocks, private landowners opened narrow alleys to create more frontage lots. Middle-class houses were usually built facing the wide main streets; working-class cottages were crowded into the alleys. Even though they were completely rebuilt after 1906, Chinatown, North Beach, and the South of Market preserve this "outside" and "inside" block pattern. In only a very few areas, including the Beideman Tract in the Western Addition (Larkin to Franklin, and Pine to McAllister), service alleys were cut through the city-surveyed blocks by private developers. Blocks without alleys were preferred by the wealthy and middle class because they precluded the alley dwellings that housed a lower-class population. And

since even the well-to-do used the cable cars and streetcars, there was no need for narrow mews giving access to back stables.

The uniform grid was the classic American town plan throughout the nineteenth century. With roots in William Penn's 1683 plan for Philadelphia, and in Thomas Jefferson's 1784 checkerboard proposal for the states in the old Northwest, it was the favorite town plan on the western frontier. When taken to its ultimate extreme in the interior towns of Yankee California, the grid's abstract quality was reinforced by numbering the streets going in one direction, and by giving the letters of the alphabet to those running in the other direction. An address such as Third and B streets could be poetic only to a Cartesian surveyor. But on the other hand, the grid was rational, simple, easily understood, and facilitated the buying and selling of undeveloped lots.

Unanticipated Drama:
The Grid in Hilly
San Francisco

The grid that was projected over San Francisco's hilly topography has, by accident, created one of the most dramatic city plans in the world. It is because of the unimaginative grid that San Francisco enjoys such stunning vistas up and down its long thoroughfares. The views of the streets themselves seem telescoped. When coupled with the technology of the hill-climbing cable car, San Francisco's all-American grid produced a city with a singular kinetic quality. Movement through San Fran-

cisco is stimulating: views open and close as her streets are traversed. Rows of buildings create distinctive steplike profiles as they climb the slopes. Valleys seem more defined when spread out in a quilt of regular blocks.

In the long run, the speculator's simpleminded plan has worked beautifully. The proof is that where streets were closed for parks and the grid interrupted in the Western Addition under urban renewal in the 1960s, San Francisco's unique and agreeable "feel" is lost. On the other hand, where the grid collides with sharp slopes and stairways have been built, such as at Filbert and Greenwich streets on Telegraph Hill, or at Lyon, Baker, and Broderick streets below Broadway in Pacific Heights, a city form results that is dramatic, memorable, and distinctly San Franciscan.

House Lots and the
Business of Subdivision

Once blocks had been surveyed and sold off in six large square lots, the next step was "retailing" the land in narrow house lots on which contractors and individuals could build. Here is where great profits could be made. After gold, land was the most precious commodity in early California. Because the earliest American surveys had continued the use of the Spanish vara, subdividers had to find lot widths that converted neatly into American feet. There were various ways that fifty-vara lots could be "short platted." Obviously, the more lots into which a block could be subdivided, the greater the returns to the subdivider. Some early subdividers sliced their fifty-vara-wide

lots into five ten-vara-wide house lots each fifty varas deep. This yielded thirty house lots per block. Extra lots could be squeezed out of blocks by inserting them along the small dimensions of the blocks, resulting in thirty-four or thirty-eight lots per block, as on page 17. Ten-vara widths translated as 27 feet, 6 inches, and fifty-vara lot depths were equal to 137 feet, 6 inches, a one to five ratio of individual lot frontage to depth. Quickly, however, land dealers discovered that the market would willingly accept lots only 25 feet wide. This configuration could be neatly carved out of two adjoining fifty-vara lots, thereby yielding eleven narrow house lots. In 1878 the *Real Estate Circular* noted that the San Francisco market favored 25-foot-wide lots, while in New York City house lots averaged only 17 feet in width.

Since lot subdivision in the early days was not governed by city ordinances, it was the real-estate market coupled with the desires of the subdividers that determined how each block was sliced up. This process was incremental and executed by a variety of subdividers. Thus, underneath the apparent sameness of Victorian San Francisco's thousands of rectangular blocks is a highly varied reality. Upon close inspection, every block reveals a unique lot pattern, as on page 17. There is an almost random distribution of lot widths along the city's nineteenth-century blocks. Uniformity with variety is the legacy of the era's subdividers.

Generally speaking, blocks had three kinds of house lots: corner lots,

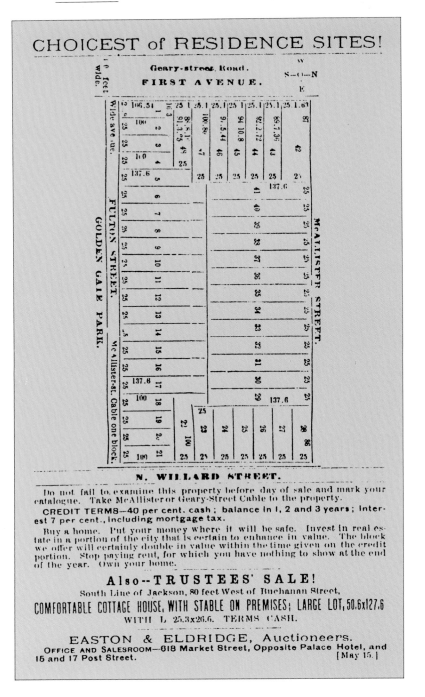

CHOICEST of RESIDENCE SITES!

mid-block lots along the long sides of the block, and what were called key lots, the lots in the middle of the shorter sides of the rectangular blocks. The value of lots generally followed this hierarchy, with the corner ones the costliest and the key lots the least expensive. Lots along the main, east-west streets were usually more expensive than those along the north-south cross streets. Large corner lots were often created to accommodate large, freestanding mansions with surrounding gardens. These lots were also favored for the corner grocery stores and saloons that were dotted all over unzoned Victorian San Francisco and that happily survive today in the city's older neighborhoods. Such corner commercial buildings, often with flats or apartments upstairs, have survived into the twentieth century because they were continuously income producing. The large corner mansions, on the other hand, have mostly been torn down. Their oversized sites with two street exposures were ideal for the con-

struction of much larger apartment buildings in the early twentieth century, or for such uses as parking lots and service stations by the mid-twentieth century. All over contemporary San Francisco, large corner apartment houses appear like bookends, framing rows of surviving mid-block Victorians.

Sometimes mid-block row houses were set back slightly from the street. Their recessed positions lend the buildings a sense of seclusion in comparison to corner properties built out to the lot line. Conversely, corner commercial buildings with shops on their ground floors often have second- and third-story corner bay windows that project out over the sidewalk. When projecting corner bays are combined with set-back mid-block rows, a satisfying sense of both sharp definition and relative privacy is created along the block front.

The truly remarkable thing about the long-term effect of the random, individual, profit-driven process of Victorian lot subdivision is how practical, resilient, and beautiful the infinitely varied pattern is. While blocks share unifying modules, each block front in the city is found to be unique once it is closely analyzed. Along with the changes over time in landscaping, house color, and new construction, there is almost never monotony along a surviving Victorian block, even one that might have been cookie-cutter uniform when first constructed.

Homestead Associations

Two institutions were of great importance in making Victorian San Francisco a city of homes. First were the homestead associations; second were the often fraternally or ethnically based savings-and-loan societies.

Homestead associations have a somewhat misleading name; they were usually not the builders of homes, but rather the subdividers of land. These organizations arose as mediators between the land rich and the individual would-be homeowner. They were private corporations that bought large tracts of land at the city fringes and then recruited members. The members paid an initial fee or deposit of from ten dollars to one hundred dollars, followed by monthly payments of ten dollars. Once the member had paid up the appropriate amount, he or she acquired title to a house lot. Each new title holder would then hire a contractor to build a house. In the 1870s some homestead associations began to build houses in addition to their subdividing activities.

In 1866, Langley's *San Francisco Directory* took note of this recent development with this observation:

One of the most important as well as pleasing features in the unexampled progress of our city is the organization of numerous Homestead Associations, which, by united effort and consolidated capital, place it within the scope and means of any industrious and prudent individual to secure a tract that he can call his own and secure to him the proud title of lord of the soil. . . . by the organization of Joint Stock Homestead Associations and the purchase of large and eligibly located tracts of land, every member of the community may become a landhold-

er at a comparatively trifling cost. By the payment of a small fee into the capital stock and a comparatively trifling amount in stated assessments, everyone may . . . become the possessor of an unencumbered site for a homestead.

Some 170 of these homestead associations were formed in San Francisco in the 1860s. In 1870 the Langley directory noted that the past three years had seen a wave of new organizations and that the idea had spread to the formation of associations to subdivide tracts for horticultural, viticultural, and farming purposes in the valleys surrounding San Francisco Bay. It added that

among other existing causes tending to encourage this method of acquiring small parcels of real estate has been the large aggregations of land growing out of the former system of Spanish [actually Mexican] grants, which, being held mostly by men of wealth, could only be purchased in extensive tracts. . . . house rent has always been one of the most oppressive items of family expense in this metropolis. . . . Hence the alacrity with which they have taken shares in the various Homestead Associations. . . . We can only remark, in a general way, that they have almost always resulted in a great benefit to their founders and original shareholders; no examples of decided failure having yet occurred among those undertaken in San Francisco, while the advance in the value of real estate so secured has generally been marked and rapid.

Most of these corporations had their offices on Montgomery or California streets in the Financial District. Often

**THE DEED TO THE
LOT FOR THE
HAAS-LILIENTHAL HOUSE**
*The ornate Victorian lettering and
copperplate script of the deed to the
Haas-Lilienthal house lot at 2007
Franklin Street has an eminently
satisfying look for an important docu-
ment. More important than this
paper was the reliable Registry of
Deeds, the municipal department
responsible for recording this transac-
tion at exactly 2:02 P.M. on April 17,
1886, in liber (book) 1197 on page
123. (The exact time could be impor-
tant in a lawsuit, and lawsuits over
title abounded in the fast-growing
Victorian city.) Thomas Magee, the
real-estate agent who conducted this
transaction, was the dean of property
dealers in nineteenth-century San
Francisco. He wrote and published
the* Real Estate Circular, *the trade
bible in its day and a gold mine for
the historian today.
The Foundation for San Francisco's
Architectural Heritage.*

their names helped locate and/or mar-
ket their tracts. Among the homestead
associations in San Francisco in 1870
were the Bay View, Bay View Railroad,
Clinton Mound Tract, Felton Tract,
Geary Street Extension, Harrison Street,
Laurel Hill, Mission and Thirtieth
Streets, New Potrero, Point Lobos, and
Visitation Land Company. Others
adopted promotional monikers, includ-
ing City Land, Endowment, Fifty Asso-
ciates, Golden, Keystone, Miners',
Pioneer, Prosperity, Seventy-five-dollar-
a-lot, Teachers, and Merchants home-
stead associations.

An Honest Outfit:
The South San Francisco
Homestead Rail Road Association

Not all of the homestead associations
were made up of poor men; some were
owned by the city's richest citizens. One
of the more active of the well-capitalized
corporations was the South San Fran-
cisco Homestead and Rail Road Associa-
tion (SSFH & RRA), which, despite its
name, was active in what is now the
Bayview District. First the SSFH & RRA
bought a hilly tract of land near Hunters
Point for $75,000. In 1863 the associa-
tion managed to get a bill passed by the
California legislature giving it permis-
sion to cut down the hills of the tract and
fill in the state-owned tideland out to a
depth of six feet. For this submerged
land the association paid the state from
$1.25 to $2.00 per acre. The SSFH & RRA
then spent $9,000 on a turnpike to open
up the area and donated thirty acres to a
syndicate to build a dry dock at Hunters
Point, a facility that was guaranteed to

create a market for working-class house
lots. In 1865, five hundred lots were dis-
tributed to the shareholders, each share
good for three lots measuring seventy-
five feet by one hundred feet. A wharf
was built in 1865 and a site was sold for a
metalworks. The association then in-
vested $40,000 in the Potrero and Bay
View Railroad and a year later dis-
tributed two thousand more lots. In this
way transit, industry, and sites for
working-class housing were created in
the southeast corner of the city with a
total assessed value of $1.5 million.

Sharp Practices: The Golden
City Homestead Association

The obvious subsidy in this operation
was the cheap sale of the state's tideland
and submerged land. Seeing this
bonanza, Frederick Mason and John
Bensley, two real-estate speculators with
connections in high places (Mason
stayed at Governor Frederick Low's
house when in Sacramento) who had
bought one hundred hilly acres on the
Potrero Hill slope in 1853 for about
$20,000, formed the attractively named
Golden City Homestead Association
(GCHA). Their land had an 1,800-foot
frontage on the bay. After bringing Gov-
ernor Low's brother into their corpora-
tion, they petitioned the legislature for
title to the submerged land adjoining the
tract. Their intent, they told the legisla-
ture, was to cut the hill to fill the bay,
thereby creating homesteads for poor
people and taxable property for the
municipality. The bill as drafted, how-
ever, simply gave the GCHA title to 153
acres for $300, with no conditions and

no stipulated improvements. To assure passage of the bill, legislators were promised, sold, or given shares in the association. The bill was passed in the press of business on the second night before adjournment, by a margin of one or two votes.

Next Mason and Bensley set out to defraud their confederates. The directors of the Golden City Homestead Association announced that they would pay $100,000 for the one hundred acres of upland property that Mason and Bensley had bought for $20,000. With this move, several little fish in on the deal realized the game was not theirs. The small speculators and legislators who had taken shares in the GCHA now saw themselves as part of a $100,000 liability for which they would be assessed. They dumped their shares at low prices to brokers who were ready to pick up the pieces for, of course, Mason and Bensley. Now the two sharp partners controlled all the land, solid and submerged, which they simply held, never having intended to create "homesteads for the poor" in the first place.

In 1875 *part* of the land was used by the partners to secure an $80,000 mortgage (in gold coin) from the Nevada Bank. At this time all the property was assessed for tax purposes at $60,000. More money was realized by selling a right-of-way at $15,000 a block to a subsidiary of the Central Pacific Railroad.

The reason we know so much about the workings of the Golden City Homestead Association is that in 1870 some of the legislators who had been burned in the scam opened a formal investigation.

Once testimony was taken and the hearing was adjourned, the vital records of the association that had been turned over to the legislative committee disappeared. This loss occurred following Senator Duffey's order to allow Bensley to consult the impounded papers. After this "consultation," the two key account books recording who held the shares were nowhere to be found.

In 1876 a second investigation was launched. But now several principals, including Mason and Governor Low's brother, produced statements from their physicians stating that they were ill and unable to attend. Other witnesses had a remarkably hard time remembering anything substantial about their own business, except, as Bensley helpfully pointed out in testimony, the enabling legislation said not a word about improvements, and that the three-year statute of limitations had already run out. Bensley's sudden ignorance of his own holdings was astonishing. He guessed some 672 lots, each either fifty feet by one hundred feet, or seventy-five feet by one hundred feet; the committee guessed some 1,344 lots.

Testimony got no more precise as the investigation proceeded into the messy details of land and money. And, with no records, how could human memory, suddenly so fallible, be refreshed? In the end nothing was done. When asked to characterize the original plan to secure the state tideland, one of the double-crossed would-be confederates put it all in perspective: "I believed it to be a legitimate transaction, as much as any in real estate."

The End of the Homestead Associations

Some legitimate homestead associations progressed from providing lots to building houses and selling them on easy terms. When the associations actually constructed houses, they tended to use standard plans in order to build economically. Preeminent among these organizations was The Real Estate Associates, formed by developer William Hollis. In the 1870s it built more than a thousand houses in San Francisco. Its operations are discussed in Chapter 4.

The homestead associations all but vanished by 1876. But they were an important early force in the subdivision of San Francisco's outlying lands. Now mostly forgotten, they left their indelible imprint in the jumble of street grids in the southern neighborhoods and in the many ribbons of row houses across the city.

Savings-and-Loan Societies, Natives, and Immigrants

The second important institution in the building of Victorian San Francisco was the patchwork of savings-and-loan societies, many of which were originally organized around ethnic or fraternal loyalties. The precursor of such institutions was the San Francisco Accumulating Fund Association, established as early as 1854. In 1857 it reorganized as the Savings & Loan Society, with offices downtown on Washington Street. An elite Yankee institution with relatively wealthy depositors, it paid dividends of 1.5 percent per month.

San Francisco's large European immigrant population, shunned by native American bankers, quickly created its own savings banks. The first was the Hibernia Savings & Loan Society, which was set up by John Sullivan in 1859. (Irish immigrants and their children were over one third of the white population of the city by 1880.) The Hibernia was well managed and wonderfully successful from the start; after five years it became the leading savings-and-loan society in the city. By 1869 it counted 14,544 depositors and more than $10.6 million in savings. All other savings banks in San Francisco had approximately 12,500 depositors combined.

In 1860 the *Société Française à Épargnes et de Prévoyance Mutuelle*—the French savings-and-loan society—was formed. It also appealed to San Francisco's budding Italian community. In 1861 the California Building, Loan & Savings Society was organized by another Irishman, Thomas Mooney, and 1868 saw the formation of the German Savings & Loan Society. The latter drew upon the savings of the city's prosperous German-American immigrants and had a long and profitable career.

The California legislature passed its first savings bank statute in 1862, which authorized five or more persons to incorporate as a savings bank and stipulated that married women and minors could open individual accounts. In that year the San Francisco Savings Union was formed. By 1866 San Francisco boasted five savings associations with a total of 24,550 depositors. In fact, depositors outnumbered voters in the city, since rural Californians also opened accounts in the metropolis.

Fraternal organizations were key institutions in Victorian America and they too organized savings societies. In 1866 the Odd Fellows formed a savings bank, and in 1869 the Masonic Savings & Loan Bank opened. The Improved Order of Red Men's Savings & Loan Company followed in 1870. These insti-

tutions, however, were not as important as the "Anglo" and ethnic-based savings banks, probably because their members had access to establishment banks.

Many small savers put their money in savings banks even if they themselves had no intention of building. Fearful of the unregulated stock market, and not rich enough to buy large-denomination government bonds, the city's working class found these local banks congenial. When first organized, the Hibernia accepted deposits of as little as $2.50. An 1873 issue of the *Overland Monthly* reviewed the city's savings banks and noted that the working-class saver

is a feeder to that great river of wealth which builds cities [and] constructs railroads and great public works. . . . Large annual additions are made to this vast monetary ocean by the hundreds of thousands of little rivulets which flow constantly and steadily into its capacious bosom.

In that year the average deposit was a substantial $922 in gold coin and the total capital in the city's savings banks was more than $43.7 million. This was the money that helped build the expanding Victorian city.

The history of these institutions is fascinating, reflecting as it does the intersection of the brutal economic cycles of the nineteenth century with the complex social and ethnic history of San Francisco. There was no easy, steadily upward growth in savings; periodic crises hit the city's overextended and occasionally grossly mismanaged savings banks. In 1870 San Francisco's seventeen savings banks had $36 million in deposits; seven years later there were twenty-eight savings societies with $75 million. The severe banking crisis of 1877 reduced the number of savings banks in the city to about a dozen, and the size of the average deposit also shrank, to $858. By 1880 the city had twenty savings societies with only $45 million in capital. In 1886 the *Real Estate*

CUT AND FILL ON CALIFORNIA STREET
The abstract grid imposed on San Francisco's rolling topography necessitated extensive grading of virtually the entire city for streets and building plots. The costly process went on for years. This profile of street grades along California Street was made for the California Street Cable Rail Road. The hill to the right is Nob Hill; the high ground in the center is Pacific Heights. Visible in the valley at Larkin Street is the cable-car power house.

Circular reported that the savings banks of "serving girls, laborers, and mechanics hold the largest pool of capital in San Francisco," some $53.5 million in mortgages on property. Deposits mounted until 1892, when they fell again. So cumbersome was the process of liquidation in the nineteenth century that some savings banks that had failed in 1878 were still untangling their affairs in 1891! Between 1904 and 1907 a wave of prosperity hit California and new savings societies were formed. There were twelve savings banks in Edwardian San Francisco in 1908.

Over time the dividends paid by San Francisco's savings-and-loan societies drifted downward with the deflationary century. In 1857 the elite Savings & Loan Society paid 18 percent in annual dividends; in 1860 the rate dropped to 17 percent. In 1871 the *Real Estate Circular* noted that the city's savings banks charged the poor 12 percent interest on loans and the rich 10 percent. In 1880 Langley's *San Francisco Directory* reported that during the past year

the leading savings bank [the Hibernia] has been loaning at 8 per cent. per year, it agreeing to pay the mortgage tax, which will consume 1⅞ or 2 per cent. of the 8. This is practically loaning money at 6 per cent., which for California is certainly a low rate. . . .

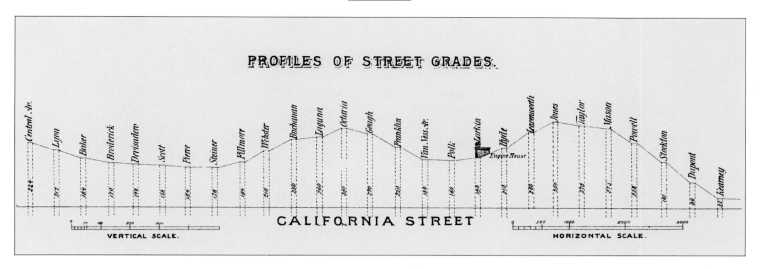

By 1889 rates charged to borrowers were 6 or 7 percent and dividends paid to depositors ranged from 4 to 5 or 5.5 percent for term deposits. San Francisco became the great financial reservoir of the West Coast and much of the savings of the city's people, especially its working class, was invested in house building.

Cut and Fill: Grading the Streets and Blocks

Once the land had been surveyed, platted into streets and blocks, auctioned off in large lots, and then subdivided into individual house lots sold to developers, contractors, or individuals, the process of city building had only just begun. The next step was a costly one, the grading of public streets and private lots. This was a highly uneven process and for many years Victorian San Francisco looked like one vast earthwork. At great expense, the land had to be made to fit the city plan.

In 1853 the city council adopted a system of grades for the downtown. The city surveyor set the elevation and grade, or slope, of each block of public street. Property owners along the block were assessed to pay for the grading and paving of the street and sidewalk. Parts of the downtown had already been built by this time and the official city grades did not always conform to the existing state of

things. Even three- and four-story brick buildings had to be raised or lowered to conform to the official grade.

Because the settlement was ringed by steep hills to the north and west, and by water and swamps to the east and south, the general pattern was to cut down the hills to fill in the swamps and the bay. The most valuable lots were those underwater in Yerba Buena Cove, because they were immediately behind the docks that linked California with the outside world. The east-west streets projected by surveyor Jasper O'Farrell appeared first as wooden piers that reached out into the shallow cove. The city granted franchises to private syndicates, which constructed the piers and charged for their use. Some, like the Commercial Street Wharf, were highly profitable. Fill was hurriedly dumped between the piers, creating flat blocks on which warehouses and business edifices were built. Some of the fill consisted of ships abandoned in the harbor during the Gold Rush. Today when excavations are made for the foundations of Financial District high-rises, fragments of the old ships are often uncovered. The first landfill block was at California and Sansome. The filling of the cove was so rapid that by 1850, Montgomery Street, once the shoreline, ran through the heart of town. Buildings were quickly erected on

the newly made land—sometimes too quickly. The new American Theater at Sansome and Halleck, for example, settled two inches on its opening night due to the weight of the audience.

By 1878 Theodore Hittell wrote:

We may assume that the present level of three thousand acres is in the average nine feet above or below the natural surface of the ground, and these figures imply the transfer of twenty-one million cubic yards from hill to hollow.

Grading and carting away sand hills was an expensive process and created much employment, in particular for Irish day laborers. In the 1860s this work could be done for from fifteen to twenty cents per cubic yard. By 1882 costs had risen to thirty to forty cents and went as high as fifty and sixty cents when demand was abnormally high. Soon steam shovels were employed to speed the work; some nicknamed them steam paddies. Temporary tracks were laid on some streets to accommodate the small steam railroads that were needed to move the sand and rock. The results were drastic. In some places the change in ground level amounted to fifty feet or more. Natural features disappeared. Happy Valley, St. Ann's Valley, Hayes Valley, and Spring Valley were obliterated by dismantling the hills that enclosed them

or raising the level of the low ground.

Landowners only graded their lots when they were preparing to build. As more and more of the city was graded, the isolated sand hills and miniature plateaus left behind on unimproved lots became more and more objectionable. A sixty-foot-high sand hill on O'Farrell Street, west of Franklin, became an issue in 1882. Neighbors unsuccessfully sought to have the offending dune declared a public nuisance because drifting sand made adjacent lots unsuitable for building. Rising land values, however, proved to be the most effective mechanism in stimulating the removal of the last dunes.

Until streets, sidewalks, buildings, and, very much later, parks covered over the rearranged land, much of the city outside the downtown presented a disjointed appearance. Hills looked like stepped ziggurats with raw embankments cut across them. New York–born writer Fitzhugh Ludlow wrote that "the candid visitor must regret that the grading of San Francisco seems to have been done by a Giant armed with a fish-slice and a coal-scoop under the influence of Delirium Tremens."

Robert Louis Stevenson apparently had a somewhat more positive view of this radical reshaping. In 1882 he wrote that

> the indefinite prolongation of its streets, up hill and down dale, makes San Francisco a place apart. The same street in its career visits and unites so many different classes of society, here echoing with drays, there lying decorously silent between the mansions of Bonanza millionaires, to

founder at last among the drifting sands beside Lone Mountain cemetery, or die among the sheds and lumber of the north.

In a description of the thriving city in 1888, Hittell's *Guide* stressed the practical aspect of the changes, reminding visitors that

> the hand of art is hidden in this vast plain. . . . The face of nature has been changed, so that those who saw the site in 1848 no longer recognize it. Then there was scarcely level space enough for 500 people; now there is room for 1,000,000 people. Hundreds of hills and ridges have been cut down; and large tracts of ravine, swamp, mud flat, and bay filled up.

The Public Sector and the Great Improvements in Urban Utilities

The popular perception of the nineteenth-century American city stresses political corruption and pervasive municipal incompetence. It reserves its admiration for the captains of finance and the achievements of the private sector, such as the construction of the transcontinental railroad. But this is not an accurate view. It was the achievements of the public sector—so easily overlooked when they function—that made the Victorian city both possible and attractive to the millions who flocked to it seeking better jobs and bright lights. The rapid provision of paved streets, sidewalks, sewers, police protection, fire protection, postal service, streetlights, public health, building regulations, public schools, and later libraries and landscaped parks was a tremendous accomplishment. It is a distortion to focus only

on the graft and waste and overlook the much, much greater sound investments in infrastructure and public happiness that the Victorian city provided its citizens. Only our unthinking anti-government ideology blinds Americans to the real and lasting achievements that tax dollars and public spending created.

Why did people leave farms in upper New York state, towns in Germany, or the fields of Ireland to come to such expanding cities as San Francisco? They came because life here, hard as it might be, was better, richer, more exciting, and more capable of providing a wide variety of individuals and families with employment, friendship, achievement, education, and amusement. And what held the city together, what made it a living system, was the collective investment that produced the services that made possible the jobs, houses, schools, and safety that the residents enjoyed. People came to San Francisco then, as they come now and will in the future, because the activities available in the metropolis make life better, more human, more fulfilling.

In the Victorian era, no rural or suburban area could match the public works and communal services available in the central cities. Their technological achievements were great. The City and County of San Francisco as a municipal corporation was, on balance, a great success. Its city departments were not mere "tax eaters." They were essential service providers.

In Victorian San Francisco certain public utilities were privately owned and operated, including the water, gas,

electricity, telephone, and transit companies. Technological progress was rapid and San Francisco kept up with the breakthroughs of the day. The first horse cars, the Yellow Line, began operation in 1852, running on Kearny, Third, and Mission streets. By 1853 the city had its first coal-gas illumination in hotels and theaters and on downtown streets. By 1856 the gas company had more than four thousand customers. The city was linked by telegraph with New York City in 1862. In 1869 the transcontinental railroad was completed. Seven years later a lightning express train went from Jersey City, New Jersey, to the Oakland mole in just eighty-one hours. California's first telephone exchange opened in San Francisco in 1878.

In 1888 Hittell's *Guide* observed that "the street-cars are so cheap, and run at intervals so brief, and are generally so clean and convenient, that relatively little use is made of cabs." All these utilities operated with city franchises and under municipal regulation. That there were imperfections is undeniable, but that the systems, and the city, worked is also true—and more important.

For what good was the most elaborate Victorian house without legal title, police protection, a fire department, a street to provide it access, a sewer to service it, and schools for the children who were raised in it? We should look at the private house as the flower on a much larger plant. The flower could not blossom without the roots, stems, branches, and leaves that fed it. Victorian houses must be appreciated as the private manifestations of much vaster

public investments. They would have been literally uninhabitable without the city that brought them forth, then sustained and serviced them.

The Stratified Victorian City

As San Francisco grew along the extended cable-car and streetcar lines reaching out over the sand hills from the docks and the downtown streets, neighborhoods assumed distinct social characters. Market Street acted as the great divide, separating the working-class districts in the South of Market and in the Mission District from the middle-class streets of the north of Market Western Addition. California Street, with its cluster of banks downtown and its luxurious California Street Cable Rail Road reaching west, became the dividing line between the middle class and the upper class. Nob Hill was not big enough, or remote enough, to hold all the houses of the very well-to-do. North of California was Pacific Heights, with its sweeping views of the bay and the Marin hills. Elaborate houses rose atop the ridge along Washington Street, Pacific Avenue, and Broadway.

The basic trend was that of suburbanization, of fleeing the crowded, expensive, congested core for quiet streets and blocks lined with similarly priced houses. While there was no zoning to control growth in the nineteenth-century city, lot sizes helped to determine the social composition of streets and neighborhoods. Subdividers provided larger lots in fancy neighborhoods, especially large corner lots fit for great

houses. In middle-class areas standard house lots of twenty-five feet by one hundred feet were carved out of identical rectangular blocks. Different neighborhoods and streets quickly attracted different classes. The tendency was toward uniformity; most houses on a block had the same number of stories and cost the same as neighboring structures. It was rare for house sizes to vary much within a neighborhood. Builders respected and reinforced these patterns. The class homogeneity of a street became its most salable element. Each block's architecture and degree of elaboration assumed rough geographic predictability.

There was extraordinary mobility in the Victorian city. Even wealthy families moved frequently. Many middle-class families rented their houses and were ready to flee to newly developed areas as expanding commerce and industry invaded close-in neighborhoods. As individual Victorian families rose in the social scale, they moved to a new house in another neighborhood rather than add onto their existing home. New houses tended to be larger and better equipped. Neighbors had to be of the same class, or better. Streets and districts could also become déclassé, as happened in parts of the sunny Mission District despite its superior climate. South Van Ness Avenue, originally Howard Street, in the Mission District, still has clusters of houses grand enough for Pacific Heights but which rapidly lost their cachet. Two things helped rearrange the city's social patterns: the invention of the cable car and a growing

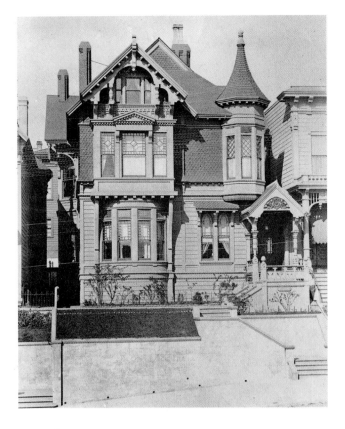

RETAINING WALLS
Grading the streets often created dramatic house sites, such as this one at 2292 California Street, with a house designed by Pissis and Moore. High brick retaining walls, covered with cement scored to look like stone, were built to contain the sandy soil. These "pedestals" give the city's ornate Victorian houses a uniquely San Francisco setting.
Artistic Homes of California.

appreciation for views of the always-changing bay. Cable lines made the precipitous hills encircling the downtown and the Pacific Heights ridge overlooking the scenic north bay easily accessible from the Financial District. This turned the tide of fashion from sunny Rincon Hill, the flat South of Market, and the Mission District's "warm belt" to Nob Hill and Pacific Heights. Historian John P. Young wrote that "toward the close of the century the water prospect had gained ascendancy and the streets west of Van Ness [Avenue in Pacific Heights] with a view of the harbor were affected by the socially pretentious."

The Victorian city was intricately stratified. The ranking we apply to suburban towns, Victorians applied to city streets. In San Francisco, residents could look at the number of an address on almost any street and guess with great accuracy as to the income level and social class of that household. Adna F. Weber, one of the earliest scientific students of cities, commented on this stratification in 1899:

The city is the spectroscope of society, it analyzes and sifts the population, separating and classifying the diverse elements. The entire progress of civilization is a process of differentiation, and the city is the great differentiator.

The marked specialization and complex stratification of San Francisco became one of its chief attractions. Specialized neighborhoods, institutions such as hospitals, theaters, shopping streets, churches, libraries, and parks made San Francisco the cultural oasis of the western states and Hawaii. It attracted to itself a disproportionate share of the money, talent, culture, and taste of a vast region. Its gregariousness and concentrated wealth made it a precocious center for music, painting, and new arts such as photography. It offered a wider choice of jobs for the worker, a wider choice of goods and services for the consumer, wider educational opportunities for the young, and a wider market for the artist than any other western American city. There was poverty, there were social barriers, but there was also relative free-

dom and great opportunity for personal improvement and economic, scientific, and artistic creativity, including architecture.

The very variety and constant movement of life in Victorian San Francisco had a magnetic effect. Tourism developed early as westerners came to experience the bright (gas) lights of the big city. East Coast Americans, fascinated by the phenomenal expansion of their country, traveled to San Francisco via the transcontinental railroad to see the Pacific Ocean from San Francisco's Cliff House. The motion and life of the city produced pleasure in those dying of boredom on quiet farms and remote ranches. Just walking the city's downtown thoroughfares to see her expressive peoples promenading on Kearny Street, her exotic Chinatown, her gaudy Nob Hill mansions, her rows of Western Addition houses gave joy and life to both her residents and her visitors. San Francisco fostered pleasure by simply being herself, the Queen City of the Pacific Slope. Her fanciful houses were the jewels in her glittering crown.

Booms and Busts:
The Waves of Building

BOOMS AND BUSTS:
THE WAVES OF BUILDING

The Pulses of Growth

Victorian San Francisco, if we could visualize it in a time-lapse film, would not show even, steady growth, but rather a series of jerky spurts of speculative building interrupted by longer slack periods. There was building of some kind at all times, but there were brief periods when construction boomed and hammers could be heard pounding away almost everywhere in the city, especially in the new neighborhoods at the ends of the cable-car and streetcar lines.

After initial confusion and lawsuits over land titles, the city began to fill in, lot by lot, within the city-surveyed grid. San Francisco had an unfinished look in almost all of her growing "suburban" neighborhoods throughout the Victorian era. There were unbuilt lots in nearly every block and at many intersections. Only the blocks closest to downtown were solidly built-up. In many outlying areas small investors held onto lots that they had bought cheap and then kept vacant as long-term investments. In a few cases family trusts held multiblock areas of raw land for relatively long periods of time while the side streets were built up with large houses. One such trust was the John H. Baird Estate,

which owned many blocks along Haight Street in the Haight-Ashbury.

Even the best Pacific Heights streets had unbuilt gaps into the twentieth century. Today San Francisco has a city ordinance requiring that every unbuilt lot be fenced and be kept free of rubbish. In the Victorian city, raw lots were unfenced. Sand drifting from adjoining undeveloped lots was a constant nuisance to neighboring householders. The city itself kept its Western Addition park reservations—so splendid in theory—ungraded, unfenced, unlandscaped, and minimally maintained. Until the very late 1890s, one had to be a visionary to want a San Francisco city park across the street. Only then did the city begin spending money on grading and landscaping neighborhood parks. (Golden Gate Park was, of course, the great exception.)

Gold Rush Boomtown:
The Fires of the 1850s

Between 1848 and 1850 San Francisco's population exploded from about 1,000 in a flyspeck seaport to 34,776 in a bustling *entrepot*. Historians estimate that half a million people passed through the city between 1850 and 1860. Gold Rush San Francisco was like a great railroad station filled with milling throngs en

route to the goldfields in the Sierra foot-hills. By 1860 the city had 56,802 residents, giving a growth rate of 63 percent for the first decade of its life. The Gold Rush did not last long; the peak yields from the goldfields came in 1853–54. Between 1855 and 1859 San Francisco experienced her first sharp depression. We know little of the residential patterns of the Gold Rush city of the 1850s. Our best evidence includes early panoramic photographs of the raw, sandy, mostly wood settlement with its brick downtown. We also have directories of addresses, which are especially good for tracking businesses; U.S. Census returns listing residents; and historical records documenting the location patterns of churches. In 1854 the *San Francisco Bulletin,* the earliest major daily newspaper, complained that

> there was as yet no really clean, pure, and large neighborhood in the city to which respectable families could go for their dwelling places and be safe. The struggle for a true and humane life was still a hand-to-hand fight in public with legions of loathsome little devils.

In the 1850s the city was repeatedly destroyed by great fires that consumed both frame buildings and brick ones. One witness wrote of the destruction:

Frame houses faded away like frost work. Brick structures became batteries of flame, and poured forth immense jets from their windows and doors. Iron and zinc curled up like scorched leaves . . . and sent forth their brilliant flames of green, blue, and yellow tints, mingling with, and modifying the glare of the great red tongues of fire which flashed upwards from a thousand burning houses.

While fearfully expensive to un-insured merchants and householders, these great fires each led to better re-buildings. As the early historian Hubert Howe Bancroft put it:

As the spider, whose web is again and again destroyed, will continue to spin new ones while an atom of material or a spark of life remains in its body, so did the inhabitants set themselves industri-ously to work to rear new houses and a new town.

What the fires did not destroy, con-stant rebuilding did. By 1852 there was only one old adobe from Mexican days left downtown and it was soon pulled down for a more modern structure. De-struction of the core drove merchants living over their stores out of the center of the seaport to new houses on the edge of the city. Downtown fires created mar-kets for new brick commercial buildings in the center and for new frame houses on the "suburban" periphery.

Early Residential Neighborhoods

Even in the "instant city" period of the early 1850s there was a pecking order, a social hierarchy, to the raw city's blocks.

"Neighborhoods" then could be as small as one block and still have their particu-lar character. The city was arranged in a semicircle around Portsmouth Square (today the park and underground garage in Chinatown that fronts on Kearny Street). To the northeast along Broadway, between Montgomery and Sansome, was Sydneytown, a rough, transient zone of cheap lodgings near the passenger docks that took its name from its sprin-kling of resident Australian ex-convicts. A block to the west, along Pacific Street, between Kearny and Grant, was the city's first Latin Quarter, Little Chile, a working-class area with some Spanish-speaking Chileans and Peruvians. Only a block west, along Stockton Street, was where the upper class lived. This was San Francisco's first prestigious residen-

tial address, from Sacramento Street (where Chinatown is today) to Washington Square in North Beach. It was "le Boulevard Stockton" to those mocking the pioneer society ladies. Just south of Portsmouth Square was a pocket of French merchants. South of them, near the block bounded by California, Pine, Kearny, and Montgomery streets, was a settlement of Germans. Immediately east of them was Boston Row, rimmed by California, Pine, Montgomery, and Sansome streets, right behind the city's docks. These divisions were not absolute; there was considerable mixing in the Gold Rush city, but individual blocks did attain a dominant character.

Elite Stockton Street was soon rivaled by Rincon Hill, south of Market Street. It became the first discrete fash-

MINERAL WEALTH
Bonanza silver spurred a wave of building in Victorian San Francisco in the mid-1870s. Seven hundred ounces of Nevada silver were fashioned into an epergne, a dining-table centerpiece, by W. K. Vander-slice & Company for the Joseph A. Donohoe family.
The Society of California Pioneers.
(Page 31)

BOOMS AND BUSTS,
1867 TO 1906
Waves of building swept over Victorian San Francisco in a series of booms and busts. Thomas Magee's Real Estate Circular *charted the volume of real-estate business in the Golden Gate city between 1867 and 1906. Frenzies of construction occurred in 1868–69, 1874–75, and 1889–90; the new century opened with a great two-step boom in 1902–05.*

ionable neighborhood in San Francisco. Because of its proximity and yet relative remoteness, Rincon Hill attracted a cluster of Gothic Revival houses set in lush, fenced gardens of ferns and roses. Some of the homes sported distinctly Bostonian styles. Here the Protestant establishment gathered and formed congregations around the crown-steepled Episcopal Church of the Advent, and the equally elite Gothic Revival Howard Presbyterian Church. The showy Gothic Revival, twin-spired Howard Street Methodist Church, between Second and Third streets, was another eminently respectable congregation. Farther away both geographically and socially was the much simpler red brick Gothic Revival Roman Catholic St. Patrick's on Mission Street, between Third and Fourth streets (still there, although rebuilt after 1906).

Unfashionable by the 1870s, Rincon Hill burned completely in 1906. The area was rebuilt as an industrial and warehouse zone, and much of the hill was cut down and absorbed into the approach ramp for the San Francisco–Oakland Bay Bridge in the 1930s.

The Expanding Downtown, "Leapfrogging," and New Neighborhoods

In its particulars, the growth of the Victorian city was complex. Before zoning, which was imposed on San Francisco only in 1926, discordant uses were often found side-by-side throughout the city. Relative accessibility, either by foot or by transit; land titles; availability; prices; and notions of prestige were the forces

that shaped the unregulated city. The engine of all change was the expansion of the port, its warehouses, and the commercial uses in the downtown immediately west of the docks. As these money-making activities expanded, high prices were paid for old buildings that were then torn down, driving residential housing out of the core blocks. Those building new houses "leapfrogged" over the existing city out to the unbuilt periphery, where land was cheaper and industrial and commercial uses were less prevalent. The housing close to the downtown was either converted into offices or subdivided into working-class dwellings. The city grew so fast, and on so constricted a peninsula, that a ten-year-old house was considered out-of-date. This, of course, created a demand for new houses and new architecture.

Thomas Magee's *Real Estate Circular:* The Best Window on the Victorian City

One man literally made it his business to track meticulously the development of San Francisco. His name was Thomas Magee. Born in Belfast, Ireland, in 1840, he came to San Francisco in 1859 and began working as a printer. In December 1866, Charles D. Carter's real-estate business launched the *Real Estate Circular,* with Magee as editor. Eventually Magee became a real-estate dealer himself and bought the *Circular.* He edited it continuously from 1867 until his death in 1902, when his sons took over his business and the paper. Each month the four-page newspaper listed all the sales

and title transfers recorded with the city. Magee also wrote short notices on political and business developments, streetcar extensions, building laws, real-estate trends, rumored deals, and anything else that affected the value of lots and buildings in the growing city. Now and then he commented on architectural changes, often quite negatively.

Thomas Magee was involved in real-estate ventures with some of the biggest landowners in Victorian San Francisco. He knew the development of the city from the inside and kept his ear to the ground. The run of his *Circular,* preserved in the city's archives, is our best window on the unfolding of Victorian San Francisco. Magee was a stalwart defender of private property, low-cost government, minimum taxation, and the morally beneficent influences of widespread home ownership. He was a foe of land monopolists and of the rich who preferred to spend their money in New York City and Europe rather than at home. As a retailer and not a wholesaler of land, and as an instinctively conservative man whose job was the appraisal of the value of property, he detested all "booming," or what we now call hype. Inflated values offended his Scotch-Irish soul. While it is likely that he framed his newspaper's coverage to boost his own real-estate business (the back pages of his newspaper listed the properties he had for sale), he must have run an honest journal in an often dishonest business, for it outlasted all others and became the bible of the real-estate industry.

In December 1906, Thomas Magee's sons published the statistics their father had assembled over his active lifetime (the records had escaped the fire in April) and wrote a short history of the real-estate business in San Francisco. They devised a graph of peaks and troughs that reflected the aggregate volume of real-estate sales over a forty-year span. A copy of the graph appears on page 32. It is on this solid foundation that the following brief schematic overview is based.

The Booming 1860s

The Vigilance Committee of 1856 transformed itself into a political party called the People's Party. This merchant-dominated party controlled the city government from 1856 to 1867. While there had been a great amount of building in the 1850s, the 1860s saw the fastest expansion the city was ever to experience. The population exploded by 163 percent, growing from 56,802 to 149,473. As has already been noted, the overland telegraph linked San Francisco with New York City in 1862. That same year the city saw the establishment of a stock exchange and the operation of the first street railway. Everywhere downtown and along the industrial waterfront there was building. The traffic and noise in the center intensified as the city boomed, driving out genteel families. Sutter, Pine, Bush, and other easily walked sloping streets leading west from the downtown to the Western Addition saw Italianate-style houses pop up all along them. In 1863, 1,200 new houses were built in San Francisco; 1,200 more houses were built the following year.

Chinatown and North Beach became the city's first slums, as the "old" houses there were abandoned by the middle class, subdivided by absentee landlords, and rented out to poor immigrants. Although there were horse cars in this period, most people still walked to work. Flat blocks in the South of Market along Howard and Harrison streets sprouted large middle-class houses. In the narrow alleys that subdivided the large South of Market blocks, small working-class houses were packed in tightly. The city of the 1860s was still quite small. The *Real Estate Circular* noted in 1885 that "beyond Sixteenth street was in the country, and beyond Larkin street was a sand desert."

In 1865 the German Jewish congregation of Emanu-El constructed its second synagogue, downtown north of Market at 450 Sutter, near Powell Street (today the site of a Mayan-Deco medical building). The congregation, understandably not attracted to the avowedly Christian style of Gothic Revival, built a twin-towered extravaganza capped by bulbous Moorish domes. In its day the building, designed by William Patton, was described as being in the Gothic Byzantine style. It was the most exotic accent on the early city skyline and was a notable monument to the importance of the Jewish community in Victorian San Francisco.

Isolated by the Civil War, California began its own manufactures in the mid-1860s. As a war measure, the transcontinental railroad was begun with federal land and money subsidies. Two great events marked the end of the decade: the

settling of the titles to the Outside Lands (from Divisadero Street to the ocean), and the completion of the transcontinental railroad. Both of these developments fueled wild speculation in empty lots on the city's fringes between 1867 and 1869. It was popularly predicted that the completion of the railroad linking San Francisco with the East would greatly stimulate business and draw more settlers. Building boomed in expectation of further prosperity.

But, in fact, the completion of the railroad in September 1869 was followed by depression. Suddenly eastern manufactures were cheaper in San Francisco, and local industries that had been protected by distance and costly shipping, and had paid high wages, collapsed. Unemployment increased and poor, rather than prosperous, migrants flocked to the city. Land values in the sandy, undeveloped Outside Lands fell drastically and were not to recover their inflated values for many, many years. In 1868 the merchant-dominated People's Party reorganized itself as the Taxpayer's Party and continued in power until 1876.

The Depression: 1870 to 1873

The sharp and deep depression of the early 1870s came as a shock to San Franciscans. Having expected so much from the railroad, they were all the more stunned when its effect was opposite from their expectations. Building activity dropped dramatically. Land costs fell. In 1870 the 4,500-acre undeveloped Visitation Rancho at the southeastern edge of the city was bought by a syndicate of land speculators for $625,000.

A key improvement at the end of this period was the opening of the first cable-car line. It was launched on August 1, 1876, along Nob Hill's Clay Street. Andrew Smith Hallidie, a wire-rope manufacturer, perfected this new means of transit, which effectively brought the power of the stationary steam engine out into the city streets by means of a moving underground cable. The long-term effect of this invention was dramatic in hilly San Francisco. It made the tops of the city's steep hills easily accessible and drew the rich from flat streets such as Stockton and the wide streets South of Market to the blocks with marine views atop Nob Hill, Pacific Heights, and later Russian Hill. What had been cheap, hard-to-reach hilltop property suddenly became highly desirable. The city was turned "inside out" as the well-to-do moved from the valleys to the hilltops. Eventually San Francisco had eight privately owned cable-car lines with a total of 112 miles of track.

Nevada Silver and Economic Revival: 1874 to 1877

The city's population grew by a robust 57 percent during the later 1870s, going from 149,473 to 233,959. The city's influence reached out to neighboring Nevada with the discovery of silver there. The distant mines had a stimulating effect on San Francisco. Virginia City, Nevada, was sometimes called San Francisco's richest suburb. Unlike the gold of the 1850s, much of the silver from the Nevada mines stayed in San Francisco rather than being exported to New York or Boston. As the *Real Estate Circular* put it: "San Francisco was largely built up then with dividends from the Comstock mines." Downtown San Francisco experienced a change in scale, as great brick and stone business buildings appeared on key corners. Among these new structures were the Stock Exchange, the Dividend Building, the Nevada Block, the Arizona Block, the Hobart Building, the Union Block, and, looming over it all, the immense, seven-story Palace Hotel on Market Street at New Montgomery.

The Palace Hotel, built by financier William C. Ralston and designed by John P. Gaynor, opened in 1875. It boasted a seven-story-high, glass-roofed central court where carriages deposited guests. It had 850 rooms, 437 bathtubs, four artesian wells, five hydraulic elevators, three dining rooms, and a tremendous number of bay windows. It was noted in 1876 that "each room also has a thermostatic alarm, indicating at once to the office the beginning of a fire." Its elaborate furniture was made in San Francisco of California woods. The Palace Hotel quickly became the epicenter of social life in San Francisco and the West.

While the original Palace Hotel of 1875 was lost in the earthquake of 1906, another monument to the 1870s survives today as a museum. Located at Fifth and Mission streets, the United States Branch Mint designed in the Greek Revival style by Alfred B. Mullett was erected by the United States Treasury between 1869 and 1874. Behind its sandstone Doric portico a cascade of silver dollars was minted and a substantial

part of the nation's gold reserve was housed. (During the Victorian era, San Franciscans insisted on "hard money," locally minted gold and silver coins, rather than flimsy paper banknotes.) Another 1870s monument is the fine Conservatory of Flowers in Golden Gate Park. Indeed, Golden Gate Park itself is a great piece of 1870s urban design.

The early 1870s saw the eclipse of "old money" Rincon Hill by the new rail- road and silver millionaires who built bigger, showier piles atop Nob Hill. The opening of the luxurious California Street Cable Railway in 1878 linked the banks on California Street with the sum- mit of the commanding hill to the west. Leland Stanford, one of the Central (later Southern) Pacific Railroad's Big Four and the organizer of the new cable line, assembled the block bounded by Cali- fornia, Powell, Pine, and Mason streets. He sold the western half of the block to Mark Hopkins, another of the Big Four, and together they had the engineers of the Central Pacific Railroad build great gray granite retaining walls on the Powell, Pine, and Mason sides of the steep block, which still stand today. Leland Stanford commissioned archi- tect Samuel S. Bugbee to design him a huge, dark brown, frame Italianate man- sion. Hopkins's splashy wife, Mary, had a Modern Gothic fantasy designed by Wright and Sanders built in 1878—the most elaborate Victorian house ever erected in San Francisco. Historian John P. Young noted that the 1870s "witnessed the remarkable passion for architectural adornment which did so much to con- vert San Francisco into a place of pinna-

cles and steeples which, however absurd when considered in detail, gave the town its admittedly picturesque appearance."

These were the major monuments. What was of greater importance to the city was the construction of blocks of working-class and middle-class houses in the valleys of the Mission District and the Western Addition. In 1874, 1,300 houses were built in San Francisco; in 1876, 1,600 new dwellings were added to the city housing stock. Theodore Hittell observed in his 1878 history that San Francisco had more millionaires

> and at the same time has fewer paupers, more land-owners, and more comfort in the homes of the multitude. . . . Each class here has better houses, better furni- ture, better tables, better clothes than the same class in American cities on the Atlantic slope.

Dull Times: 1878 to 1884

The Comstock silver boom crested in a wild orgy of stock speculation in the mid-1870s, which the *Real Estate Circu- lar* recalled in 1885 as an "almost furi- ously insane spirit of gambling." In the late 1870s paper fortunes were lost as quickly as they had been acquired. The crash in mining stocks rippled out to overwhelm all other financial activities. The *Circular* noted that "San Francisco suffered the longest period of dull times in its history from 1878 to 1884." Real- estate values shrank by 25 to 35 percent. By 1886 Thomas Magee could report that the "surplus water has been squeezed out" of San Francisco real estate.

Social tensions in the city were acute in the late 1870s and class conflict flared. Under the impact of the depression, the city's working class turned against the Chinese immigrants, whom they blamed for the fall in wages, and against the capitalists who employed them. The Workingmen's Party emerged, led by an Irish-American drayman, Denis Kear- ney. On October 29, 1877, Kearney led a mob that stormed the mansions on the summit of Nob Hill, but was beaten back down to the flats by an upper-class vigilante brigade. Isaac S. Kalloch, a Mas- sachusetts-born Baptist minister, was elected mayor in 1879 with support from the Workingmen's Party.

In 1882 Robert Louis Stevenson, standing atop Nob Hill with its osten- tatious mansions, described the city he saw:

> Looking down over the business wards of the city, we can descry a building with a little belfry, and that is the Stock Ex- change, the heart of San Francisco: a great pump we might call it, continually pump- ing up the savings of the lower quarters to the pockets of the millionaires upon the Hill.

California was changing in signifi- cant ways in this period: Agriculture was spreading over the dry, sunny valleys of the interior, first as wheat, later as fruit. In its role as the transport and service cen- ter for this vast region, San Francisco began to shift from reliance on sudden mining booms to the less spectacular, but more reliable, steady wealth to be derived from California's agricultural abundance. It was wheat, not gold or sil-

*RESIDENTIAL AND
COMMERCIAL CON-
STRUCTION, 1860 TO 1880*
Fire codes demanded brick construc-
tion in the downtown area; redwood
was the nearly universal material for
houses. This graph, which illustrates
the number of brick and wood build-
ings constructed between 1860 and
1880, shows the early building of
the commercial city and the later
construction of the residential neigh-
borhoods.
Anne Bloomfield.

ver, that built Victorian San Francisco. California's grain was exported through San Francisco to the great wheat market in Liverpool, from where it was dispersed to feed the burgeoning cities of Europe. In this period San Francisco's fortunes were closely tied to wet years and droughts, because they affected the crops of the interior. In 1882 the *Real Estate Circular* noted that crops were plentiful and prices good. Conversely, in 1884 the price of wheat was low and "little prosperity came to us." In the late 1880s San Francisco began to fear the expansions of two rivals, Los Angeles and Portland. The *Circular* reassured its readers by telling them that "their growth is not at our expense, but a part of the advance of the whole coast."

Some house building *did* continue during this long, dull period, and build-

ers and the manufacturers of the many products that went into house construction and furnishing were motivated to keep finding ways to bring down costs. They did this by standardizing house plans and by mechanizing as much of the process of house-part and furniture making as they could. This had a great impact on the housing industry in San Francisco and on the city's architectural appearance.

Expansion Again: 1885 to 1893

The city's growth rate slowed to "only" 28 percent in the 1880s; the city's population went from 233,959 to 298,997. Politically this was a long era marked by Democratic-machine rule, the decade-long reign of "Blind Boss" Christopher A. Buckley, who never occupied the

mayor's office but who pulled the strings from behind the scenes. Contrary to popular opinion, this was not an era of extravagant municipal spending, but rather one of just the opposite. The Democratic machine kept taxes low by invoking the sacred fetish of the "dollar limit" on real-estate taxes. This translated into minimal expenditure on the city's sewers, streets, parks, schools, and other essential public services.

The 1880s was the peak era of construction of privately owned cable-car lines. Between 1882 and 1888 cable traction was the state of the art. The year 1885 was particularly important in the history of the city's transit net. New cable lines opened reaching Golden Gate Park and the Haight-Ashbury, the Richmond District, and south into the Mission. This made much more land available for

house building. The well-informed historian and *Chronicle* editor John P. Young noted that

> owners and speculators in real estate proved a great factor in the promotion of [cable-car and streetcar] expansion, and as is usual in such circumstances, while appearing to be catering to a demand for expansion, they were in reality creating the demand to which they responded. This is made clear by the presence of the names of prominent real estate operators in many of the grants of franchises in the closing years of the seventy decade and in the opening years of the eighties. They are found associated in many cases with those of men known to be closely connected with the [Central, later Southern Pacific] railroad, and sometimes with those of the magnates [Stanford, Crocker, Hopkins, and Huntington] themselves.

In 1886 business picked up and the familiar cycle of speculation and inflation of values began again. The short period from 1886 to 1889 saw the construction of some of the city's most exuberant Eastlake-style houses, including the surviving 1885 Vollmer house designed by Samuel and Joseph Cather Newsom, and the 1886 Haas-Lilienthal house designed by Peter R. Schmidt. The wealthy began seeking large corner lots on the commanding heights that enjoyed marine views of San Francisco Bay and Marin County to the north. Residential property in Pacific Heights went as high as $300 to $400 a front foot in the 1880s.

In the downtown, prices for large lots along Market Street rose steeply. In 1886 the largest sale in the area up to that time was consummated when the Parrott estate bought the property of the Jesuit-owned St. Ignatius church and college on Market Street. Ten years later The Emporium, the city's first great department store, was built on that land. With the $900,000 from that sale, the Jesuits built an opulent new church and college on Van Ness Avenue where Davies Symphony Hall stands today. That church accommodated six thousand parishioners and had twin 275-foot spires, the tallest on the West Coast. The largest real-estate sales were along Market Street, where the gore lots on the north side of the street, with their good streetcar connections and high visibility, attracted high prices and large new commercial buildings that often proudly bore the names of their owners.

There was a sharp break in the market in 1890 when the Baring Bank failed in London, the center of international capitalism in the Victorian age. But in 1891 there was a reaction and business property picked up again. The following year the federal government paid the Pope estate and others $1,040,000 for the site of the new post office and courts building. That structure, designed by John Knox Taylor, was erected between 1902 and 1905 at Seventh and Mission streets. Also in 1892 the Hibernia Bank built its new headquarters at 1 Jones Street, at the northwest corner of McAllister Street at Market. Designed by Albert Pissis, this superb light gray granite bank, with its fine corner entrance dome, broke with Victorian design and introduced the more sober Neoclassical style to San Francisco. (Ex-

panded in 1905, the bank was rebuilt in 1907 and has perhaps the finest surviving interior of its period in the city.) In 1893 the Union Trust Company paid a record $83 per square foot for a lot at the northeast corner of Montgomery, Market, and Post streets (today the site of a 1910 Wells Fargo Bank branch).

At the end of the Victorian era, massive steel-frame structures like the old Chronicle Building at Market and Kearny, designed by the famous Chicago firm of Burnham and Root in 1889, and the 1891 Romanesque Mills Building on Montgomery at Pine by the same architects, brought modern skyscraper construction to California. From the heart of the old brick downtown, a new kind of city began to emerge. Elaborate Victorian hotels were torn down for office buildings. Large, choice gore lots on the north side of Market Street reached $107 per square foot.

In 1889 Hittell's *Guide* described the residential districts of the Victorian city:

> Almost as numerous as the hills are the valleys, some of which are in the shape of amphitheaters, nearly surrounded by heights, from which the spectator looks down on a densely populated territory, interesting by day and brilliant at night when numerous long rows of gas lights and lighted windows are spread out reaching to the hilltops in the remote distance.

Splashy great hotels and houses appeared all over California during the late-1880s boom. Southern California saw its first great expansion in these heady years. The greatest surviving monument of the period is the Reid

brothers' enormous Stick-style Del Coronado Hotel, completed in 1888 outside San Diego. It is the largest surviving Victorian frame structure in California.

Closer to San Francisco, Stanford University, one of the greatest late-Victorian landscape and architectural designs in the nation, was planned and partly executed between 1887 and 1891. Designed by Charles Allerton Coolidge of the Boston firm of Shepley, Rutan and Coolidge, the successors of famed American architect Henry Hobson Richardson, it is one of the earliest examples of Mission-style design in California.

The *California Architect and Building News* was struck that this remarkable growth and material progress was achieved despite "all the vices, immoralities and cosmopolitanism" permitted within San Francisco's city limits. In the 1890s there was a noticeable migration to the metropolis of rich men from the interior who had made their fortunes in mining, lumber, or industry and who sought the cultural refinements of San Francisco for themselves and their families. Van Ness Avenue was lined with mansions, and many of the elite congregations skipped from the downtown to that wide boulevard. St. Mary's Roman Catholic cathedral rose as a great red brick pile on Van Ness. Some private clubs also left the downtown for Van Ness Avenue and parallel Franklin Street. By 1890 luxury apartment houses began appearing along tony Van Ness Avenue. Wealthy residents kept noisy streetcars off the avenue for many years.

Money Crisis: 1894 to 1898

In mid-1893 another banking panic stopped expansion in the East and satellite San Francisco and led to the failure of the Pacific Bank. Interest rates soared and no loans were made on real-estate security. Building stagnated. The mid- and late-1890s saw another long trough in real estate and construction activity in the Golden Gate city. The financial crisis that began in the East hit San Francisco hard.

During these difficult economic times, city politics took a turn for the better. A wave of Democratic reform swept the troubled metropolis between 1893 and 1902. Prussian-born Adolph Sutro became reform mayor in 1895. Sutro was an engineer and a self-made millionaire who had amassed his fortune through the Sutro Tunnel Company, which drained the Comstock silver mines. He sold the company and bought vast tracts of undeveloped land in the city, including the San Miguel Rancho that embraced Twin Peaks. He eventually held one twelfth of all the city's land. Sutro began a campaign to plant forests on the sandy peninsula, among them the eucalyptus groves that today blanket Mount Sutro behind the University of California at San Francisco Medical Center.

Golden Gate Park Lodge, now known as McLaren Lodge, was designed in 1896 by Edward R. Swain in the Mission style. The sandstone structure has a fine Arts and Crafts interior with plain but sumptuous woodwork, custom-designed furniture, and a pigskin-lined boardroom. Sutro was followed as may-

or by James Duval Phelan, a wealthy Irish Catholic banker and elite reformer who had great visions of what San Francisco could become. It was under Phelan that the city's long-neglected neighborhood parks began to be improved by Golden Gate Park Superintendent John McLaren.

In the late 1890s one man, Claus Spreckels, who had made a fortune in sugar refining, took advantage of stalled prices to invest heavily in prime downtown property. Over a two-year period he spent some $2 million buying key Market Street property. The *Real Estate Circular* wrote that his spending spree "greatly strengthened the tone of the market, showing as it did the confidence in our future of one of our wealthiest business men." Only the very best business and residential properties saw much activity. In 1896 Albert Pissis and Joseph Moore designed The Emporium department store on Market Street, a notable essay in the monumental Neoclassical style that succeeded the Victorian styles. During these years the rich built fine houses in Pacific Heights, but the large middle-class market for standard houses fell dramatically. The Gay Nineties were not all that gay. In 1900 the *Real Estate Circular* described the years between 1891 and 1898 as the "greatest dullness ever known here."

The Great Boom: 1899 to 1906

The Victorian era ended and the Edwardian era commenced with a tremendous burst of building and expansion in San Francisco. In two steep, stairlike bursts, the century concluded with record real-

estate activity and a boom that benefited all, working class, middle class, and wealthy alike. Strong industrial growth inside the city powered the boom. In 1900 the *Circular* reported that "during the past year more existing factories have bought new and larger sites for their business than in any previous twenty years of San Francisco's history." Money had been accumulating in the city's savings banks since 1893, but interest rates remained high until 1899. At that point money flooded into the market and building took off. The long depression that had begun in 1893 was finally over. The city's population grew by 15 percent, from 298,997 in 1890 to 342,782 by 1900. While this was the lowest growth rate recorded during the Victorian half century, it was coupled with the great expansion of building and other improvements. The combination meant better conditions at the turn of the century for many, not just a few. In the words of the *Circular,* "the increase of business has been far greater than the increase of population." Stimulated by the Klondike gold rush and the colonial war in the Philippines, manufacturing and wholesaling in San Francisco had never done better business.

Politically, however, the city saw its lowest point. The period from 1902 to 1906 was dominated by the Union Labor Party and "Boss" Abe Ruef, who installed Eugene Schmitz as mayor. Wholesale corruption flourished, especially in the selling of utility franchises for streetcar, gas, and telephone systems. The mayor and the board of supervisors were all Ruef's creatures. The new century began with a series of graft trials in 1907 that toppled the Schmitz administration and sent Ruef to San Quentin Prison.

In 1905 the *Circular* reflected on the five-year boom that closed the Victorian era:

> The door to the past has been closed and we have entered the open door of the future. The old, unprogressive, one-railroad, backward city of San Francisco has been obliterated just as fully as Pompeii was obliterated. The New San Francisco is only five years old.

In 1906 the *Real Estate Circular* concluded its forty-year review in a state of near euphoria:

> [Between 1895 and 1906] our population had increased over 46 per cent; our bank clearings had increased over 160 per cent; our real estate sales had increased 360 per cent; our savings bank deposits had increased about 60 per cent and our building operations 260 per cent. . . . The growth of San Francisco, as evidenced by the great increase in population, by the heavy increase in bank clearings, by the steady increase in our savings bank deposits, by the large increase in our building operations, the upward movement of prices in real estate and the immense increase in the volume of real estate business done in this period preceding the fire of 1906 has been nothing short of marvelous.

The Earthquake and Fire of 1906

San Francisco was fortunate in the timing of the great catastrophe that almost completely destroyed the Victorian downtown. The quick series of earthquakes at dawn on April 18, 1906, and the devastating fires that raged for three days afterward, came at a time when San Francisco was booming. In the early 1900s she was the Queen City of the Pacific Slope and had no rival. (Los Angeles did not overtake San Francisco in population until the 1920s.) In 1906 San Francisco held the key strategic position on the Pacific coast for commerce and industry. All the railroads, shipping lanes, and trans-Pacific communication cables focused on her. Her banking interests were dominant over a vast region; her factories served an enormous hinterland; and her cultural influence over California and the Far West was at its peak. Business never contemplated relocating anywhere else, and neither did the important federal government offices located here. Although the city's downtown, elite Nob Hill and Van Ness Avenue, and many surrounding working-class neighborhoods were reduced to rubble and ashes, the locational advantages of the city remained.

In fact, the earthquake turned out to be very good for business, and a modern Edwardian downtown emerged. In 1912, still the dominant city on the West Coast, San Francisco was endowed with ten national banks, eleven savings banks, and twenty-two state and trust banks. Large areas of Victorian residential architecture that had survived the earthquake and fire stood west of Van Ness Avenue in the Western Addition, in Pacific Heights, in the Haight-Ashbury, and south of Twentieth Street in the Mission, Noe Valley, and other neighborhoods. Those fanciful houses are the subject of this book.

4

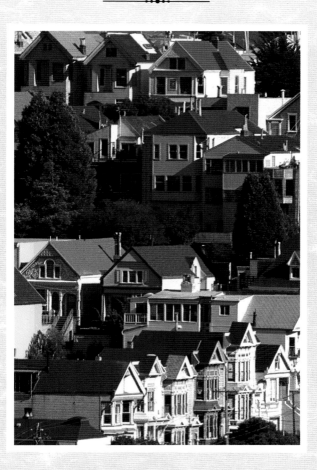

THE ROW HOUSE

THE ROW HOUSE

The Earliest Houses: Imported Types

In Monterey, the old capital of Mexican Alta California, there was, very briefly, a fusion of Mexican and Anglo culture when English-speaking seamen and merchants converted to Roman Catholicism and married the daughters of *Californio* families. Members of these unions joined with other Yankee merchants in the port to create a unique architectural look that combined local adobe houses with Yankee woodwork in the form of doors, windows, hipped roofs, and, especially, second-floor wooden balconies. This blend later came to be known as the Monterey style. The best surviving example is the Larkin house, built in 1835 for American consul Thomas O. Larkin's store with living quarters upstairs. (Beautifully furnished by his granddaughter, the house is now a museum and part of the Monterey State Historic Park.)

What later became the city of San Francisco was merely a small backwater port during the Mexican era. Founded as a place to gather the cattle hides produced on the ranches that surrounded San Francisco Bay, the settlement of Yerba Buena took its name from a perennial herb (*Micromeria Douglasii*) that grew on its sand dunes. Here English and

Yankee merchants built rude houses. The 1836 trading post built by London-born William Richardson was a simple one-story adobe on what is now Grant Avenue, near Clay Street, in San Francisco's Chinatown. It replaced a board-and-tent dwelling he had improvised the year before. In 1836 American-born Jacob P. Leese erected the first frame house on the cove. The structure measured sixty feet by twenty-five feet and was constructed of redwood brought by ship from Monterey. It was sheathed in clapboards and roofed with shingles. Since it was put up in only three days, it may have been prefabricated in Monterey. A scattering of other adobe and frame trading posts and houses were built over the next decade on the crude grid of streets platted by Vioget in 1839.

The next well-known pioneer house erected in Yerba Buena was Samuel Brannan's two-story saltbox, built in 1847. Born in Maine and a migrant to Ohio, Brannan came to Yerba Buena in 1846 as the leader of a Mormon contingent. He operated the settlement's first flour mill and published its first newspaper, the *California Star.* The two-story house he built was of heavy-frame construction with mortise-and-tenon joints. Over this massive frame was laid a shell of redwood clapboards and a shin-

gle roof. The redwood had been milled in Corte Madera in today's Marin County. Brannan's house had a steeply pitched roof and a saltbox extension to its rear. In front was an open veranda. Painted white with green shutters, it was an altogether classic New England dwelling and the most substantial of the hundred or so frame and adobe buildings in pre–Gold Rush Yerba Buena.

When the Gold Rush hit in 1849, the population boomed and there was a sudden demand for houses and shops. A flimsy encampment of tents and shacks appeared overnight. Some East Coast merchants shipped prefabricated houses to the boomtown. Twenty-five such dwellings were shipped from Boston to San Francisco in November 1849 aboard the *Oxnard.* Others came from Maine, New York, and Philadelphia. Most of these instant houses were extremely simple, one-room structures with pitched roofs, one or two windows, and one door.

A handful of early San Francisco's prefabricated buildings were made of sheet metal, a practical material in a city with a habit of catching fire. E. T. Bellhouse of Manchester and John Walker of London shipped prefabricated iron houses and warehouses to Gold Rush California. By 1849 the city boasted forty

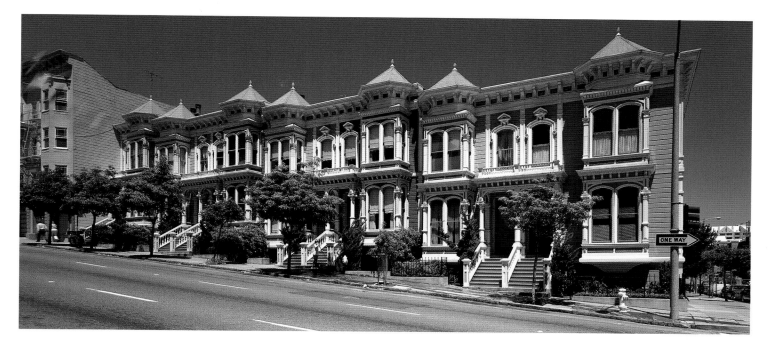

corrugated-iron buildings made in England. Very occasionally—much more occasionally than local legends recount—rather elaborate houses were brought around the Horn.

Most early Yankee frame houses were either simple vernacular dwellings or in Greek or Gothic Revival style. Typically New England in appearance and construction, the buildings shipped around Cape Horn were invariably painted white with green shutters. None has survived. The Abner Phelps house at 1111 Oak Street, between Divisadero and Broderick, dates from about 1850. The two-story Gothic Revival dwelling with a steeply pitched roof, dormers, and an open porch was believed by some to have been imported from New Orleans, but when it was restored in 1976 it was found to be of local construction.

Immediate post–Gold Rush San Francisco was a motley assembly of one-story Mexican adobes, frame structures imported from New England, some corrugated-iron houses and warehouses made in England, and a mass of canvas tents and board shanties. As the town boomed it sprouted more neat frame buildings, copies of structures in the East. Sprinkled across the sand dunes, Bancroft wrote, were "snug frame buildings glittering in whitewash and fresh

paint." It was from these imported seeds that Victorian San Francisco evolved.

George Gordon and the Introduction of the Row House

All of San Francisco's earliest houses were freestanding, albeit crowded together. It was London-born George Gordon who introduced the row house to San Francisco. After making a fortune in lumber, wharf building, an iron foundry, and a very profitable sugar refinery, Gordon began buying land near Rincon Hill in 1852, in the block bounded by Bryant, Brannan, Second, and Third streets. He engaged British-born artist, architect, and surveyor George H. Goddard and in 1854 published a prospectus for a new subdivision he named South Park. Designed after the squares of London's West End, Gordon's development featured an oval, gated park 75 feet wide and 550 feet long, surrounded by sixty-six house lots facing South Park Avenue. Center Place bisected the block, and Park Lane North and Park Lane South ran behind the lots to give access to separate lots for stables and coachmen's quarters. Around the private park Goddard designed brick-and-stucco row houses. Following London precedents, the basement of these houses had a kitchen, a dining room, pantries, and a

EASTLAKE ROW
The 1400 block of Golden Gate Avenue, at Steiner, in the Western Addition, consists of three four-flat buildings, and one two-flat building (far left). They were designed by John P. Gaynor in 1884 for banker and investor William Sharon. Unusual peaked roofs cap their bay windows. Multiple-unit dwellings were designed to look like large houses in the Victorian period.

servant's room. The main floor was devoted to parlors, and on the second floor were five bedrooms.

Gordon instituted a set of deed restrictions on the lots forbidding stores, warehouses, or saloons. In addition, all the houses were to be built of brick or stone. Goddard designed two rows of sober, flat-fronted Italianate houses that filled all of the northwest and part of the southeast quadrants of the development. These structures were built in 1854 and occupied in January 1855. Home buyers were given keys to the private park, which was landscaped and planted with geraniums and fuchsias. In a city that had recently suffered a rash of fires, brick dwellings covered in stucco scored to look like stone offered a sense of security.

Gordon was able to attract a high-

society clientele to his urbane houses. With nearby Rincon Hill lending tone to his development, he induced an elite migration to South Park. Lloyd Tevis, later president of Wells Fargo; Isaac Friedlander, the grain king; James Otis, a future mayor; the Reverend William Scott of the prestigious Calvary Presbyterian Church; society doctor Beverly Cole; and a phalanx of Southern-born social leaders settled in his tight cluster of tastefully understated row houses. In the 1860s Charles Lux of Miller & Lux, United States Senator James McDougall, California Supreme Court Justice Elisha McKinstry, Commodore Watkins of the Pacific Mail Steamship Company, and Asa Stanford, brother of railroad magnate Leland Stanford, all resided in South Park. But unfortunately for Gordon's plans, the banking panic of 1855 came just as South Park opened. The vision of a uniform London-style crescent never materialized. Gordon had a hard time selling the remaining lots and no success in forcing later purchasers to build in brick or stone (they chose less costly wood).

Other builders saw the practicality and profits of row-house construction and adopted the idea George Gordon had introduced. But they abandoned the expensive notion of a gated park and service alleys, built in wood rather than brick or stone, and evolved a floor plan without costly basement excavation for their eventually ubiquitous Victorian row houses. Today South Park still exists in the South of Market as an oval open space. In 1897, long after the tide of fashion had swept toward Pacific Heights, the originally private park was made a city park. The fire of 1906 destroyed all the old buildings framing the park.

The Two Housing Markets: Formal and Informal

We do not yet have a complete history of the creation of housing in nineteenth-century San Francisco. In its place it is useful to look briefly at the path-breaking work of historian Olivier Zunz, who has charted the development of Detroit, Michigan. Like San Francisco, Detroit was a rapidly growing manufacturing center with both native-born and immigrant families. Zunz found a dual housing market in Detroit:

> One was formal, operated through professionals from their downtown offices. It produced expensive homes for the native white American community, many of them for rent. The other market was informal, highly localized, controlled from within the ethnic communities and designed to fit their means. It was this second housing market that produced the owner-occupied cottages of the working class.

The formal market operated by builders and realtors catered to the middle and upper classes. It built, rented, and sold houses in the more desirable parts of town. Realtors acted as gatekeepers, seeking to keep undesirables out of particular neighborhoods. They only operated in areas with city services—water, sewers, gas, streetcars. The formal market stayed away from the city's fringes, where streets were not paved and services were only rudimentary. Houses were sold for a large down payment, with the balance loaned at interest.

The informal market was the converse of the formal market in every way. It built low-cost cottages in unfashionable neighborhoods on the fringes of the Victorian city. Its market was the immigrant working class that was often frozen out of bank loans. They purchased small lots on unpaved streets. Zunz describes how this informal market worked:

> Not only did they invest their savings— past and future—in putting a roof over their heads and providing shelter for the family, they also invested their time. . . . Delaying services, buying unimproved land, building with local help, and doubling or tripling up were all parts of the overall strategy of becoming homeowners.

Construction was often carried out by the owners themselves, and many built their houses without borrowing money. They, of course, did not employ architects, but they did lightly ornament their dwellings with gingerbread bought from planing mills. Usually overlooked in architectural histories, this informal market worked in the nineteenth and early twentieth century to give a part of the working class a stake in the city.

Costs: Materials, Labor, and Profits

It was the formal market that built most of the Victorians in this book, and it is to that process of house building that we now turn. Together, the formal and informal house markets produced an astonishing volume of affordable dwellings. In

1870 the *Real Estate Circular* estimated that two thirds of the people in San Francisco owned their own homes. While that estimate may have been high, it does reflect the remarkable achievement of widespread home ownership in nineteenth-century San Francisco. This phenomenon was a direct result of deep changes at work in the Victorian economy. In England urban historian Donald J. Olsen has observed that

the notable rise in real incomes of the last third of the century meant that more of the population could participate in the advantages of urban life—whether this be a small house of their own in the suburbs, seats in the pit of one of the new music halls, . . . a bank-holiday excursion, . . . or acquiring some cheap but attractive treasure at the burgeoning multiple shops or the expanding department stores.

With a generally deflationary economy, the introduction of mass production of house parts, and the use of standard floor plans, house costs actually declined in the Victorian city. In October 1873, the informed *Circular* noted that house prices fell during the post-railroad depression, with price tags for better houses dropping from $4,000 or $4,500 to $3,000. While this decline was accelerated by the sharp depression, the overall pattern of rising real incomes and more economical building methods put house purchase within the reach of many. In 1886 the *Circular* noted many "strange names" on real-estate transaction records, a sign that immigrants were part of the expanding housing market. Perhaps a bit overenthusiastically, the

Circular crowed that "here, if anywhere on the globe, the man of small means has an opportunity of owning his own homestead, and of indulging in the independence which such possession brings. . . . Packed tenement houses are unknown."

San Francisco architectural historian Anne Bloomfield has studied the workings of developer William Hollis's The Real Estate Associates (TREA), a company specializing in land subdivision and house construction. Active during the 1870s, TREA built more than a thousand homes, many of them row houses. The Real Estate Associates was the first major tract builder in San Francisco. Before it was declared bankrupt in 1881, it claimed to have built "more detached houses than any other person or company in the United States in a similar time span." Because TREA's projects were often covered in the real-estate press, and because several lawsuits attempted to untangle its affairs in 1881, Bloomfield was able to piece together part of the financial history of row-house construction in the 1870s.

Architectural historian Judith Lynch has done extensive research on house building in the Mission, Western Addition, Haight-Ashbury, and Noe Valley. She has also uncovered the receipt book of contractor-builder Fernando Nelson. Nelson was especially active in the 1880s and 1890s, when he was San Francisco's most prolific builder. With his sons he constructed some four thousand houses, many of them inexpensive cottages in Noe and Eureka valleys. The receipt book he carried in his hip pocket

from 1876 to 1906 carefully records his expenses and income. From these two sources, one a mass builder of two-story, middle-class houses, and the other a contractor-builder specializing in economical, one-story, working-class cottages, a general picture can be drawn of the financial side of Victorian house building in San Francisco.

The Real Estate Associates: An Early Large-Scale Victorian Tract Developer

The Real Estate Associates left its mark on San Francisco. Incorporated in 1866, it was first listed with the homestead associations and bought and subdivided land. It began with $30,000 in stock subscriptions and an equal amount in loans. Of the founders, four were bookkeepers, four were in insurance, and three were in real estate. In the 1870s the directors changed and so did the focus of the corporation. The new directors included the owner of a stair-building and wood-turning company, the owner of a planing mill, a real-estate auctioneer, the bookkeeper of a lumber company, and two real-estate specialists, including William Hollis, who served as secretary-manager and later as president. In 1870 TREA built its first batch of row houses, most of which were bought by the corporation's directors or suppliers. The company's peak year was 1875, when it built and sold some 350 houses. In that year TREA put up its own office building, designed by prominent architect David Farquharson, at 230 Montgomery Street. This six-story brick-and-granite structure had an elevator and a dramatic

Second Empire, mansarded facade with a central tower.

For its row houses TREA used standard plans, not individual architects' designs. Among the well-known rows it built are the beautifully maintained Italianate houses on the 2600 block of Clay Street, near Steiner, facing Alta Plaza, and the uniform row on the 2100 block of Bush Street, between Webster and Fillmore.

Beginning in 1875, TREA subdivided and developed most of the block bounded by Mission, Valencia, Twentieth, and Twenty-first streets in the Mission District. It cut two narrow north-south side streets through the tract, today San Carlos and Lexington streets, which are still lined with unbroken rows of the company's lowest-cost houses. In this, its largest undertaking, TREA sold 99 houses for a total of $495,187, or an average of $5,000 apiece. This tract, although unusually large, followed all the conventions of Victorian lot subdivision and house building. The largest lots and costliest houses were built on the prime corners. Some were mixed commercial-residential buildings. They were described as "palatial" and sold for an average of $9,990. Their original buyers were a real-estate office, grocers, a street contractor, an ironworks owner, a master mariner, and a salesman. (These houses have all been demolished.)

On prominent Mission Street, two-lot widths were platted out and two different-sized houses were built. On the wider lots, which measured thirty-five feet by ninety feet, "villas" were built.

They were L-shaped and had eight or nine rooms (a TREA villa survives at 2373 California Street, east of Fillmore). On the standard lots, twenty-five feet by ninety feet, conventional two-story Italianate row houses with bay windows were constructed. These houses averaged $7,368. The first owners along Mission Street included an attorney, a druggist, a photographer, and a foundry owner. (All these Mission Street buildings have since been demolished for commercial buildings.)

On lower-ranked Valencia Street, typical lots measuring twenty-five feet by ninety feet were laid out and two-story, bay-windowed Italianate houses were built and sold at an average of $5,841. These houses had six to ten rooms. Six of them, built between 1875 and 1877, survive on the 900 block of Valencia Street. Buyers could pay for extras, including porches with Corinthian columns, colonnettes framing the bay windows, dentil moldings, pediments, and marble mantels. These houses were bought by a lumber dealer, a railway freight agent, a ship joiner, a physician, and several clerks. Twentieth Street houses were priced at an average of $5,146, and Twenty-first Street houses averaged $4,576. Lots on these streets varied from twenty-two feet to thirty-seven feet, six inches, in width; all were eighty-five feet deep. Buyers here included an attorney, barbers, and a teacher.

The lowest-cost buildings were on the two interior streets, where lots were shaved down to twenty-two feet in width and seventy-five feet in depth. Some of the houses on San Carlos, closer to Mission Street, have bay windows. They averaged $3,697. The most inexpensive houses were built on Lexington, all with flat fronts and no bay windows. They averaged $3,350. Buyers on these inside blocks included craftsmen, small proprietors, engineers, foremen, and teachers. Most of these simpler dwellings survive and are today undergoing restoration. Now that the Mission District's main streets carry heavy traffic, the quiet side streets are preferred. The simple Italianate houses of Lexington and San Carlos streets are classic examples of California's first tract houses.

Most of these houses were sold on the installment plan, with one fifth to one half of the purchase price as a down payment. The balance was paid in monthly installments over one to twelve years; interest ran from 8 to 10 percent a year. The Real Estate Associates held the mortgages itself, rather than conveying them to a bank. This permitted them to take greater risks and to sell more houses. Historian Anne Bloomfield has found patterns in how these houses were marketed:

> Certain social restrictions may have been imposed or encouraged by the company in its efforts to boost sales. . . . names of a single nationality dominated some TREA streets. For instance, Irish names were listed as buyers on the east side of Valencia Street north of Twenty-first, and German names on the same side of the same street in the next block south.

The typical TREA two-story, bay-windowed Italianate house sold for

PATTERN BOOKS
This illustration from Pelton's Cheap
Dwellings *of 1880 shows a typical
low-cost clapboard Victorian house
with minimal ornament.*

$7,000 in the mid-1870s. Of this total cost, one third was spent on day labor and another third was spent on lumber (mostly redwood from Mendocino County and fir from Tacoma, Washington). One eighth (12.5 percent) of construction costs went for millwork, including doors, windows, interior paneling, and exterior ornament. About one fifth was paid to suppliers of plumbing, sewer pipe, paints, glass, marble, plaster decorations, stoves, tinware, and hardware. Newspaper advertising and administration expenditures also contributed to the costs of these dwellings, so we do not know what the profits were on TREA houses. (Perhaps, since so many of the directors were in the

building-supply or real-estate business, the real profits were in supplying the construction materials and in commissions on sales.)

The crash in mining stocks in 1877 slowed house buying, and this seriously affected TREA, which suspended its July 1877 dividend. The company quickly unloaded lots and construction stopped in 1878. Hollis then embarked on what Anne Bloomfield calls "evasive action," including launching a new entity, The Real Estate and Building Associates. But creditors petitioned the courts to declare TREA bankrupt in 1881 and a receiver was appointed. Thus ended the career of one of California's earliest tract-house developers.

Fernando Nelson: San Francisco's Record-breaking Contractor-Builder

San Francisco's single most productive builder was Fernando Nelson, who began as a carpenter and ended as a contractor-builder with some four thousand low-cost houses to his credit. Nelson built his first house at sixteen and went on to build inexpensive cottages in the Inner Mission, Eureka and Noe valleys, and the Duboce Triangle. He brought his sons into the business and built blocks of houses in Park Merced Terrace in the early twentieth century.

Fernando Nelson bought small pieces of land near the outer limits of the streetcar lines, which he then

subdivided and covered with one, two, or a handful of houses. These buildings followed stock plans. One-story cottages and two-story houses were his specialty. He, like many contractor-builders, developed signature details, in his case round, flat wood ornaments he called donuts and halved dowels he called drips. Other favorite trademarks were "bowties" and turned front-porch columns of a strange shape, which can be seen in the five 1897 houses he built at 711–733 Castro Street, above Twentieth Street. A wavy, stylized quarter sunburst was another favorite motif. These ornaments Nelson devised himself and then mass-produced at the Townley Brothers' Planing Mill on Berry Street in the South of Market district.

Some houses that Nelson produced cost as little as $750, lots included. Prices usually ranged from $1,000 to $4,500 and depended upon size and location. Nelson built a house on Brazil Street, in the Outer Mission, for James Smith in May 1887. We know from his receipt book that the lumber cost $350, sinks and doors $130, plastering $140, and painting $90. Plumbing cost $50, hard-ware $40, chimneys $37, and mantel $35. The total cost was $967.50. Nelson sold the house for $1,330.50, earning for himself a 27 percent profit of $363.00.

Pelton's Cheap Dwellings

In 1880 the daily *Evening Bulletin* published a set of low-cost-cottage plans designed by architect John C. Pelton, Jr. These were known as Pelton's Cheap Dwellings and they set out the plans and specifications for a three-room cottage that could be built for $585, of which the "carpenter, labor & nails" accounted for $130. Economizing on words as well as materials, Pelton called this design Dwelling No. 1. Next in the series came Dwelling No. 2, estimated at $854.25, and a more decorated Dwelling No. 3 at $1,140.00. While the tony *California Architect and Building News* mocked "the Peltonian era in Architecture" and protested that such houses could not "be erected in any sort of *workmanlike & substantial manner* for the sum named," simple, pattern-book cottages and two-story houses did pop up all over San Francisco's working-class districts, including the Potrero and the Outer Mission.

5

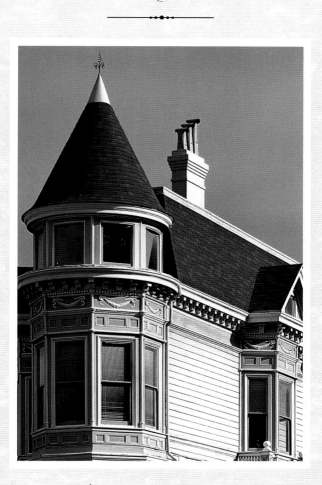

THE SEQUENCE OF VICTORIAN
ARCHITECTURAL STYLES

THE SEQUENCE OF VICTORIAN
ARCHITECTURAL STYLES

Architects in Victorian San Francisco

Modern architects like to claim that they are beyond such superficial notions as "style." Mario Botta, the Swiss architect of the new San Francisco Museum of Modern Art, unveiled his design with the claim that it was in the style of "no style." Rationalist modern architects popularized the slogan that "form follows function," as if designing a building were merely a mathematical process. Others have projected the image of architects as godlike form givers who create each building wholly out of their private vision, unsullied by what is being built around them or what they see in magazines. Nonetheless, styles are real and inescapable, if often quite difficult to define.

The *Oxford English Dictionary* de-

fines style as "a definite type of architecture, distinguished by special characteristics of structure or ornamentation. . . . A kind, sort, or type, as determined by manner of composition or construction, or by outward appearance." Styles are conventions of form. They include the way I write and how Richard takes his photographs. The Norwegian architect and critic Christian Norberg-Schulz takes the idea further in his *Intentions in Architecture:*

> The style is a cultural object on a higher level than the single work. While the individual work has one determined physical manifestation, the style has an infinite number of such manifestations. While the individual work concretizes a particular situation, the style concretizes a collection of such situations; in principal it may concretize a culture in its totality.

Victorian architects, against whom the moderns reacted so strongly, plunged into the sea of historic styles with high enthusiasm. To them it was not enough to construct a straightforward structure—although they did do that if we look at the utilitarian backs of their buildings. The facades and inte-

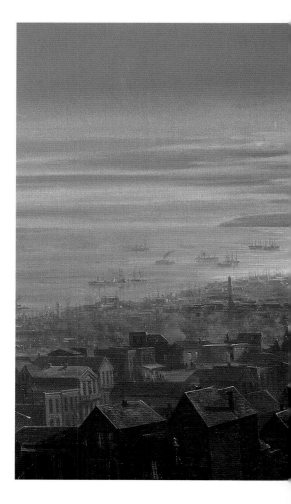

riors of houses had to be dressed in an appropriate style. Ransacking architectural history as depicted in the flood of folios that issued from the modern steam presses, they selected styles to suit the tastes and budgets of their clients and themselves. Robert Kerr's *The Gentleman's House or how to Plan English Residences from the Parsonage to the Palace,* published in 1864, listed eleven styles from which an architect could choose: Elizabethan, Palladian, Italian, Revived Elizabethan, Rural Italian, Palatial, Italian, French Italian, English Renaissance, Medieval, and Gothic. All, of course, with modern plumbing. Nor did the designer have to stick to only one style; mixtures were more than possible, if not on the exterior, then in the decoration of individual rooms. Few ages have ever seen such an exuberant, even anarchic, parade of styles, materials, colors, or their critical justifications. Victorian

architecture gloried in a display of erudition that defined its overriding style.

San Francisco's Victorian architects were like all other nineteenth-century San Franciscans, immigrants from other places, either the Atlantic seaboard or Europe. They brought with them their training in other cities and their memories of buildings from other places. Once in San Francisco, they continued to read illustrated books imported from Boston, New York, London, Paris, or Berlin. Those who could traveled back to New York or Europe on long vacations. On the far periphery of the Western world, San Francisco felt the pulses of fashion only after a long journey. There was a notable time lag in nineteenth-century California architecture. Styles in San Francisco tended to be somewhat dated and conservative.

The definitive book on San Francisco's Victorian architects has yet to be

PIONEER COTTAGE
This vernacular clapboard cottage on the Filbert Street steps at Napier Lane was built in 1863. It was restored and expanded in 1978.

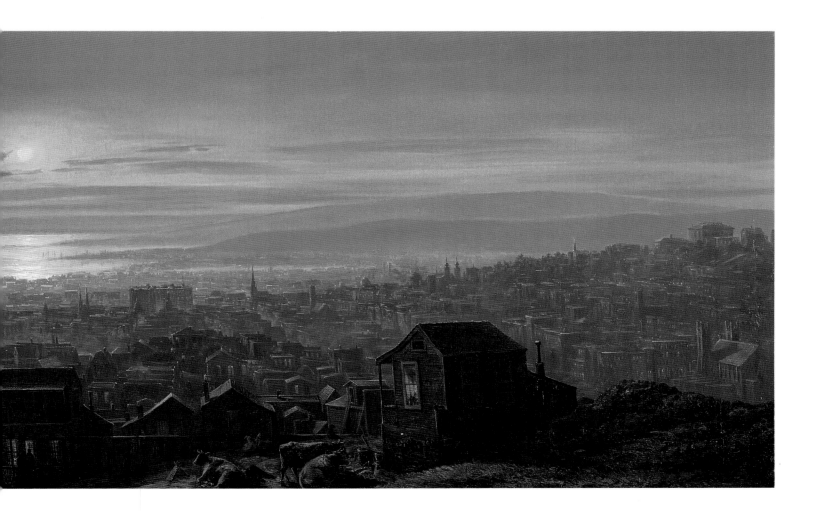

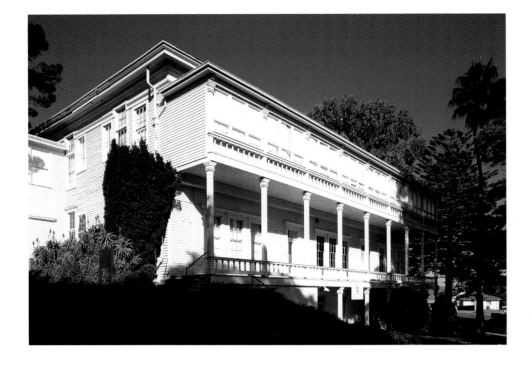

EARLY PREFAB
The 1852 Charles Stanyan house at 2006 Bush Street, in the Western Addition, is said to have been prefabricated in New England and shipped around the Horn. This hall-less Greek Revival structure has a steeply pitched roof for shedding snow and heavy rains, and an open porch for hot summer afternoons, both unnecessary in arid, cool San Francisco.
William Walters.

written. It will not be easy to research. Nearly all records and drawings burned in the great fire of 1906. What published records survive lie fragmented and unindexed. And, of course, the heart of the Victorian city—her commercial buildings—was lost in 1906 as well. What remains are photographs, newspapers, a few key journals, and the long rows of Victorian houses in the peripheral neighborhoods that are the subject of this book.

The architects and engineers of the Victorian city were equally fascinated with the technology of the present and the styles of the past. They built modern structures in antique dress, epitomized by the famous Brooklyn Bridge with its modern steel cables and its Gothic Revival stone piers.

Builders and Pattern Books in Victorian San Francisco

Most San Francisco houses, however, were not designed individually by trained architects. They were erected by speculative builders who married economical vernacular frame construction with mass-produced, mill-made, historicist ornament following the designs of popular pattern books. Those few architects such as Samuel and Joseph Cather Newsom who published pattern books had great influence on these house builders. As the Newsoms wrote in their *Picturesque California Homes*:

> We have succeeded . . . in producing houses which suggest the Romanesque, the Eastlake, the Queen Anne and many other styles in a manner which is free from the restraint of hard and fast lines, and which satisfies the dictates of comfort, pleases the eye and is peculiarly graceful and so peculiarly *Californian*.

They added that

> the degree of ornamentation will be governed, more or less, by the size of the builder's purse, though nowadays beauty in this form is becoming happily less and less of a luxury. . . . Carved, turned and machined wood can now [1890] be had in all manner of beautiful forms at a tenth of what it cost seven or eight years ago, and there are factories whose sole business it is to turn out small ornaments in wood.

More important than decoration, however, was the standardized form of the row house that pattern books institutionalized. Fitting modern houses onto

long, narrow lots, stacking bathrooms over kitchens to economize on plumbing, standardizing window and door sizes, and specifying easily secured finishes and fixtures produced formulas for economical building. As mentioned earlier, San Francisco architect John C. Pelton, Jr., published a series of newspaper articles with house plans in the 1870s, which he then republished in book form in 1882 under the wonderfully marketable title of *Cheap Dwellings*. Carpenters and builders used such pattern books to construct thousands of houses in the burgeoning city.

In the Victorian period The Real Estate Associates and other similar organizations bought large blocks of land, subdivided them into house lots, and then built batches of identical row houses that they sold on the installment plan. Building large numbers of similar houses allowed savings in the bulk buy-

ing of materials and in the steady employment of the carpenters and others who did the building. The Victorians produced California's first tract houses and put those homes within the reach of many in the middle class.

What historian Hubert Howe Bancroft wrote of his fellow Victorian San Franciscans' taste in clothes could also be applied to the city's proliferating houses:

Dress partakes somewhat of the composite character of the people, and exhibits in still stronger light the bent for display, among the lowly as well as the wealthy. French and English goods and fashions are general, with a certain additional mixture. Shop-girls and wives of laborers sport silks and imitation jewelry to a striking degree. The explanation lies . . . in the easy acquisition of money, and in the benign climate, which favors a snug yet light costume.

GREEK REVIVAL COTTAGE
The narrow clapboard Tanforan cottage at 214 Dolores Street in the Mission District was built about 1853 and is another rare survivor in the Greek Revival style. Porches with square columns and simple brackets characterized this style that was so popular in New England, the Deep South, and California in the 1840s and 1850s.

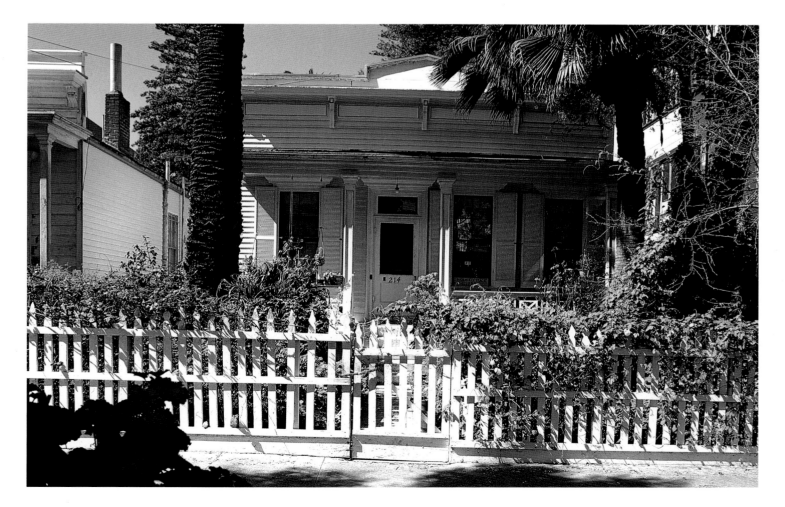

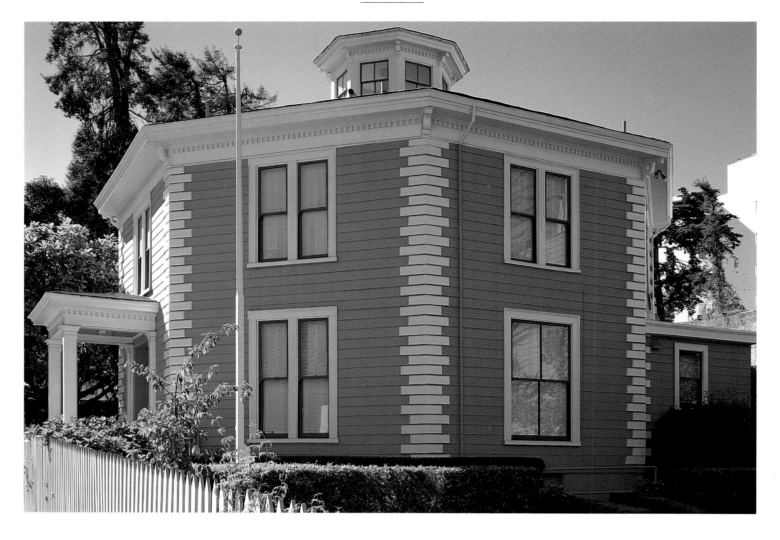

OCTAGON

William C. McElroy, a miller, had this octagonal house built in 1861. It was one of five such houses built in San Francisco following the ideas of phrenologist Orson Squire Fowler, who published a book on octagonal houses in 1848. An eight-sided plan, Fowler wrote, was a superior design because it enclosed one fifth more floor area than a square with the same total wall length. The wood-frame house is capped by a cupola. (Above)

The graceful staircase and banister of the cupola of this octagonal house gives access to the eight-sided belvedere. In 1951 the National Society of the Colonial Dames of America moved the house to its present location at 2645 Gough Street, at Union Street, in Cow Hollow, and restored and adapted it as their meeting place and as a museum for the public. (Left)

GOTHIC REVIVAL

The Mark Hopkins mansion atop Nob Hill was designed by Wright and Sanders in 1878 and was the most elaborate High Victorian Gothic house ever built in California. Constructed of redwood and painted to look like stone, it loomed over the city the way the Big Four of the Central Pacific Railroad dominated the state's economy. In 1893 it was donated to the San Francisco Art Institute, which taught freehand drawing, modeling, and "practical architecture" here. It made a splendid bonfire in 1906.

GOTHIC REVIVAL CHURCH

The Victorians thought the Gothic style especially appropriate for churches. St. Paulus Evangelical Lutheran Church at 999 Eddy Street, at Gough, in the Western Addition, was designed by Julius E. Krafft in 1894. Inspired by the cathedral at Chartres (with its lacy spires reversed to take advantage of the corner site), it is built of redwood. It is a building with superb acoustics—an architectural musical instrument.

ITALIANATE VILLA

Henry Casebolt's impressive Italianate villa at 2727 Pierce Street, in Pacific Heights, was built about 1865 for a wagon-and-carriage manufacturer. A vertical emphasis, symmetry, classical ornamental details, quoins (corner boards cut to look like rusticated stonework), heavy brackets, and a low-pitched roof are some of the characteristics of houses in "the Italian manner." This dwelling was built with massive ship timbers supporting its four corners. The lofty palms flanking the entrance were favorite Victorian landscape elements. (Right)

FANCIFUL METALWORK

The elaborate bronze gates surrounding the Italianate Flood mansion at 1000 California Street, at Mason, atop Nob Hill, were designed by Augustus Laver in 1886. Fanciful metalwork such as this gave Victorian architects the opportunity to let their imaginations run wild. The brownstone mansion was gutted by the fire in 1906 and reconstructed in 1909 to house the Pacific Union Club. (Opposite)

ITALIANATE ROW HOUSE WITH MODERN GARDEN

This two-story Italianate-style row house at 1825 Sutter Street, in the Western Addition near today's Japantown, was built in 1878 for Captain and Mrs. John Cavarly. It displays all the essential elements of the Italianate style as it was adapted for the San Francisco row house: an emphasis on verticality, with high ceilings and tall, narrow, double-hung windows; an entrance porch with Corinthian columns capped by a balustrade with urn-shaped ornaments; classically enframed windows; slant-sided bay windows with pipestem colonnettes; quoins to reinforce visually the building's corners; a heavily bracketed cornice; and a flat or low-pitched roof.

In 1983 the imaginative boxwood-grid front garden was planted, and sculptor James Nestor's black steel Streetlight was installed, making this house a happy blend of the historical and the modern, the typical and the singular.

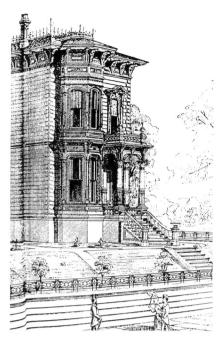

ITALIANATE BLIND WINDOWS

The Victorians had a horror of empty spaces. Here at 1900 Webster Street, at Pine, in the Western Addition, architect B. E. Henriksen added elaborately enframed blind windows to the Pine Street side of this 1884 Italianate row house. (Above, left)

FLAT-FRONT ITALIANATE ROW

Speculative builders erected pairs or small clusters of identical houses, California's first tract houses. The flat-front Italianate row of six houses at 2115 to 2125 Bush Street, in the Western Addition, was built by The Real Estate Associates, headed by Iowa-born William Hollis, in 1875. Mass production helped keep costs down and carpenters employed. The Real Estate Associates built some one thousand houses and sold them on the installment plan, with one fifth to one half the purchase price down. The balance was paid in monthly installments over one to twelve years; interest ran 8 to 10 percent a year. (Below)

THE ITALIANATE ROW HOUSE

The Italianate style was adapted to the row houses that proliferated on San Francisco's long, narrow lots. Popular from the late 1860s to about 1880, these houses were either flat fronted or bay windowed, such as the one pictured here. Built of redwood milled and painted to look like stone, the structures quickly achieved a standard plan. Italianate ornament and building parts were mass-produced in the city's woodworking mills south of Market Street. This drawing appeared in the California Architect and Building News, the West's first architecture journal, in January 1880. (Above)

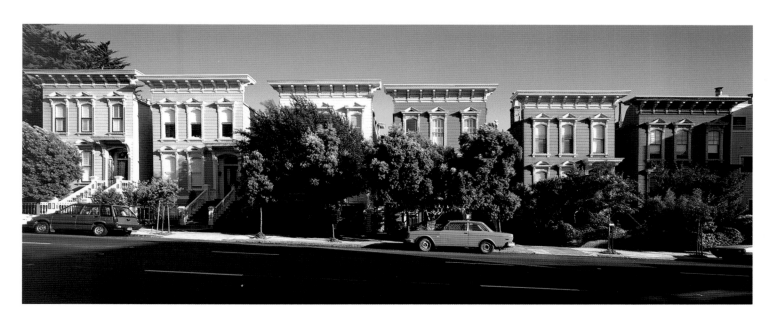

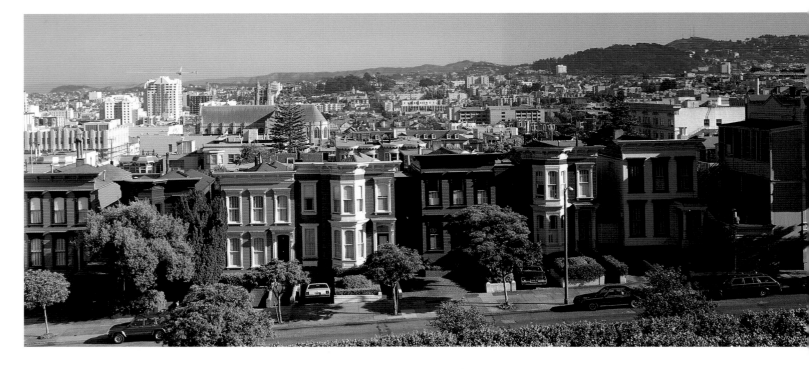

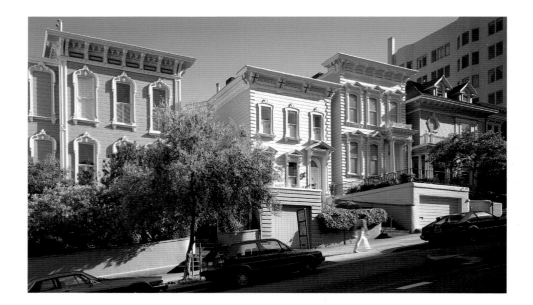

ITALIANATE ROWS AND BLOCKS

The seven Italianate row houses that line the 2600 block of Clay Street, in the Western Addition facing Alta Plaza, were erected by The Real Estate Associates in 1874–75. To vary the effect of standard plans, TREA alternated bay-windowed houses with flat-fronted houses. The building on the far right, seen in a side view, was built by Michael J. Welsh in 1892. The peak to the far right is Mount Davidson, the highest point in San Francisco, named for the scientist who surveyed the California coast in the 1850s. (Above)

STEPPING UP

The boxlike Italianate houses created stepped profiles along the city's steep streets. The 1900 block of Sacramento Street, in Pacific Heights, harbors this row of three flat-front Italianate houses built in the 1870s. At 1919 Sacramento Street, to the right, is a Queen Anne–Colonial Revival house designed by the Reid brothers in 1895. (Left)

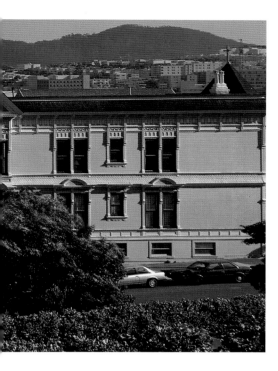

EASTLAKE: FROM FURNITURE TO FACADES

These Eastlake houses on the steep 700 block of Castro Street were constructed by builder Fernando Nelson in 1897. They sport pronounced false gables, Nelson's signature porch-column capitals, and modern pastel color schemes. (Right)

Eastlake-influenced furniture sought a sense of solidity and massiveness, as seen in this chair available from the 1887 catalog of the Brooklyn Chair Company. Dark walnut and oak were favored materials. (Below)

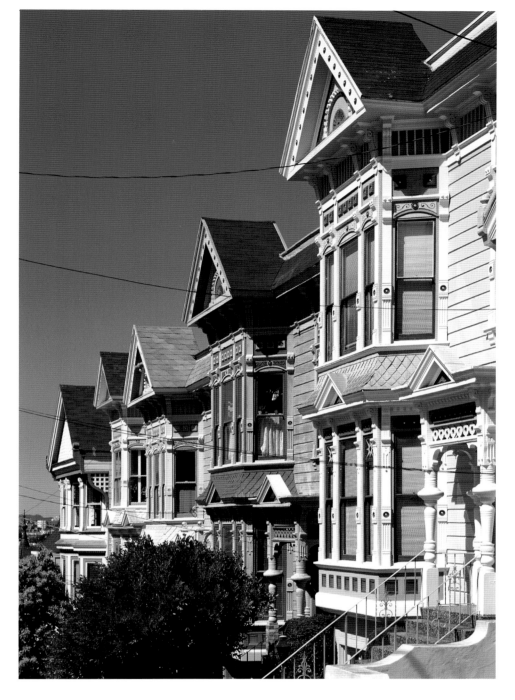

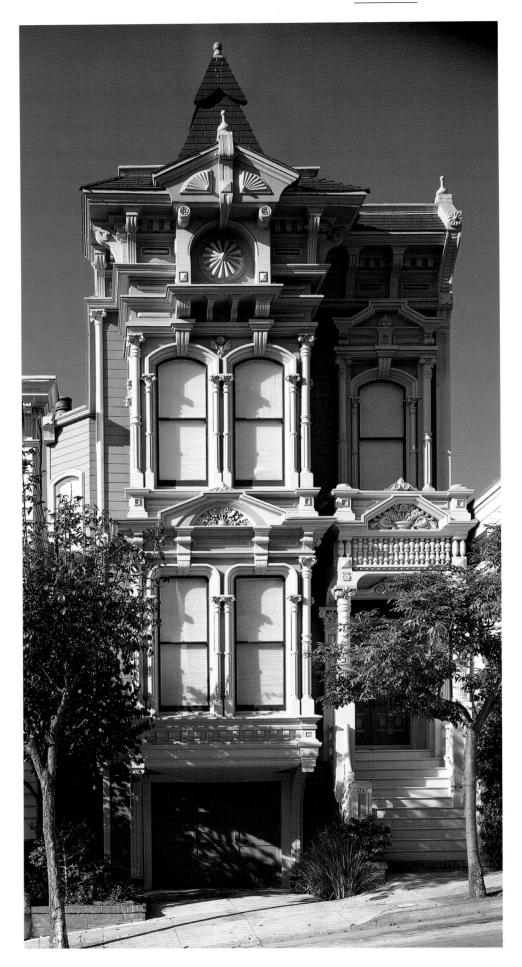

HIGH EASTLAKE

The Vollmer house at 1735–37 Webster Street, in the Western Addition, was designed by Samuel and Joseph Cather Newsom in 1885. While idiosyncratic, it can best be described as an example of High Eastlake design with a San Francisco imprint. In the 1880s bay windows became rectangular in plan rather than slant-sided, as they had been in the preceding Italianate period. All the pronounced ornament on this facade is made of redwood. (Left)

EASTLAKE PORCH DETAIL

Houses built in the 1880s were marked by fanciful ornament. This porch hood at 2436 Jackson Street, in Pacific Heights, probably designed by Henry C. Macy in 1885, has especially robust carving. It is painted in a tasteful, muted color scheme that lets the carving, not the color, dominate. (Below)

EASTLAKE HEADBOARD

This monumental Eastlake-style headboard in a Western Addition house shows how "architectural" furniture became. Made of American walnut with inset burl panels, the piece has the flatness and rectilinear quality sought in 1880s design. (Opposite)

RED, WHITE, AND GREEN

The fine group of four houses built as officers' quarters on Presidio Boulevard, at Funston Avenue, on the San Francisco Presidio, were designed by Captain Daniel P. Wheeler of the Presidio Quartermaster's Office and erected in 1885. They are in the Stick style. Army troops dug the foundations, and carpenter-builder John J. Crowley put up the houses. Their originally open porches were glassed in to make them more useful in San Francisco's cool climate. The metal chimneys at the backs of the houses are safer in seismically active San Francisco than brick chimneys.

In the late 1890s the Presidio evolved its simple, but striking, color scheme of white walls and red roofs in recollection of the post's beginnings as a Spanish fortification of white-washed adobes with red-tile roofs. This distinctive color scheme unifies nearly all of the hundreds of structures on the historic post. In March 1883, Major W. A. Jones of the Army Corps of Engineers began a massive landscaping program to turn the tree-less post into a verdant forest. Australian eucalyptus, Monterey cypress, and other exotic plantings make the site a memorable composition of red, white, and green.

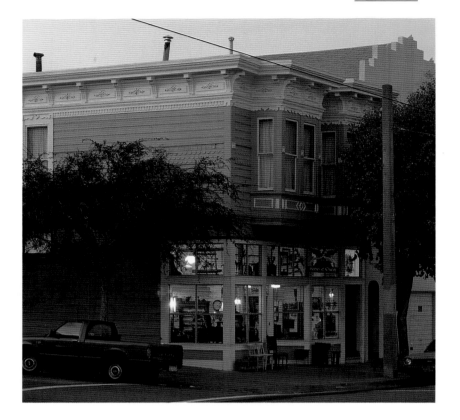

SHOP AND FLATS
Bay windows projecting out over the public sidewalk were a way developers in dense San Francisco added "free" space to their buildings and made small units seem much larger than they actually were. This Stick-style commercial-and-flats building at 1544 Church Street, at Duncan, in Noe Valley, was designed by Townsend and Wyneken in 1887 and is characteristic of the mixed-use structures commonly found along streetcar lines.

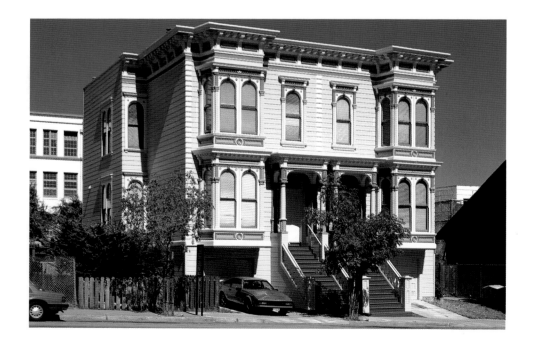

STICK-STYLE FLATS
The right-angled bays fashionable in the 1880s were applied to flats and early apartment buildings as well as houses. These flats on Webster Street, in the Western Addition, sit atop a new basement story with garages.

STICK-STYLE RESORT

The Trocadero, deep in the ravine of Stern Grove Park in the Parkside District, was built for George M. Greene in 1892 as a hotel and beer garden. Its architect is unknown. Unlike the city row houses on their narrow lots, here the Stick style could be expansive. The old resort has a steeply pitched, multigable roof and is sheathed with horizontal and vertical board siding on the first floor and fish-scale and diamond shingles on the second floor. A square cupola with a flagpole caps the festive building. Mrs. Sigmund Stern bought the property in 1931 and donated it to the city.

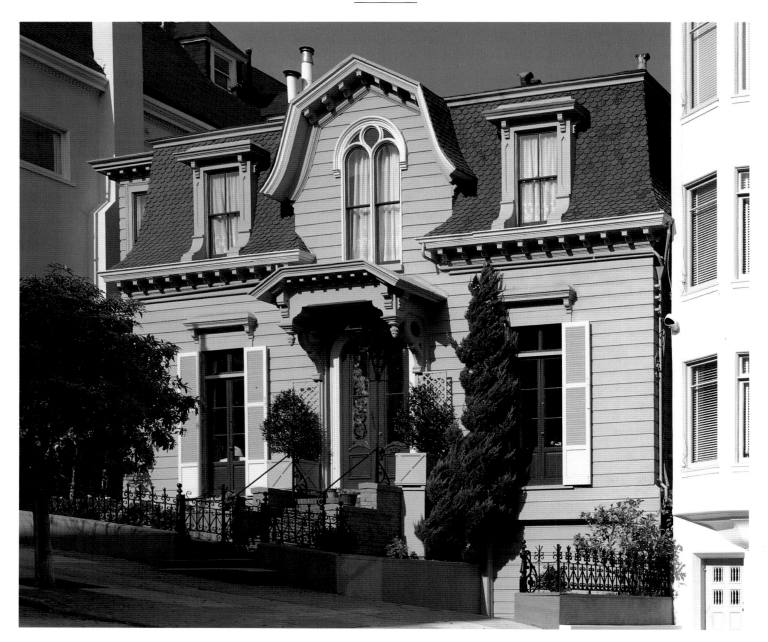

MANSARD STYLE

While England (via the East Coast) was the principal source of architectural influences in Victorian San Francisco, Paris made its contributions as well, principally in the Mansard style that appeared here and there from the 1860s to the 1890s. This house at 2460 Union Street, in Pacific Heights, was built about 1872 and then moved, altered, and expanded in 1892 by Mooser and Cuthbertson. They added the fashionable Mansard roof that distinguishes the house. It is a rare survivor in San Francisco.

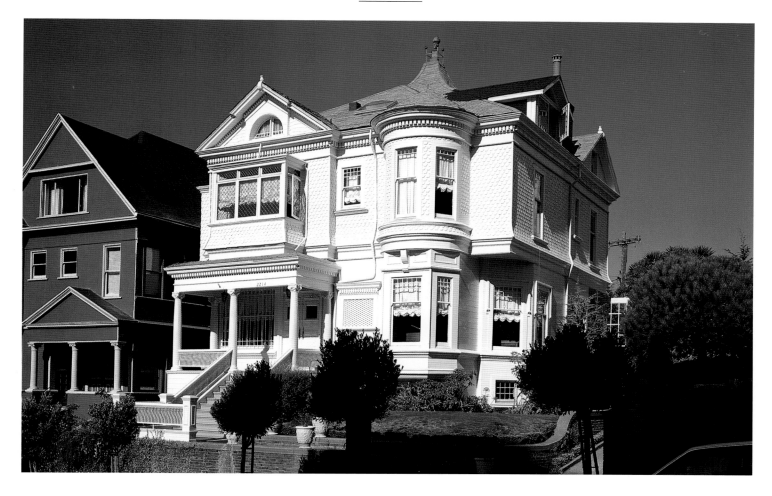

QUEEN ANNE

As the Victorian period progressed, architectural styles became ever more complex and varied. The Queen Anne style of the late 1880s and the 1890s derives its name (if not its designs) from the work of the English architect Richard Norman Shaw. In San Francisco the exuberant style was marked by irregular plans, asymmetrical massing, and variety in exterior surfaces. This large Queen Anne house at 2214 Clay Street, in Pacific Heights, was moved from Polk Street, near Union, and reworked by architect Samuel Newsom in 1894. (Above)

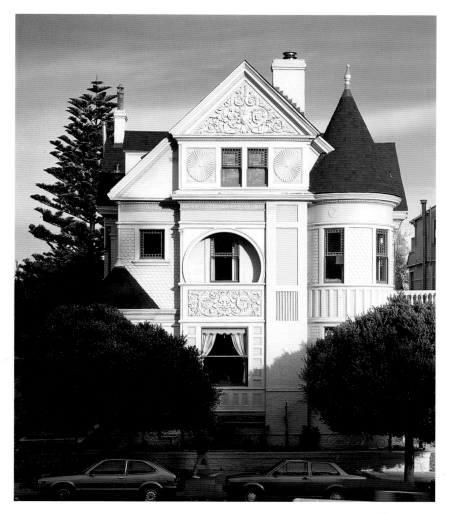

QUEEN ANNE WITH TOWER

Round corner towers with semicircular bay windows, turrets, tall chimneys, porches, and projecting pavilions were all combined in the most ambitious Queen Anne designs. The commodious house at 2004 Gough Street, in Pacific Heights, was designed in 1889 by J. C. Matthews and Son. It is a quintessential San Francisco Queen Anne. (Left)

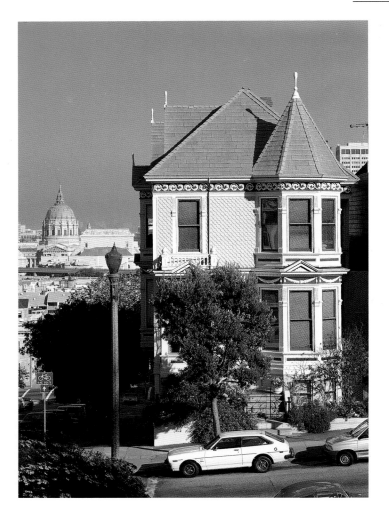

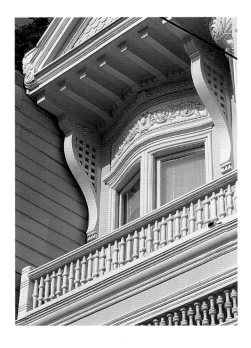

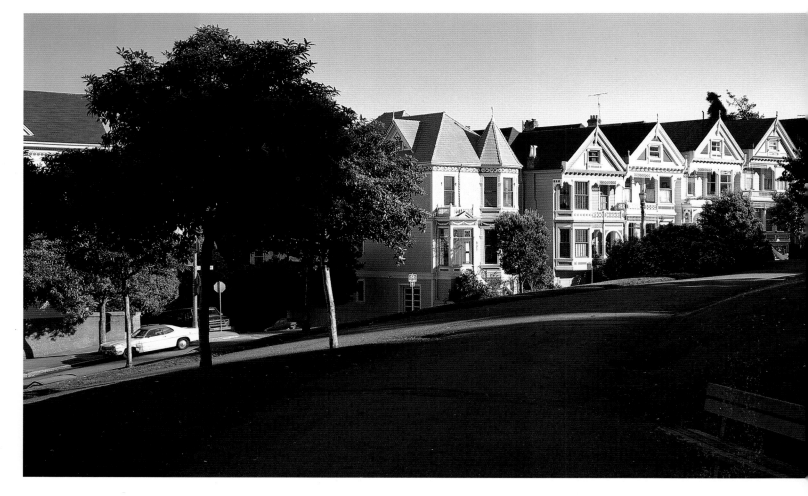

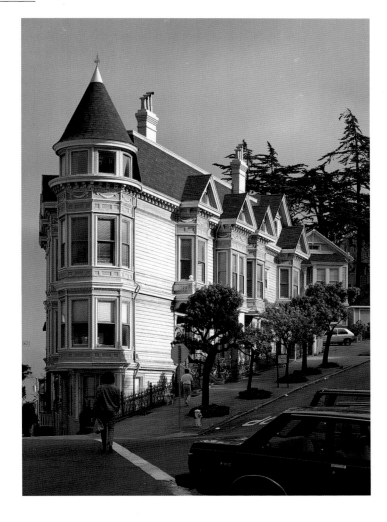

ARCHITECTURAL SPORT

The Queen Anne house at 720 Steiner Street, at Grove, part of "postcard row," is unusual in that its polygonal tower is not placed at the expected corner. Queen Anne houses often sought individual effects. In the distance is the superb dome of the Beaux Arts San Francisco City Hall designed by Bakewell and Brown and completed in 1915. (Opposite, upper left)

UNIQUE WINDOW

Unusual window treatments were characteristic of Queen Anne houses. This second-floor detail is on the home at 3014 Washington Street, in Pacific Heights, designed by Salfield and Kohlberg in 1892. (Opposite, upper right)

QUEEN ANNE "POSTCARD ROW"

Facing Alamo Square at 710–720 Steiner Street, in the Western Addition, is this splendid row of gable-roofed Queen Anne houses built by developer Matthew Kavanagh in 1894–95. Each house sold for $3,500. (Left)

COLORFUL TOUCHES

A love of color in mosaics and stained glass was part of the Queen Anne aesthetic. This is the tessellated front stair landing at 1701 Franklin Street, at California Street, in Pacific Heights, designed by W. H. Lillie in 1896 for Pacific Rolling Mill Company President Edward Coleman. (Above, left)

QUEEN ANNE FLAT-IRON HOUSE

Queen Anne designs knew how to turn a corner. The unusual 1894 flat-iron building at 1081 Haight Street/ 1–3 Buena Vista Avenue East, facing Buena Vista Park in the Haight-Ashbury, was designed by John J. Clark. It makes an exclamatory entrance to its neighborhood. (Above, right)

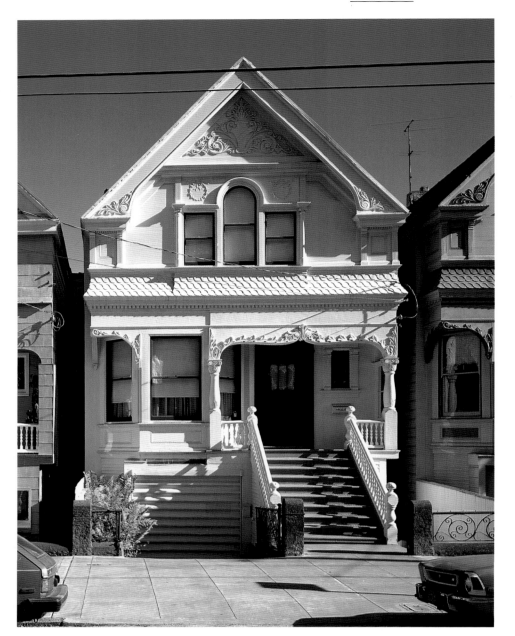

OVERLAP

A typical late–Queen Anne design is this house at 3741 Twenty-second Street, in Noe Valley, one of a cluster of four. Built in 1896 by contractor Hans Peterson, it has a porch that overlaps the first-floor bay, a characteristic Queen Anne trick. Its gable boasts a Palladian window. (Left)

ITALIANATE AND QUEEN ANNE

Many Victorian houses have been added onto over time. This grand house at 1834 California Street, in Pacific Heights, was built in 1876 for wholesale grocer Isaac Wormser in the Italianate style, as its slant-sided front bay window attests. Wealthy John Coleman bought the house in 1895 and retained the architectural firm of Percy and Hamilton to make substantial additions. The remodeling included a large, round corner tower in the Queen Anne style (far left) and a semicircular bay on the east side of the house. (Left, below)

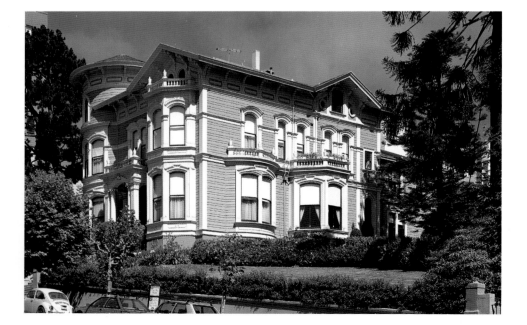

THE HAAS-LILIENTHAL HOUSE

The south, or garden side, of the 1886 Haas-Lilienthal house is a complex assembly of gables, bay windows, and a tall chimney. Strong horizontal bands between the floors pull the design together and reflect its underlying western plate-frame construction, whereby each floor was built as a separate "layer." The attic story was used for servants' quarters and a large playroom. The round turret is unfinished inside and was purely for exterior effect; its windows are too high above the floor to be usable. While the house appears to have a gable roof, in reality the unseen roof is flat. Today this grand house serves as the headquarters of The Foundation for San Francisco's Architectural Heritage and is open to the public for tours.

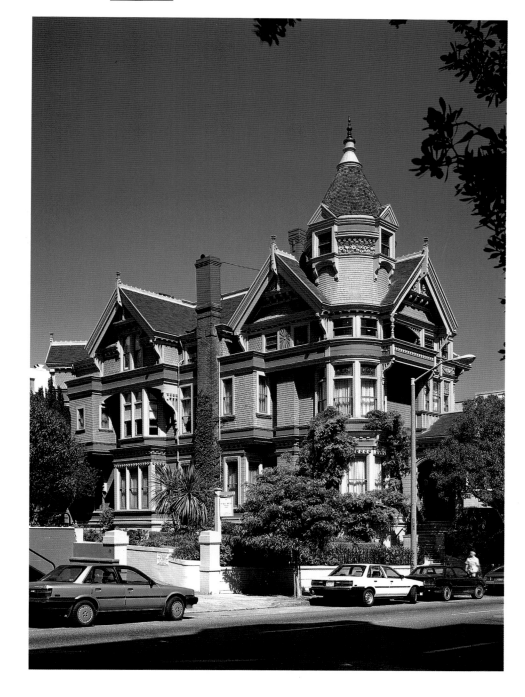

MIXED STYLES

San Francisco Victorian houses are not always easy to categorize. Many houses are transitional designs, using more than one architectural style. This drawing of the facade of the Haas-Lilienthal house at 2007 Franklin Street, in Pacific Heights, shows how architect Peter R. Schmidt fused elements of the Eastlake style with the later Queen Anne. The porch and its columns are clearly Eastlake; the round tower with its conical roof is assertively Queen Anne.
William Farnsworth, The Foundation for San Francisco's Architectural Heritage. (Above)

This is the description of the Haas-Lilienthal house that appeared in the San Francisco News Letter *on* November 19, 1887, *in the series* "Artistic Homes of California." *(Right)*

RESIDENCE OF MR. WILLIAM HAAS

SAN FRANCISCO

BEAUTIFUL residences have been erected along Franklin street, but none finer than this one, near Washington street. The front entrance is approached by a flight of steps which terminate in a covered porch, before the tile-paved vestibule. The vestibule doors are solid antique oak, heavily paneled, and lighted by beveled crystal. The entrance hall opens directly into the staircase hall, the line of union being spanned by an arch, supported in its center by a column which rises from the first newel-post of the staircase. The hall extends along the northern side of the house, is tinted in light terra-cotta, and finished in antique oak. Between it and the rear hall is a jewelled art-glass door. The fireplace and chimney-piece, with its hooded mantel-top, are on the right of the hall. Beyond rises the staircase, with its three flights and two landings, at each of which is a tall art-glass window.

The two parlors—the dining-room and the main hall are en suite. The front parlor, finished in parti-color woodwork, is delicately tinted in light terra-cotta, with cornice in relief in light chocolate. The southeast corner of the room is expanded into the tower windows, giving a grand effect. On the south side is a beautiful mantel of California onyx with tall mirror. The back parlor, also tinted in terra cotta is finished in black walnut.

The sliding doors between have tall ground-glass panels. The dining-room is tinted in light olive and finished in antique oak, with dado. The fireplace is set in the west wall, with colored tiles, and crowned by an ornate chimney-piece. The south end expands into a large square bay window.

On the left of the fireplace a door opens into the library, which is tinted in café-au-lait, with black walnut dado. A door from the library, also one from the dining-room, opens into the spacious butler's pantry. Beyond is the kitchen, communicating with the back porch and yard. The side entrance is on the north. The rear of the basement is devoted to the laundry, furnace-room, store-room and wine-cellar, while the front part is finished off for a supper-room for balls and receptions.

The second floor contains the sleeping apartments. Besides the principal chamber over the front parlor, with its dressing-room and bath and sitting-room attached, are three other bedrooms, a large sunny nursery, another bath-room and linen-closets.

The third story, or "attic," has several large rooms and an unequaled view. An air of comfort and elegance pervades the house; convenience has been consulted; electricity flies at the command of the slightest touch. The gas-fixtures present different effects in bronze, hammered copper, and combinations of oxydized silver and brass. The grounds, which are on the south side, are clad in green lawn and decked with flowers.

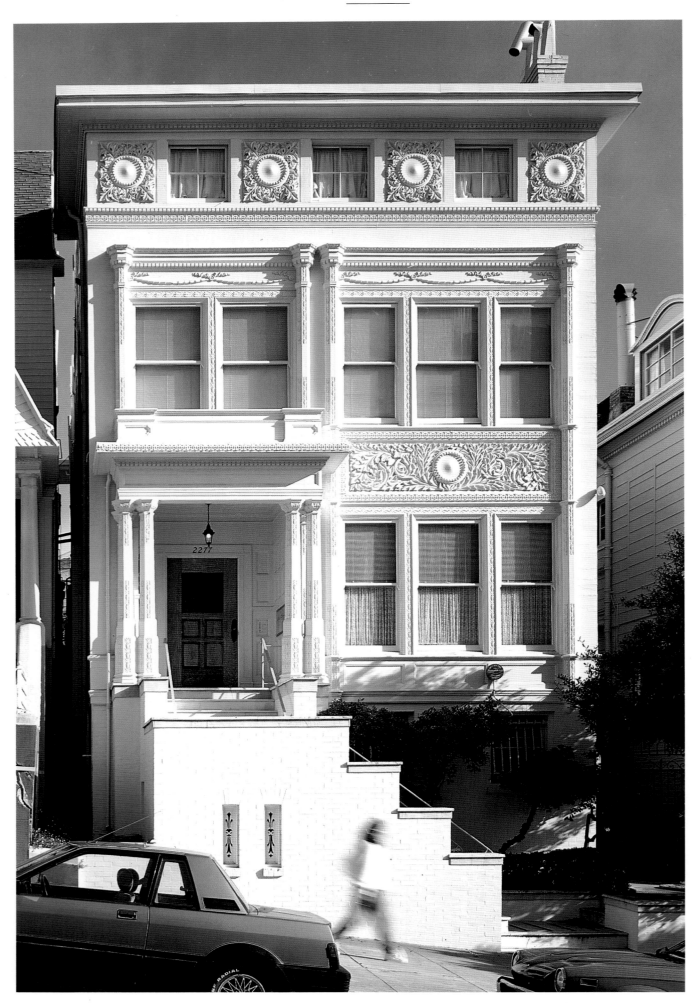

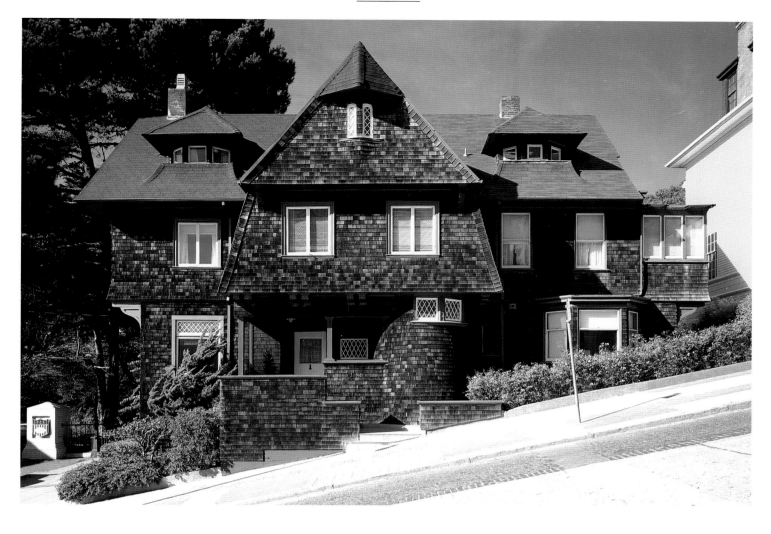

SULLIVANESQUE

Louis Henry Sullivan, the master Chicago architect, was another influential American designer in the late Victorian period. Sullivan combined simple, clear, geometric building forms with flat roofs and lively, stylized foliage and geometric ornament carved in shallow relief. Perched on its steeply graded lot, this house at 2277 Washington Street, in Pacific Heights, was designed by W. H. Lillie in 1892 in the Sullivanesque manner. It is a unique and delightful design in San Francisco. Note the sliver of sky visible to the left. (Opposite)

SHINGLE STYLE

Shingle-style houses, as the name suggests, were uniformly clad in shingles. They were commonly marked by pitched roofs with broad gable ends, and, often, by dormers. They usually had some small-paned windows. These houses embodied the ultimate reaction against the skeletal or structural emphasis of the Stick style. This house, a late example of the style, stands on the northeast corner of Pacific and Presidio avenues, in Presidio Heights. It was designed by Samuel Newsom in 1892 and is one of San Francisco's best examples of this relatively rare style. (Above)

ROMANESQUE

Boston-based Henry Hobson Richardson, one of America's greatest architects, projected his influence across the country in the 1880s. While his own massive, round-arched Romanesque designs were usually built of rock-faced masonry, San Francisco designers translated elements of his style into ubiquitous redwood. Very few Richardsonian Romanesque buildings survive in San Francisco. This porch detail at 3133 Washington Street, in Pacific Heights, shows Richardson's influence in its sense of strength; squat, grouped columns; florid capitals; round arch; and woodwork reminiscent of faceted stone. The building was designed as two flats in 1892 by architect Edward Burns. (Right)

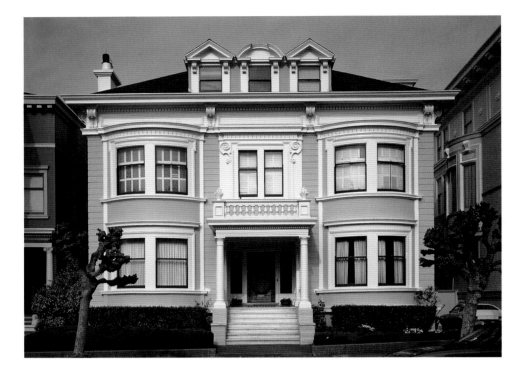

COLONIAL REVIVAL

In the late 1890s yet another East Coast fashion swept San Francisco, the Georgian, or Colonial Revival, style. Houses in this style usually have a rectangular plan, strictly symmetrical facades, hip roofs with dormer windows, and restrained classical ornament. Designed by Julius E. Krafft in 1901, this fine house at 3512 Clay Street, in Pacific Heights, has all those features, plus shallow, semicircular bay windows with double-hung sash windows and curved glass. Unlike the Queen Anne style, Colonial Revival houses sought restraint and quiet in their design. The elegant modern color scheme used here perfectly complements the balanced design.

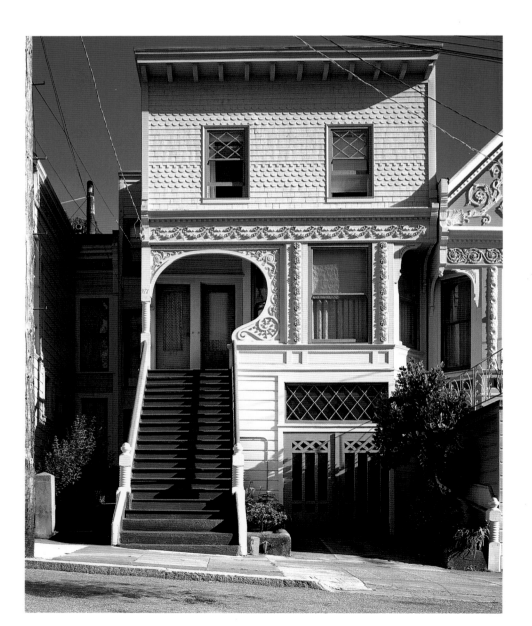

A UNIQUE DESIGN

Not every San Francisco Victorian can be categorized as to its architectural style. This unique structure at 571–73 Liberty Street, above Eureka Valley, was part of a cluster of five identical peak-roofed cottages built by John Anderson in 1897. Some time after its construction, the cottage was expanded and remodeled as two flats and this remarkable facade was added.

The building sports a pleasing, traditional San Francisco color scheme of "landlady beige" with contrasting window sash. The play of light and shadow is left to pick out the building's varied surfaces and ornament.

EDWARDIAN PALAZZO

In 1901 architect Julius E. Krafft designed the second James Leary Flood mansion at 2120 Broadway, in Pacific Heights, in a classicized manner devoid of front bay windows. A simple blocklike form, a quiet roofline, and more correct classical ornamentation mark the end of Victorian manipulation and elaboration. Its shiplap-clapboard surface is smooth and unbroken. The stately freestanding mansion sits on the commanding ridge of Pacific Heights and looks out from its back on a panoramic view of the Golden Gate and San Francisco Bay, Marin County, and the distant coastal range.

The Sarah Dix Hamlin School, founded in 1863 as the Van Ness Academy, purchased the house in 1928. Today it is known as Stanwood Hall and houses the offices and some classrooms of the oldest nonsectarian girls' school in the western United States. (Below)

EDWARDIAN ROW HOUSE

In San Francisco, row houses adopted flat shiplap-clapboard facades devoid of bay windows. More correct classical elements were used, such as archaeologically correct porch columns and cornices with egg-and-dart moldings (now usually cast plaster rather than machine-carved redwood). Double-hung sash windows had horizontal panes rather than vertical ones. An air of dignity and restraint was sought. William Walters. (Right)

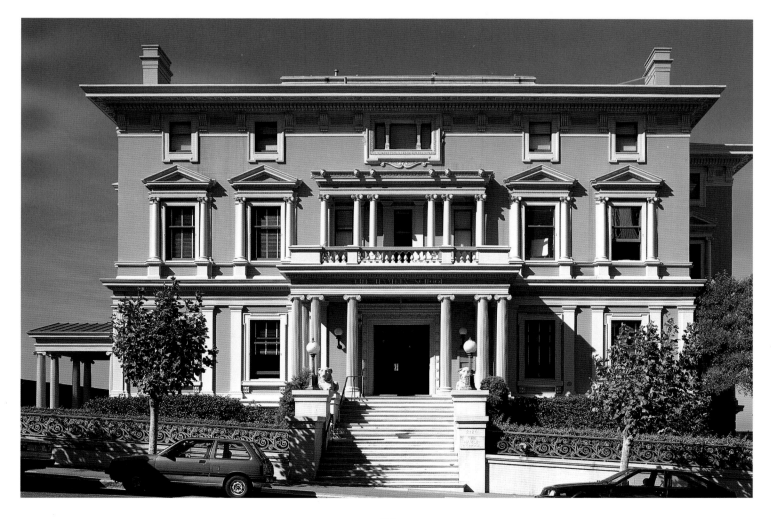

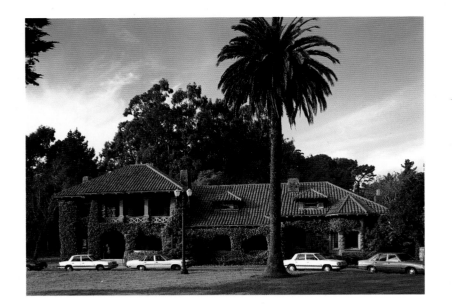

THE BEGINNINGS OF THE MISSION STYLE

The end of the nineteenth century saw the beginnings of California's own expression of Colonial Revival, the Mission style. Architect Edward R. Swain's Golden Gate Park (now McLaren) Lodge, built of sandstone in 1896, is considered a harbinger of the Mission style. Horizontal massing, an arcaded porch and loggia, and a red-tile roof were part of the effort to create a style rooted in California's past.

Originally, the left-hand section of the building housed Golden Gate Park Superintendent John McLaren and his family and the right-hand part was occupied by the Park Commission offices. Today the lodge is the headquarters of the San Francisco Recreation and Park Department. The pigskin-lined Park Commission Room is one of the finest Victorian interiors in San Francisco.

PORTALS OF THE PAST: MONUMENT TO THE LOST VICTORIAN CITY

Reflected in the calm waters of Lloyd Lake in Golden Gate Park is the Portals of the Past, San Francisco's monument to the Victorian city lost in the fire that burned uncontrolled for three days following the 1906 earthquake. Originally part of the entrance porch of the 1891 A. N. Towne mansion designed by A. Page Brown, the portal acquired its name from a famous photograph of the devastated city that used it as a visual frame for the ruins. The portal was moved from California and Taylor streets atop Nob Hill to Golden Gate Park in 1909. (Lloyd Lake is one of the irrigated park's many reservoirs.)

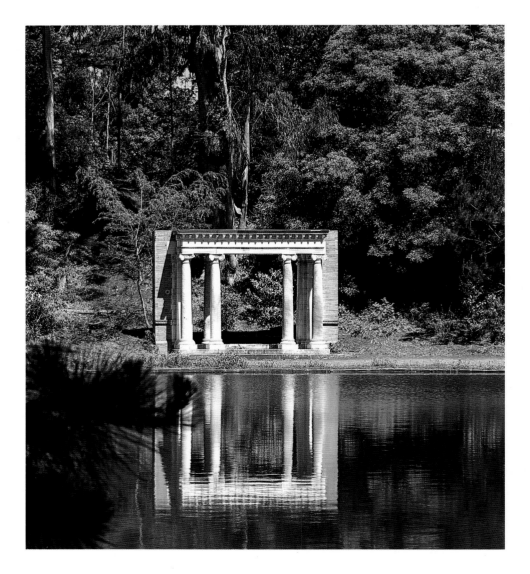

6

SOME VICTORIAN PARKS:

THE GREENING OF THE CITY

SOME VICTORIAN PARKS:
THE GREENING OF THE CITY

LAFAYETTE PARK

Landscaped parks were one of the great inventions of the Victorian city. Graded, planted, and irrigated, these green oases in the city's more fortunate neighborhoods wove nature into the city's design. Lafayette Park is one of the half-dozen generous four-block parks reserved in the Western Addition survey of 1855. The highest point in Pacific Heights, the park was landscaped in the late 1890s in the English Romantic style. Its sweeping views of the bay and the city are accessible to all. (Below)

SUTRO HEIGHTS PARK

Adolph Sutro, one of San Francisco's most farsighted philanthropists, was a reform Populist mayor from 1894 to 1896. His large estate high atop wind-blown Sutro Heights is now a park from which the city dweller can enjoy the visual release of the vast panorama of the Pacific Ocean and the mighty Golden Gate. Of Sutro's elaborate mansion and greenhouses, only this architectural fragment remains, the Stick-style Well House built over a spring about 1885. Originally there was a water fountain here to refresh visitors to Sutro Heights.

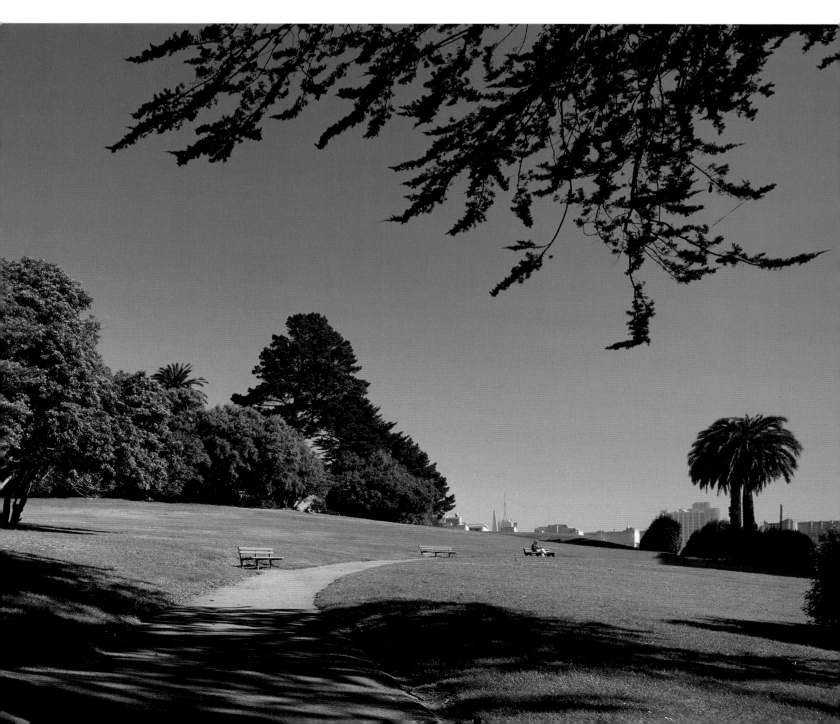

THE CONSERVATORY OF FLOWERS

The great glass bubble of The Conservatory of Flowers, with its jungle of plants, is San Francisco's most loved Victorian delight. Imported in pieces from the Hammersmith works in Dublin, Ireland, the conservatory was intended for the San Jose estate of real-estate magnate James Lick. When Lick suddenly died, it was bought by a group of wealthy businessmen and given to Golden Gate Park. The firm of Lord and Burnham from Irvington-on-Hudson erected the wood-and-glass structure in 1878. After a fire destroyed the central dome in 1883, John Gash designed the present higher, more impressive dome, which is subtly enlivened by a band of brightly colored glass.

The city's conservatory is home to soaring tropical palms and intricate exotic plants. The entrance vestibule originally housed chirping birds. In a pool in the east wing floated the Victoria Regia water lily. The flower, when fully opened, was several feet in width, and the leaves were five feet in diameter. In August 1896, the San Francisco Call reported that the spectacular flower will "bloom again to-day when it will be white, to-morrow, when it will be pink, and on Wednesday, when it will be purple, and on the evening of that day its glory will terminate."

The conservatory survived for about a century with its original greenhouse interior of simple concrete paths and wooden racks for holding clay pots. Several years ago, however, the interior was commercialized: A tourist shop was squeezed into the entrance vestibule, destroying its intended effect as a transitional space into the great dome. The west wing of the greenhouse had its original paths torn out and modern interlocked pavers were laid down. A badly proportioned interior gazebo in mock Victorian style was added so that the space could be rented out for private functions. The traditionally free conservatory (paid for by the citizens' taxes) had an admission fee imposed, destroying the high-minded Victorian legacy of free public access. San Francisco's finest civic Victorian design has been brutalized to turn a dollar. (Above, left)

ALAMO SQUARE

The finest late-Victorian landscaped neighborhood park in San Francisco is Alamo Square, another of the Western Addition reservations of 1855. Its open lawns and dark cypress groves are threaded with curving paths interlaced in a beautiful and practical pattern that was probably designed by John McLaren. In the center of this view is Pierce Street interrupted by Hamilton Recreation Center. San Bruno Mountain frames the city's southern horizon. (Opposite)

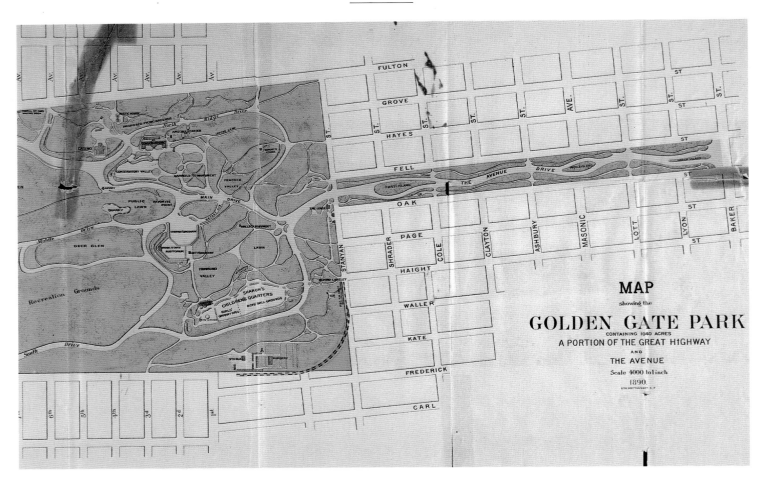

MAP

showing the

GOLDEN GATE PARK

CONTAINING 1040 ACRES

A PORTION OF THE GREAT HIGHWAY

AND

THE AVENUE

Scale 4000 to 1 inch

1890.

GOLDEN GATE PARK: VICTORIAN LANDSCAPE MASTERPIECE

The great relief and pleasure of Victorian San Franciscans was verdant Golden Gate Park. Designed in 1870 by William Hammond Hall in the English Romantic style, the park was landscaped over a period of some fifty-six years by John McLaren.

In 1890, twenty years after it was established in the shifting sands of the former Outside Lands, this is how the great park looked. Broad gravel drives for horses and carriages, and gravel walks for pedestrians, looped between lawns and groves. Special Park Police guarded the grounds and its visitors. Avenue Drive through the park panhandle was the "Rotten Row" of Victorian San Francisco, the place for the fashionable to see and be seen in glistening carriages. The impressive glass Conservatory of Flowers was a rich man's folly for the enjoyment of all. The Golden Gate Park Band played each Sunday at the Music Stand. The Children's Quarters was segregated into the girls' croquet grounds and the boys' ball grounds. By the late 1880s, streetcars made the park accessible to virtually everyone.

Golden Gate Park is nineteenth-century San Francisco's high point in public design and is the city's most valued heirloom from the Victorian age.

7

LIFESTYLES AND INTERIORS:
THE VICTORIAN HOUSE
ROOM BY ROOM

LIFESTYLES AND INTERIORS:
THE VICTORIAN HOUSE
ROOM BY ROOM

An Age of Progress

Victorian San Franciscans lived in an age of progress, progress in the making of things and in the providing of services to great numbers of people, not just a small elite. Newly tapped natural resources, wondrous inventions, industrial breakthroughs, and population growth filled shops with forests of upholstered chairs and couches, hangings and wallpapers, carpets and bronzes. The level of material and medical comfort available to many (although not all) people, and its phenomenal rate of improvement, made Victorians fundamentally optimistic. There was for them palpable progress, from running water to gas lighting, from cable cars to the first telephones.

The Victorian age was also the age of accumulation. As Victorian architecture became ever more elaborate, Victorian interiors became filled with "things." Victorians emerged as collectors. They doted on small bronze statuettes that told stories, souvenirs of travels abroad and loved ones far away, bibelots, and curiosity cabinets crammed with conversation pieces. They liked large oil paintings of the Sierra Nevada, small watercolors of the seashore, photographs of family and friends and even pets. They eagerly bought chromolithographic reproductions, a newly developed technique that made great art available to them in color for the first time. The *objet d'art* reigned supreme. Mrs. Orrinsmith, the English author of *House Decoration*, wrote that "What shall be added next?" ought to be a constantly recurring thought in domestic decoration. "What keen pleasure there is in the possession of one new treasure: a Persian tile, an Algerian flower-pot, an old Flemish cup . . . an Icelandic spoon, a Japanese cabinet, a Chinese fan; a hundred things might be named." Not just named but collected.

The Victorians ransacked the world for their parlors. They wanted animated, narrative interiors that entertained, instructed, and elevated. They loved all things exotic, curious, or antique. Among the many new kinds of furniture that they invented was the whatnot, an open set of shelves on which to display things, things in abundance, things rare and strange, things not singly but in pairs and groups. The Victorian passion for

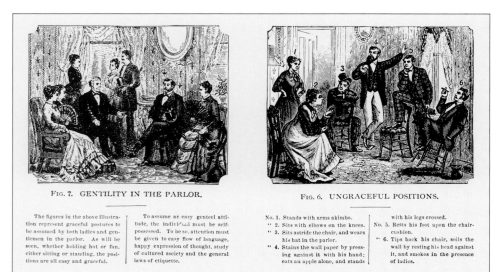

FIG. 7. GENTILITY IN THE PARLOR.

The figures in the above illustration represent graceful postures to be assumed by both ladies and gentlemen in the parlor. As will be seen, whether holding hat or fan, either sitting or standing, the positions are all easy and graceful. | To assume an easy genteel attitude, the individual must be self-possessed. To be so, attention must be given to easy flow of language, happy expression of thought, study of cultured society and the general laws of etiquette.

FIG. 6. UNGRACEFUL POSITIONS.

No. 1. Stands with arms akimbo.
" 2. Sits with elbows on the knees.
" 3. Sits astride the chair, and wears his hat in the parlor.
" 4. Stains the wall paper by pressing against it with his hand; eats an apple alone, and stands | with his legs crossed.
No. 5. Rests his foot upon the chair-cushion.
" 6. Tips back his chair, soils the wall by resting his head against it, and smokes in the presence of ladies.

GENTILITY IN THE PARLOR, UNGRACEFUL POSITIONS
In his 1876 work, Lights and Shades of San Francisco, *Benjamin E. Lloyd claimed: "Money gives the most vulgar, rank. Society opens its arms to the man who has gold, be he a knave or a fool." Actually, that was not true. The incorporation of new people into the growing middle class created a demand for manuals of etiquette. From these volumes, manners and proper parlor behavior were learned. They were the self-help books of the nineteenth century.*

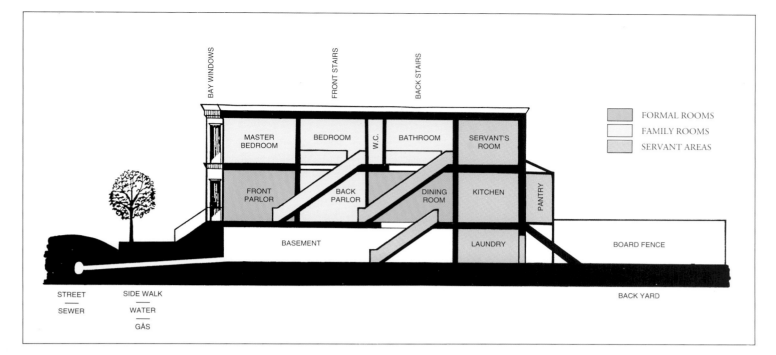

Labels in figure:
BAY WINDOWS · FRONT STAIRS · BACK STAIRS

MASTER BEDROOM · BEDROOM · W.C. · BATHROOM · SERVANT'S ROOM

FRONT PARLOR · BACK PARLOR · DINING ROOM · KITCHEN · PANTRY

BASEMENT · LAUNDRY · BOARD FENCE

STREET — SEWER · SIDE WALK — WATER · GAS · BACK YARD

Legend: FORMAL ROOMS · FAMILY ROOMS · SERVANT AREAS

THE TYPICAL ROW HOUSE
A cutaway view of a typical two-story Victorian row house and its relation to the street, sewer, and sidewalk, and to the fenced-in backyard. Dark green indicates formal, or public, rooms and spaces; light green, family rooms; and tan, servant rooms and spaces.

possessions also led to the invention of the elaborate overmantel. The simple shelf mantelpieces of the 1840s and 1850s grew and subdivided into towering arrangements of mahogany shelves on which precious things could be displayed vertically. Less was decidedly not more to the Victorians. They skied their paintings, stacking them one over the other in groups around their rooms. Even the Victorian dead could be decorative: wreaths woven out of the hair of late beloved relatives were framed and enshrined in opulent parlors.

Cosmopolitanism

Another central Victorian reality was cosmopolitanism, despite the marked rise of divisive nationalisms. Inventions pioneered in Paris were available in San Francisco not long afterward. Ideas and people moved across the globe unhindered except by cost. People, espe-

cially western Europeans, fanned out over the globe in waves of migration to the "ends of the Earth." These people met and mingled in Buenos Aires and San Francisco, Bombay and Dakar, and countless seaports around the world. In the nineteenth century, San Francisco was one of the key links in the sea-lane patterns girdling the globe. The easiest way to get to other places was through the Golden Gate. Ever since the Gold Rush, San Francisco has been on the main circuit of travel and the dissemination of information.

San Francisco's most influential migrants were, of course, from the eastern United States. New Yorkers (most noticeably upstate New Yorkers), New Englanders, and southerners were all drawn to the opening up of vast California to private American ownership. But by the early 1850s, New Yorkers and New Englanders were the dominant groups in the local culture. Others came

as well, however: Canadians, Englishmen, Frenchmen, Germans, Irishmen, Peruvians, and Chileans all followed the sea-lanes to the Pacific coast metropolis.

Rising Incomes and the Victorian Family

The fundamental trend in the late nineteenth century was a rising economic tide. There were panics, yes, and serious depressions in the 1870s and the misnamed "Gay Nineties." But in the long run there was a great increase in steamships, railroads, streets, sewers, water systems, houses, the numbers and sizes of residential rooms (including private bedrooms and fully equipped bathrooms), public schools, parks, hospitals, streetcar lines, gasworks for lighting and heating, and much more. The extraordinary changes made the San Franciscan who knew the town in the 1850s stand in amazement at the thriving world port humming with people just twenty years

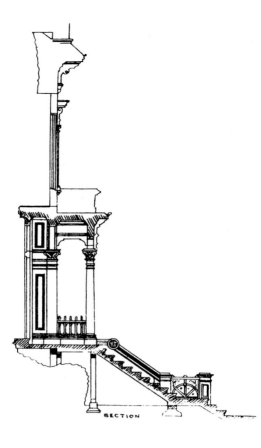

later. Sand hills without water blossomed into a bustling modern city in touch with the world. The gross national product of the United States expanded sixfold between 1869 and 1899, and real wages grew by about 50 percent. A great middle class emerged, served by the latest technology and costly, large-scale social investments. Standards of living advanced in ways that changed everyone's life.

The Expansion of Space and Privacy

The overarching trend in house design in the Victorian city was that houses became larger for all classes as the century unfolded. The middle-class house evolved specialized spaces and rooms from entrance halls to private bedrooms for children, and from formal parlors to libraries and sewing rooms. Every important function in life required a separate room. There was now more than one fireplace in the complete middle-class dwelling. Individual rooms became larger as well. Bedrooms were no longer just large enough for beds; they often had sitting areas with chaises and writing desks. A disapproving English critic wrote in 1875 that

in such sitting-room bedrooms upholstery assumes an almost tyrannical position. The sofa, not merely with spring seat but with spring back and arms, draped to the ground temptingly, spreads abroad its luxurious undulations, easy chairs, all springs, low and capacious, invite you to be lazy. There are little tables for your refreshments, reading stands for your novel. The writing table is . . . crowded with the knick-knackeries of stationery.

Over time the Victorian family and house became more child centered. Elaborate nurseries featured costly, ribbon-bedecked cribs. Miniature chairs were designed for small children. A minimum of three bedrooms became the middle-class standard to provide separate rooms for parents, boys, and girls.

THE FRONT PORCH
A cutaway view of the steps, porch, and facade of a typical Victorian row house, drawn by Samuel and Joseph Cather Newsom in 1884. Although all San Francisco houses were raised up off the damp, sandy ground, they did not all have full basements. (Above)

A GRAND ENTRANCE
San Francisco architects Smith and Freeman designed the welcoming entrance vestibule for the 1893 Ellinwood house, in Pacific Heights. It was characteristic for front doors to be varnished, not painted, and for fine mosaics to be used for the pavement. (Opposite)

EASTLAKE PORCH
The entrance to the fully evolved Victorian row house was emphatically announced by two columns supporting a fanciful portico projecting from the body of the building. Here an ornate Eastlake porch with spindle works and sunburst brackets marks the entrance to 729 Oak Street, in the Western Addition. The wood steps are painted gray, in imitation of granite; the tall, narrow, paired front doors are varnished to display their wood. (Right)

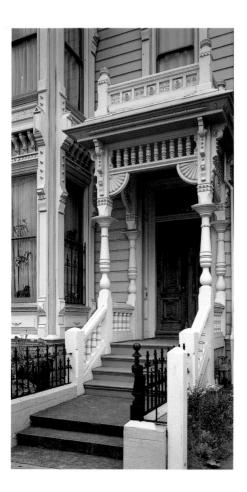

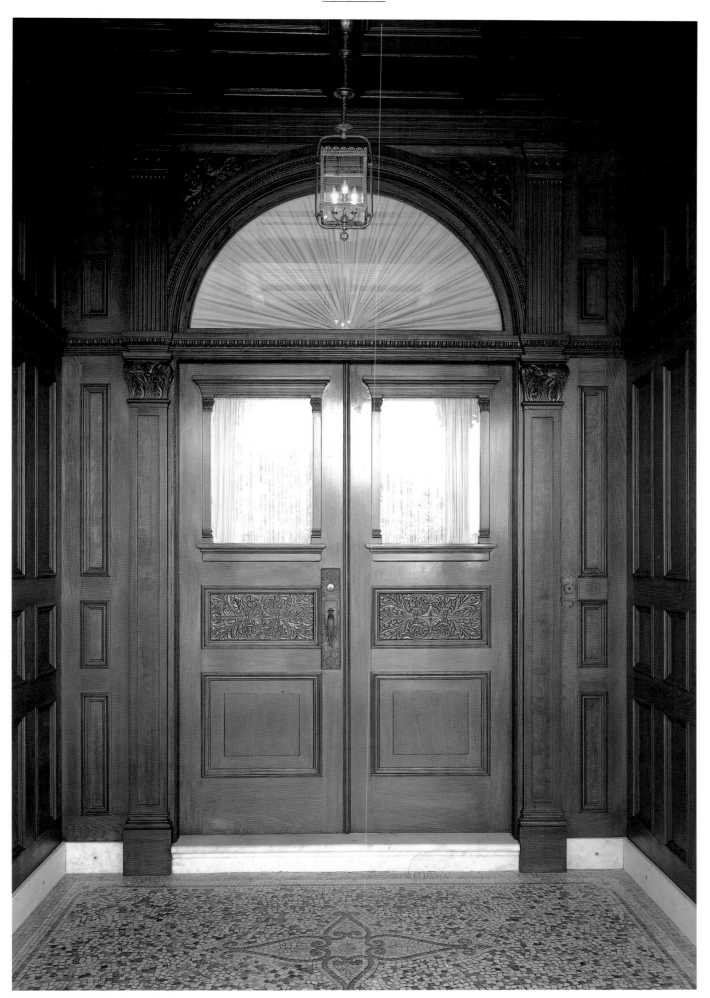

Dressing rooms evolved dedicated to the storage of ever more elaborate clothing keyed to the seasons and changing fashions of the year. As English sports like tennis came into vogue, distinct clothing was developed for each athletic activity. Eventually the closet appeared as a tiny room attached to the larger room. Storage space such as pantries and wine cellars appeared in basements. In the mansions of the plutocrats—and San Francisco had more than her share of these huge piles—rooms swelled to enormous proportions and multiplied in staggering numbers.

For the upper crust, country houses became de rigueur. With the coming of the commuter railroad, the sunny San Mateo peninsula became the favored spot for the rich to build weekend retreats. Marin County saw many upper-middle-class second houses in San Rafael and also simpler summer cottages in towns like Mill Valley. One especially house-mad San Franciscan, Mary Hopkins, wife of one of the Big Four of the Central Pacific Railroad and owner of the architectural mirage that dominated Nob Hill, accumulated houses in New York City, two in Massachusetts, and one on Block Island.

Most important, even working-class cottages expanded in size, number of rooms, and comfort. The relatively high wage rates in Victorian San Francisco paid for the so-called mechanics' cottages that dotted the city's peripheral neighborhoods in places like Noe Valley, the Potrero, and the Outer Mission. Most of these modest one-story houses had indoor plumbing and even a separate, if cramped, formal front parlor. Today these small working-class Victorian cottages are sought after by middle-class buyers who modernize their interiors and restore their facades.

The result of this expansion in the size of dwellings and in the number of rooms was more privacy for each family member. Growth and segregation were the fundamental twin trends both in the city as a whole and within the individual middle-class house. Pocket, or sliding, doors were elaborated to compartmentalize houses. The front parlor was set off from the middle, or family, parlor by mill-made sliding doors. They separated

CALLING CARDS
Visitors who could not be received, or who found the family not home, would leave their cards on a silver tray. The painting in this 1870 entrance hall is of Cum Cook Tuen Alley in San Francisco's Chinatown. (Opposite)

A MODEST
ENTRANCE HALL
Just inside the front door of a Victorian house was the entrance hall, where callers were screened and either directed to the parlor or turned away. This is the modest hall of an 1884 Italianate cottage orné in the Haight-Ashbury. (Right)

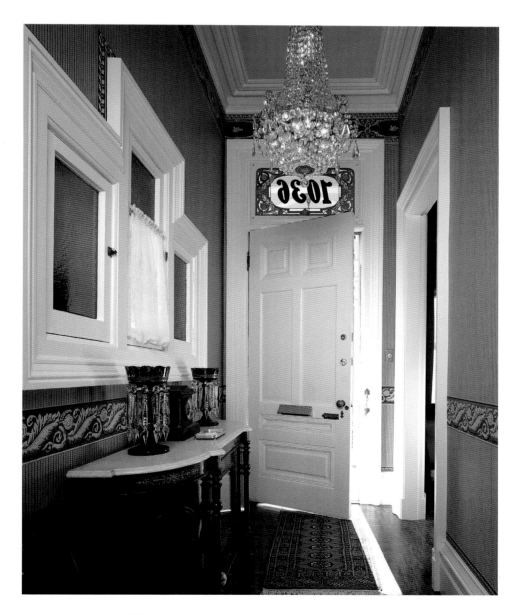

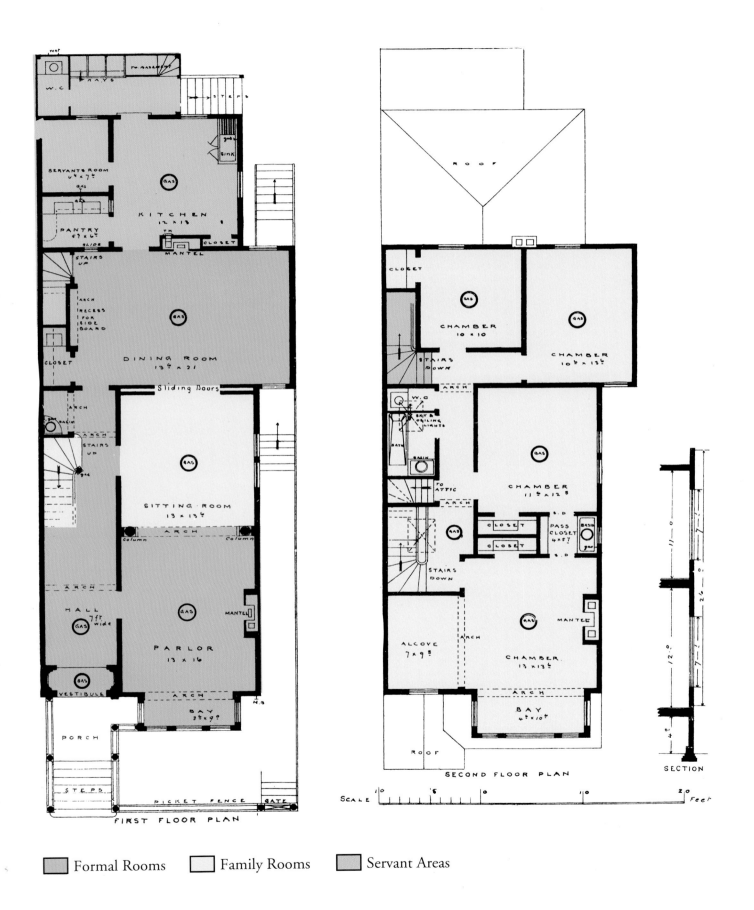

FIRST FLOOR PLAN

SECOND FLOOR PLAN

SECTION

SCALE

Formal Rooms Family Rooms Servant Areas

visitors from residents, the public from the private areas of the house. The dining room was separated from the kitchen, and then the breakfast room from the dining room. Entrance halls, stair halls, and second-floor hallways lined with mute closed doors served to separate the various upstairs rooms and their occupants. In the second-floor hall a door with frosted-glass panes separated the master bedroom from the children's back bedrooms. Servants' rooms were placed in the rear of the house or in the attic to separate them from the family. There was no such thing as an "open house plan" in the Victorian period. Even within the bedroom, standing screens in corners provided privacy for undressing, and an alcove often created a separate space for the massive half-tester bed.

Separate Spaces: Men and Women, Adults and Children

Underlying this well-delineated subdivision of the middle-class Victorian house was the social subdivision of the sexes and ages in Victorian society. Downtown was a strictly masculine province; women were drawn to the city's core only with the development of the department store late in the period. The women's sphere was the home, neighborhood, and church. Men developed separate clubs, saloons, and billiard halls. Children, of course, had their own province, the public school. When Golden Gate Park first built its Children's Playground, it was divided into a boys' ball grounds and a girls' croquet grounds.

The whole integrative thrust of late-twentieth-century culture would have been alien to a Victorian of either sex or any class. What the Victorian house did was to make the ingrained social distinctions between sexes and ages into spatial divisions. It was a segregated world. We who today open up compartmentalized Victorian interiors and remove doors are expressing not just spatial preferences but underlying social values as well.

Domestic Servants and the Middle Class

The expanding Victorian house demanded more than just the housewife to maintain it. Domestic servants were as much a part of the Victorian scene as gingerbread and finials. In 1870 half of all women wage earners were domestic servants. Native-born American women were reluctant to enter domestic service, so the jobs very often fell to young immigrant women. In San Francisco the serving maids were generally Irish and the cooks were often German. A special twist in San Francisco's domestic service was the employment of Chinese men in home laundries. These workers learned the values, habits, and even language of the middle class through domestic work.

Domestic service peaked in 1870 when there were 1.3 servants per ten American households. (In 1910 that figure dropped to 1 servant per ten households nationwide. It fell to half that by 1960.) As immigrant groups Americanized, one of the first things they did was to abandon domestic service. Mechanical inventions such as washing machines proliferated even in the Victorian period, which lessened the need for hard-to-get reliable servants. All of these domestic workers are mute to history. No diaries have come down to us, and the photographs in family scrapbooks often leave servants unnamed. But Harriet Lane Levy left a vivid sketch of Maggie Doyle, the Irish-American cook in a Polish-Jewish San Francisco household:

> The kitchen offered the social potentialities of a ballroom, and Maggie missed none of them. Twice a day the tradesman or his emissary knocked on the kitchen door. In the morning he took the order, in the afternoon he delivered it. The grocer, the baker, the steam laundryman, the fish man, the chicken man, the butcher boy came twice a day proffering a salty bit of

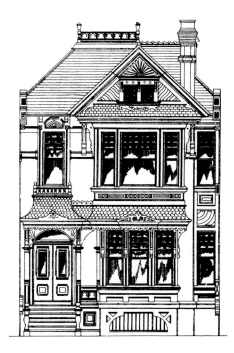

THE ROW HOUSE WITH A LIVE-IN SERVANT

The facade and floor plan of a two-story row house with a live-in servant. The circles in the centers of the rooms represent gaslight fixtures.

This facade and floor plan, and the following two house designs, are from San Francisco architects Samuel and Joseph Cather Newsom's Picturesque California Homes, *an influential pattern book published in 1884. (Above and opposite)*

*A SPACIOUS
ENTRANCE HALL*
*Grand houses had fittingly spacious
entrance halls. Here is the golden
oak–paneled entrance hall of the
Queen Anne–style Spencer house, in
the Haight-Ashbury, designed by
Frederick P. Raven in 1895. A mirror
with coat and hat hooks hangs over a
hall bench. The seat of the bench lifts
up for the storage of walking para-
phernalia. The parquet floor is of a
singular design.*

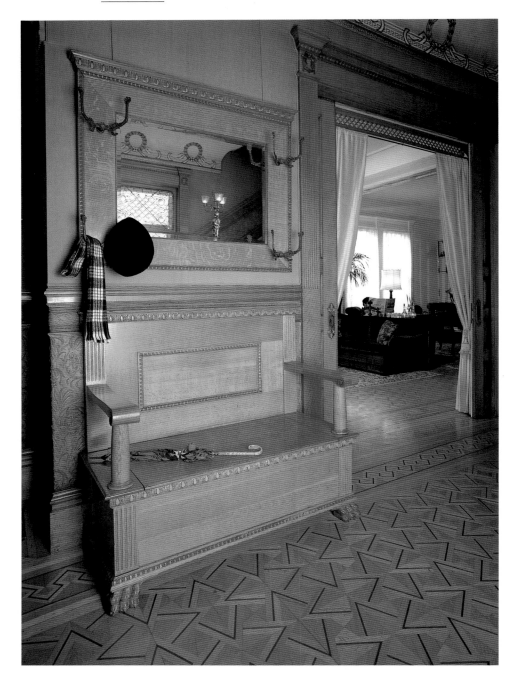

conversation or flashing a glance of fire. Bent over the sink, Maggie Doyle aimed a shaft of repartee over her left shoulder in invitation, or she buried her scorn in a bowl of dough, or she leaned lightly against the jamb of the door in coquettish intimacy with the man who pleased her.

Servants also meant surveillance of both maid and mistress. "Like a jailer, locking, unlocking, Mother habitually moved to a faint click. Ours was a locked house: storm doors, street doors, closets, bureau drawers, all locked." So wrote Harriet Lane Levy. Servants also meant

back stairs, so that served and servant could circulate separately in the strati-fied Victorian household.

Floor Plans and Lifestyles: Formality and Progression

The lives that were lived and felt in these houses, in these multiplying rooms, were not like ours. The Victorians sought to create a world of compart-ments, hierarchies, stations in life. They strove to make the sharpest distinctions. There were "separate worlds" and sepa-rate rooms for men and women, adults

and children, families and servants.

The Victorians built entrance halls where callers could wait without "enter-ing" the house. In the entrance hall there was often a narrow table with a small sil-ver tray on which calling cards could be left by those visitors the family did not wish to receive. In receiving guests the Victorians liked to progress from room to room in stately order. Dinner guests would be met at the front door and ushered into the entrance hall by a maid, who would then ask them to leave their wraps and to wait a moment. Coats,

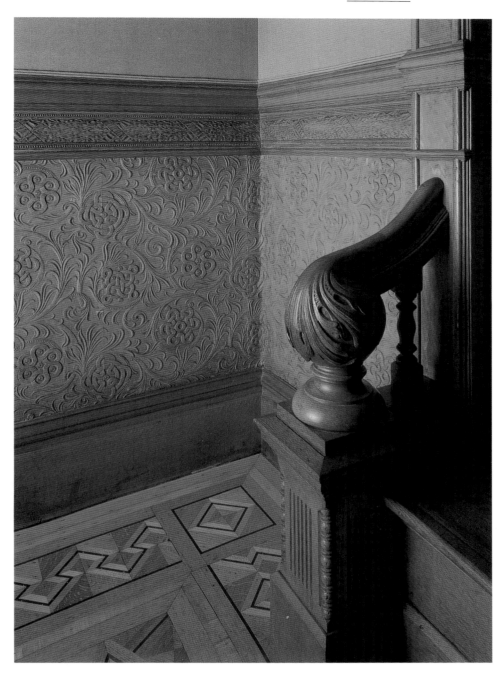

walking sticks, hats, and other impedimenta would be left on the often quite elaborate hallstand.

The host would then greet his guests by stepping out of the front parlor and shaking hands all around. Retracing his steps, he would walk his guests into the front parlor to meet the lady of the house. If it was a formal call, chairs were taken in the front parlor and polite conversation commenced. If the call was more intimate, the host would march his guests from the entrance hall, through the formal front parlor, and

then through the opened sliding doors to the center, or family, parlor, where everyone was seated in front of the fireplace. Guests might comment favorably on some piece of statuary or a recently acquired painting, although it was impolite to dwell too much on an object. After everyone visited in the parlor, a servant would enter to inform the master of the house that dinner was ready. At this point the sliding doors between the parlor and the dining room would be opened to reveal the table set with silver and crystal.

Host and hostess sat at opposite ends of the table on Carvers, heavy, turned, spindle-backed chairs with armrests. Guests, who sat on armless chairs, were positioned according to their rank, with the most honored guest to the right of the head of the household. A strict alternation of gentleman, lady, gentleman, lady was observed in seating. Cards sometimes ensured the proper location of each guest, lest the social hierarchy be disturbed.

The formal dining room was the very heart of the proper bourgeois

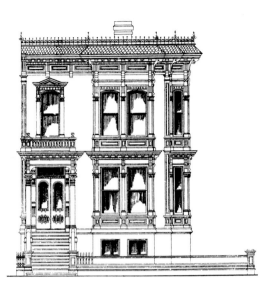

*THE ROW HOUSE
WITHOUT A LIVE-IN
SERVANT*
The facade and floor plan of a two-story row house with no live-in servant. (Above and opposite)

house. It was where the family put itself on display for guests. Its silver testified to the status of the family. An elaborate silver centerpiece was a virtual monument to the family's social standing. Gastronomic rituals were highly elaborated and refined. Linen napkins were slipped from silver rings and carefully placed on laps. Courses appeared in strict order, often with separate utensils and plates for each, a practice known as dining *à la russe.* Elders talked and youngsters listened. Servants carried courses from the kitchen to the sideboard, and from the sideboard to the table. Dinners were the high point of social intercourse and were never hurried. Conversation was expected to flow as effortlessly as the wine. Even when there were no guests, the family gathered in an only slightly less formal ritual each evening to converse about the day and to refresh the bonds between parents and children.

After dinner the table was cleared and the men would linger over brandy and cigars. The women would rise and move to the parlor or withdraw to a drawing room (hence the name). In very grand houses the men would also rise, but they would go to a special Turkish smoking room with cross ventilation so that their cigar smoke would not permeate the rest of the house. Now men and women would talk separately. When the evening was at an end, the men would rise and rejoin the ladies in the parlor, good-nights would be said, and the host would see his guests to the entrance hall. Here coats and hats were recovered before heading to the front door. Such was the central social ritual of well-established Victorian families.

Calling Cards and At Homes

One similarity between Victorian and modern lifestyles was the central role of women in defining social life and social hierarchies. While the economic standing of the family depended on the husband's income, social standing was the work of wives. Each upper-middle-class

woman kept one day of the week for "morning calls"—which, despite the term, were always in the early afternoon. Her engraved calling card would note the day of the week that she was at home.

Making and receiving calls was the ritual that defined the circles of society. It was mostly women who went calling. They stayed only a short time, perhaps half an hour, since most had several calls to make in an afternoon. Cakes, petits fours, and tea were served, often by daughters of the house, who were being trained in the ways of genteel living. The etiquette of "at homes" became standardized over time, with San Francisco tending to follow New York City custom.

Married women were the chief dancers in society's intricate ballet. Unmarried men had their nearest kinswomen perform the social duties obligatory in good society. Young women were sheltered: "Until a girl is in society she makes visits within the family circle only, or with intimate family friends, and a card for her is needless," wrote the anonymous author of *Good Form: Cards, Their Significance and Proper Usage,* in 1889. There were different cards for men and women, with women's cards larger for the notation of messages. The way names were written differed for newly-wed couples, married women, spinsters, and widows. Approved convention left no room for idiosyncratic cards; cards had to be engraved in script, not in any fancy lettering. *Good Form* was equally adamant on this question of calligraphy: "Such intrusion of personality as one's own fashion in penmanship made permanent by engraving, is decidedly offensive to those who have reserved natures and exclusive social positions. Apparent egotisms are incompatible with perfect breeding." (Ah! *Unapparent* egotisms were the thing!) Fanciful inks, colored paper, or flourishes of any kind produced "an unpleasant repelling sensation." During periods of mourning, black-bordered cards were sent out.

Calling cards were a way both of

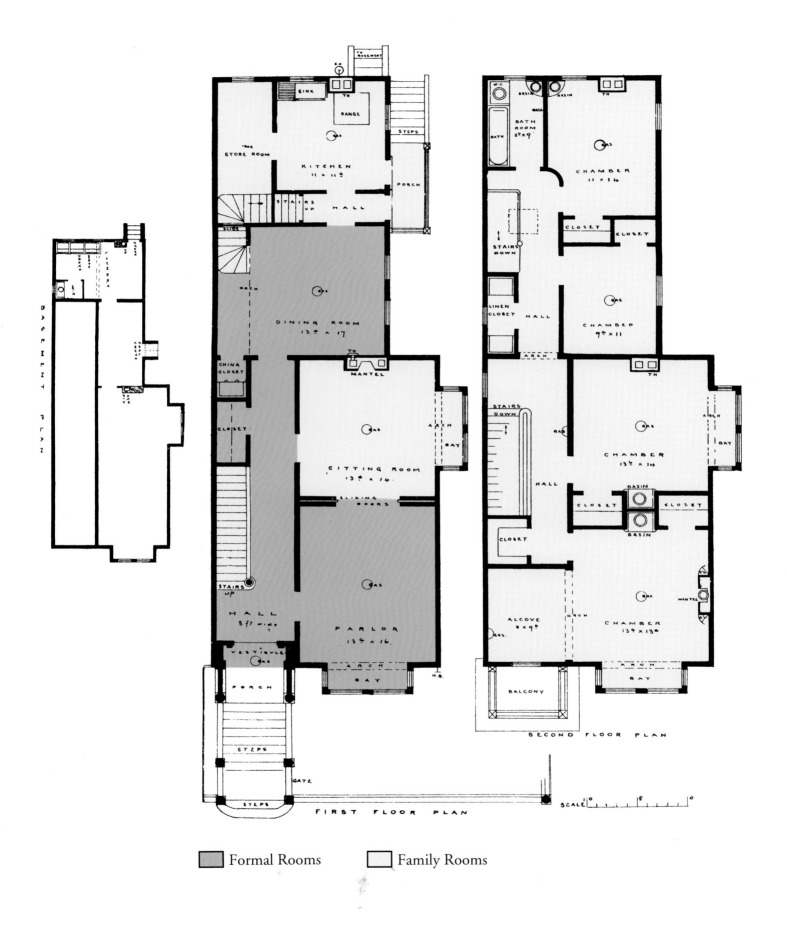

FIRST FLOOR PLAN

SECOND FLOOR PLAN

BASEMENT PLAN

Formal Rooms Family Rooms

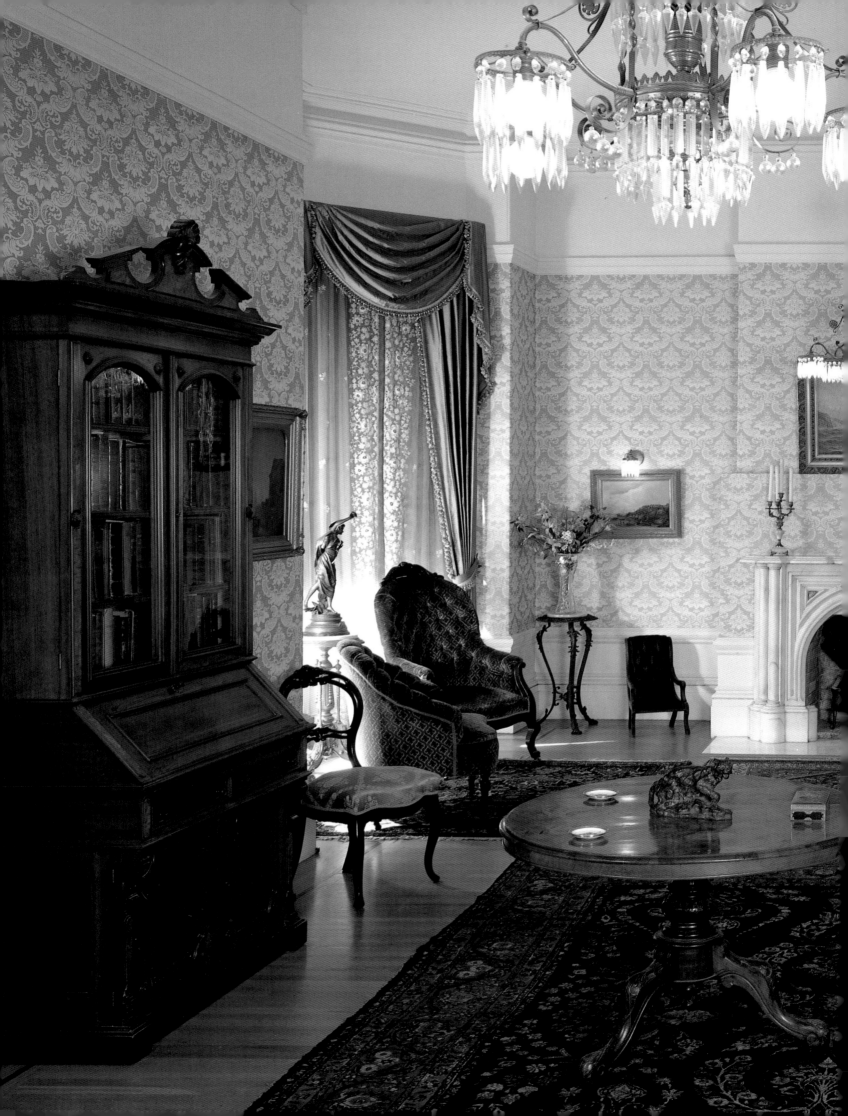

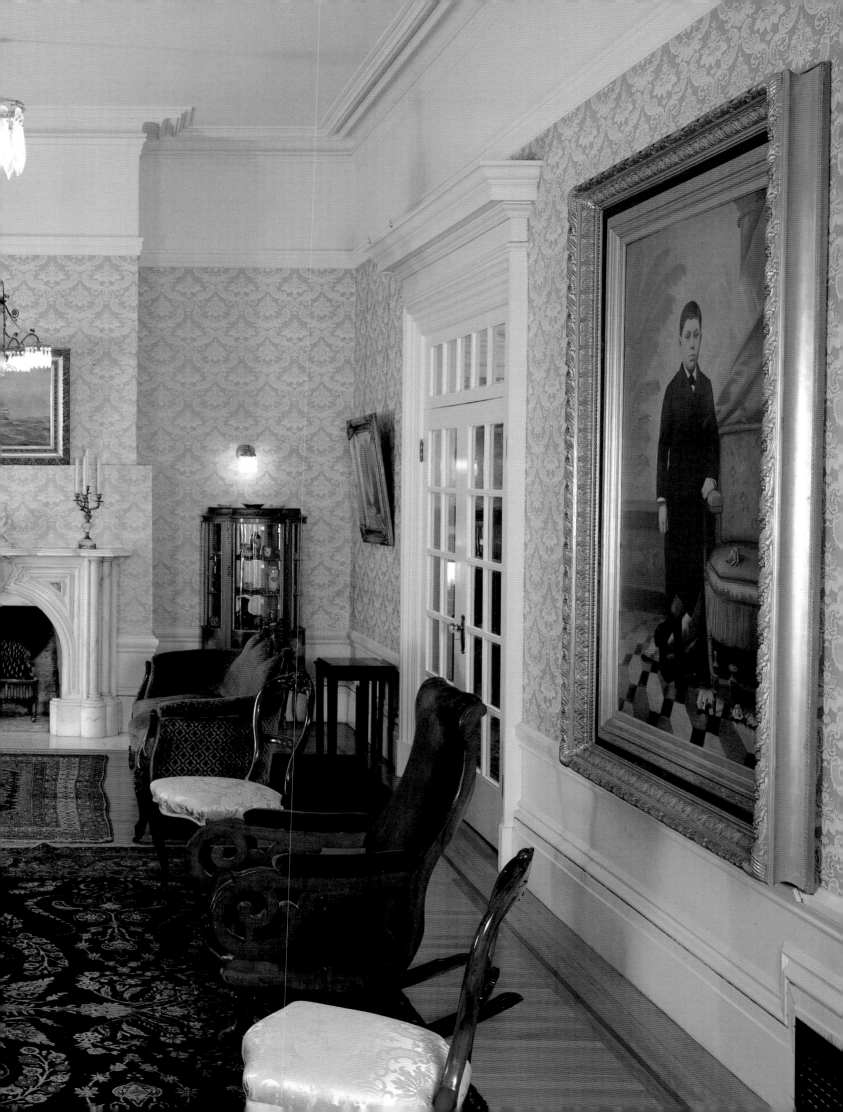

**AN ERUDITE
VICTORIAN PARLOR**
*This is probably San Francisco's most
erudite Victorian parlor. Preserved by
the grandson of the man who had it
built, this 1870 Western Addition
Italianate house shelters some of its
original furnishings and a choice col-
lection of nineteenth-century paint-
ings of San Francisco and California.
(Overleaf)*

VICTORIAN SETTEE
*Victorians liked to have fun with up-
holstery. What else can explain this
two-person settee in a sunny front
bay window? The French bronze on
the pedestal by Rancoulet represents
"La Génie humain devoile la nature
qui lui explique ses mystères."
Worth the pursuit, even on such a
contorted couch. The window is
dressed in proper Victorian fashion.*

AN ITALIANATE PARLOR
*This parlor has some of its original
1870 furniture, including this graceful
early Victorian balloon-back chair.
The Eastlake-style Honduran
mahogany bookcase to the left was
made in San Francisco in the early
1870s by cabinetmaker W. J. T.
Palmer. San Francisco artist Fortu-
nato Arriola depicted elite Howard
Street, south of Market Street, in a
light fog during the "silver seventies."
(Opposite)*

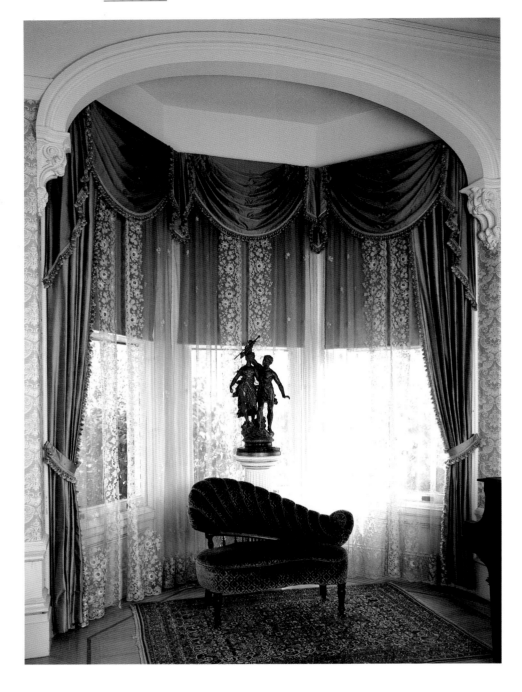

entering society and of being kept out of it. Cards were customarily left between three and five in the afternoon and their distribution was the engagement of women with conspicuous leisure. It was a kind of social Code of Hammurabi in the Victorian era—a card for a card, a call for a call. If the person called on was not home, or not receiving that day, the custom was to leave a card with its corner turned down; a dog-eared card was the sign that the call had been made in person and not by a servant. Cards and servants at the door became barriers or buffers between social circles in the expanding Victorian city. Those habitually in society were bred to its habits and rules. These forms reached their codification in the United States in the 1870s. In 1884 *The Social Manual of San Francisco* described the weekly ordering of San Francisco's at homes:

> A greater uniformity in reception days prevails from year to year. The rule is as follows: Mondays, the hotels, Tuesday, Nob Hill and Taylor Street to the north, Wednesday, Rincon Hill, South Park and the streets near the Mission, Thursday most of Pine, Bush, Sutter and parallel streets, and the greater part of Van Ness Avenue, Fridays, Pacific Heights and adjacent streets as far as the Presidio.

In 1887 the first *Social Register* was published in New York, principally from the calling cards left at elite domiciles. San Francisco had its own listing shortly thereafter.

The Cult of the Home

Those not part of the charmed circle of nineteenth-century society did not, of course, have the time, money, or status to engage in these elaborate rituals. But the great middle class, and striving families

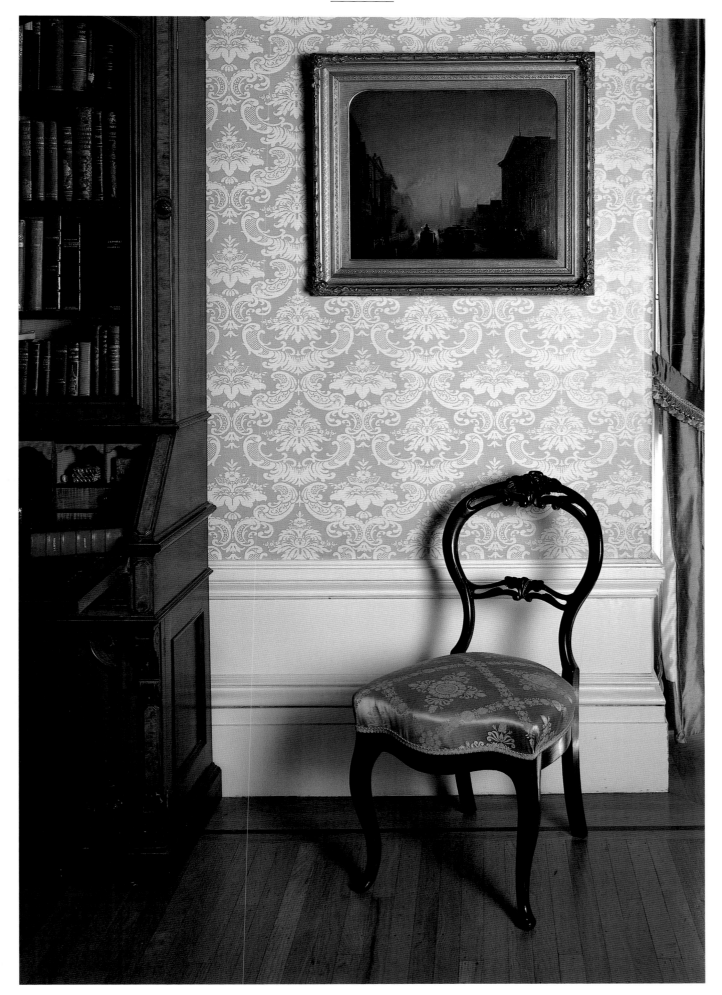

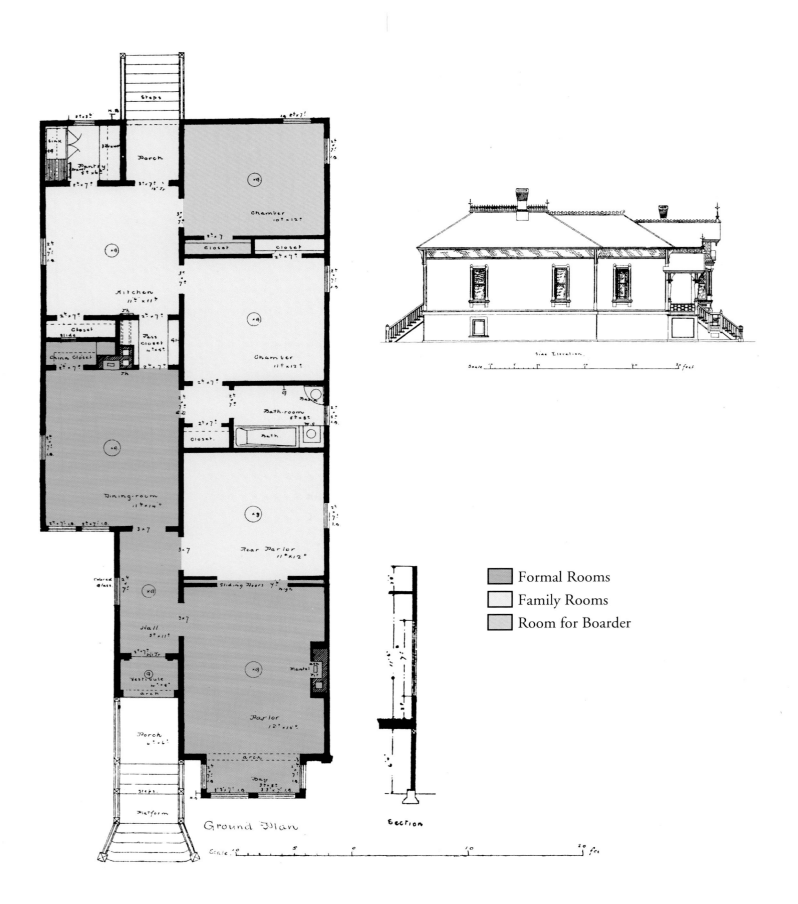

Formal Rooms
Family Rooms
Room for Boarder

Ground Plan

Section

Side Elevation

in the larger working class, did take part in a more general, even worldwide, shift in values that later commentators have dubbed "the cult of the home." As Howard Payne's opera, *Clari, the Maid of Milan,* phrased it in 1823:

> Mid pleasures and palaces though we
> may roam,
> Be it never so humble there's no place
> like home.

The rituals of family life in the Victorian age provided a sense of security in a rapidly changing world. The elaboration of the house inside and out gave comfort to families confronted with the unsettling changes inherent in industrialization, the rapid growth of immigrant populations, and the phenomenal expansion of cities like San Francisco. Home became the haven where men rested, a fortress shielded by fences, walls, drapes, servants, and etiquette. It was a nest, a place where time was supposed to stand still. Both the nest and its maker—the woman—were idealized, even exalted. The proper Victorian family sought to create a "moral home" centered on a predictable routine of daily life and Sunday worship in the family pew. Women ruled over this private world through a set of prescribed manners. "Home," "mother," and "wife" became highly sentimentalized. Books and magazines filled with "advice literature" instructed women, and through them their families, not only in how to behave, but in how to feel. Contemporary feminist historians are deeply interested in how Victorian domestic ideals, especially the cult of domesticity, both shaped and limited the world of the Victorian woman.

The Victorian cult of the home sought to make houses into temples, and familial love into something sacred. That Victorian hearths and overmantels took on something of the appearance of altars does not seem accidental.

The Victorian Christmas and New Year's Day

The cult of the home had its annual private celebration: Christmas morning. Christmas trees probably originated in Scandinavia and then spread to Germany. Prince Albert, Queen Victoria's German-born consort, introduced the Christmas tree to England in 1840. From there it spread to the United States, becoming more popular as the nineteenth century progressed. Santa Claus was brought to America by Scandinavian and German immigrants.

The interior of the yuletide house was decorated with fragrant greenery; candles were lit and a feast was set. The holiday became a child-centered celebration of gift giving and special foods. Christmas cemented family bonds and celebrated the Victorian dwelling. The old-fashioned American Christmas is yet another Victorian invention.

New Year's Day was devoted to the paying of brief calls on family and close friends. Each house offered light refreshments to the visitors. In 1854, *The Annals of San Francisco* described the first day of the year:

> All maledom empties into the streets—all ladydom remains at home. It is a gala day, a holiday, a day for polishing anew the chain of friendship and interlocking links of love. . . . The streets are full of joy in the persons of splendidly dressed men on their tour of friendship, acquaintance, or love. . . . Friendship goes on foot, aristocracy on wheels, love on wings. . . . New Year's Day [is] our mint to coin anew pleasant feelings, and turn into double-eagles the rough bullion of life.

The custom seems to have peaked in the 1870s. Historian John P. Young noted that "about the beginning of the Eighties it commenced to lose the stamp of fashionable approval." New Year's Day calls remained a popular institution for a while longer, but died out by the end of the century.

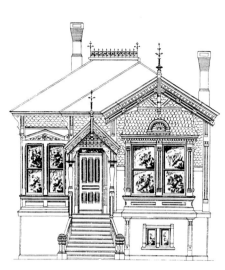

Front Elevation

A COTTAGE
The facade and floor plan of a one-story cottage with a back room suitable for a boarder. (Above and opposite)

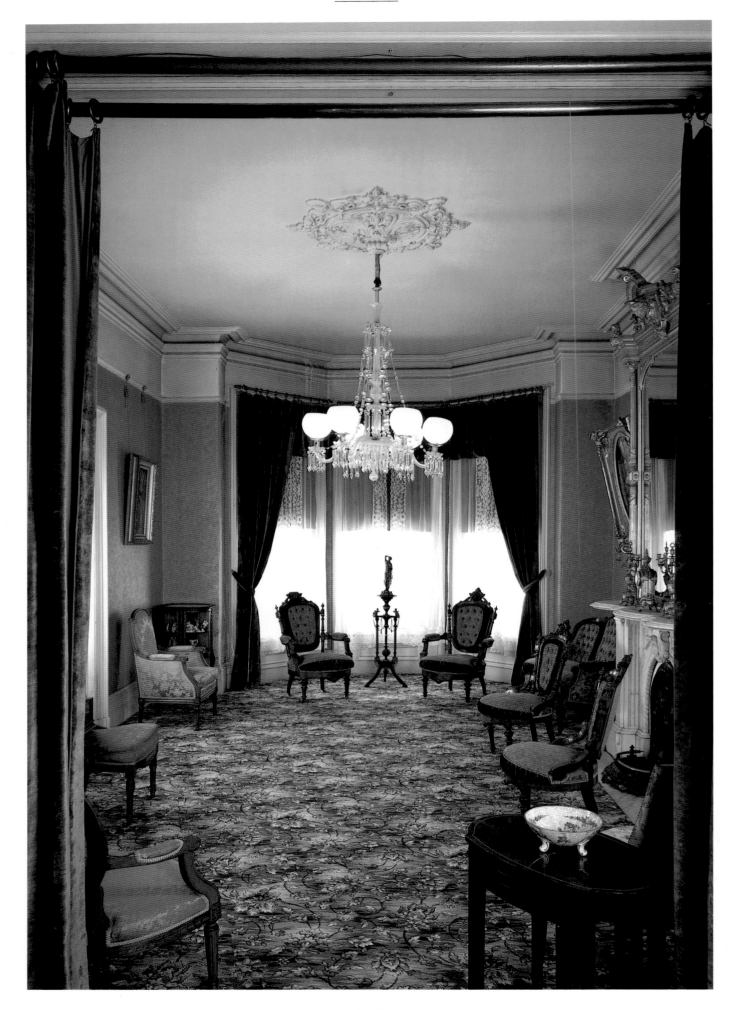

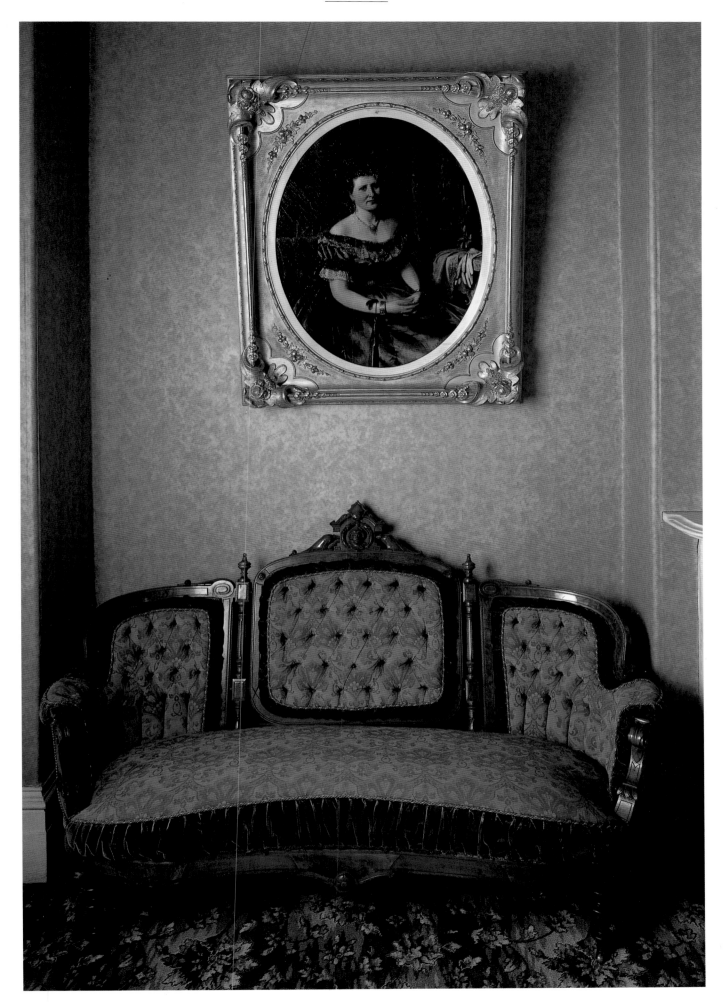

A FRONT PARLOR VIEWED FROM A CENTER PARLOR PORTIERE

This rare fly-in-amber Italianate parlor of 1875, built for forty-niner scale-and-safe importer Frank Tillman, has some of its original furnishings and carefully reproduced wall-to-wall English carpeting. The large bay window admits light and looks out over the sidewalk and street. Gaslight originally reflected from the gilt-framed mirrors at night.

Harriet Lane Levy wrote that "each piece of furniture lived under the observation of its double. A walnut armchair with seat and back of crimson brocade was here against the eastern wall and there against the western. A cushioned taboret [stool] stood on this side of the slender onyx table in the center of the room, and again on that side. Two long, high-backed sofas austerely regarded each other from opposite side walls; even the bronze chandeliers were twins." (Page 104)

PARLOR PORTRAIT

Victorian parlors cast a spell and set a tone. Here the grandmother of the owner of an 1875 Italianate home smiles serenely from the wall of her granddaughter's parlor. (Page 105)

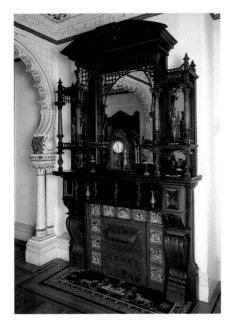

ELABORATE OVERMANTEL

This 1889 overmantel in the John Coop house, in the Mission District, is probably the finest surviving example of its type. Its woodwork has never been painted. Here is the Victorian hearth elaborated and made monumental.

A FRONT PARLOR WITH ORIGINAL WALLPAPER

A proper front parlor, dedicated to formal calls, signified membership in the middle class and made possible the Victorian rituals of sociability and urbanity.

The wallpaper and ceiling paper of this 1883 parlor are original, as is the painting on the ceiling medallion. Architect Joseph Gosling designed the Italianate-style Mission District house for British-born Frank G. Edwards, an importer of English carpets and wallpapers. The fireplace of white Italian marble is original, and the gilt-framed mirror is of the period. The present owners have laid fine pictorial Xinjiang carpets throughout the house. (Left)

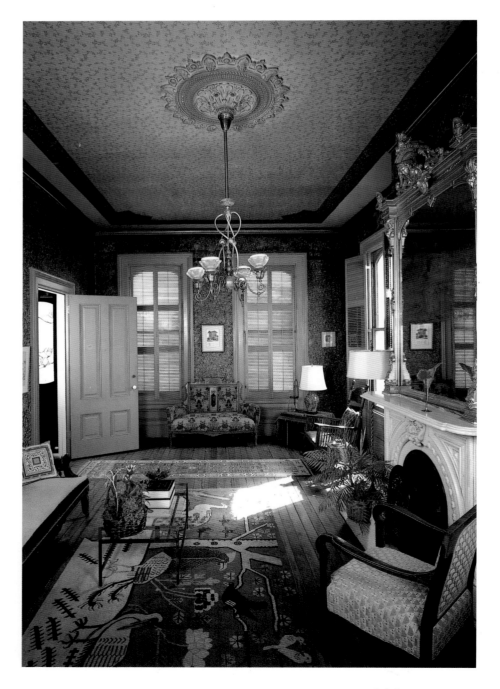

THE BLOSSOMING OF THE LATE-VICTORIAN OVERMANTEL

As Victorian interiors became filled with things, the single shelf of the early Victorian marble mantel gave way to elaborately subdivided turned-wood overmantels. In the nineteenth century, San Francisco households paid two types of taxes: property taxes and personal property taxes on such movable items as watches, jewelry, and furniture. In 1883 one-piece mirrored mantels were declared to be part of the building, not taxable personal property. These two 1884 drawings by the Newsom brothers show Eastlake-style late-Victorian overmantels.

AN ORIENTAL PARLOR

Rooms in grand houses became col-lections of exotic themes: Flemish, Renaissance, Moorish, Turkish, Japa-nese. This red lacquered overmantel is in the oriental parlor in Stanwood Hall at the Hamlin School, 2120 Broadway, in Pacific Heights. The building was designed by Julius Krafft in 1901 for James Leary Flood. Red silk embroidered with gold thread was used to line its walls and the ceil-ing was made of bamboo. (Right)

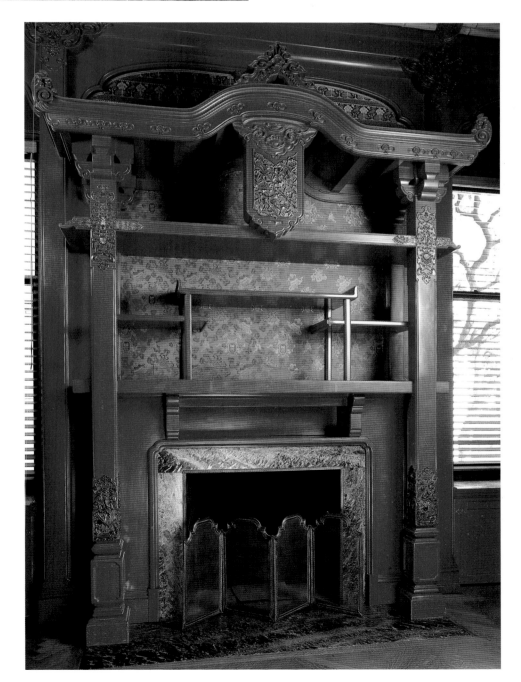

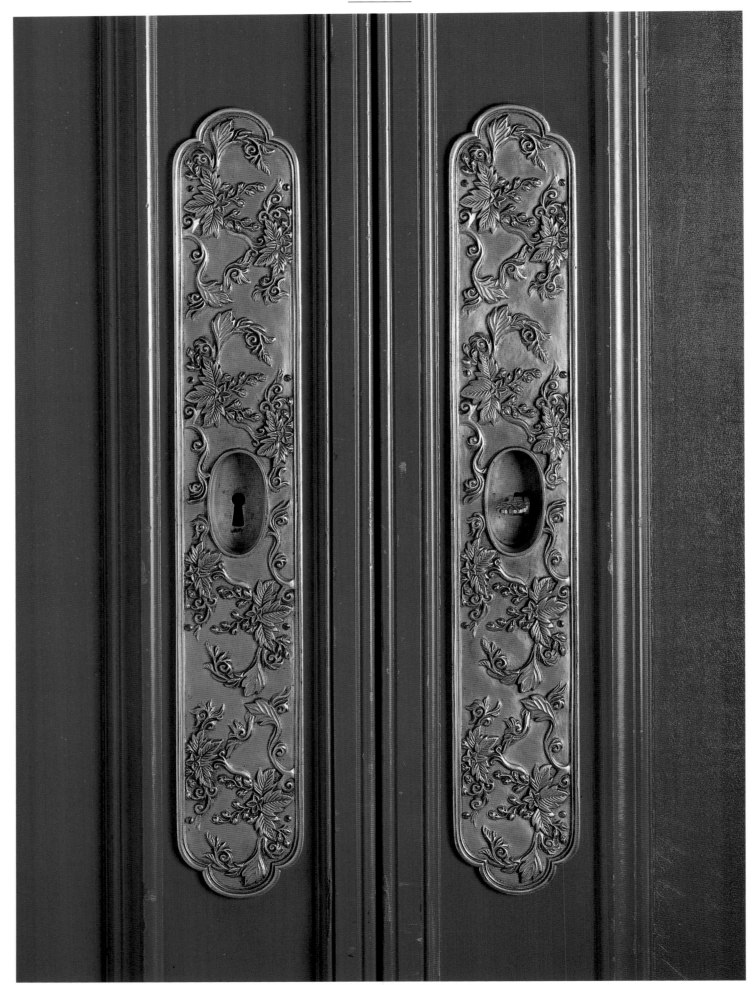

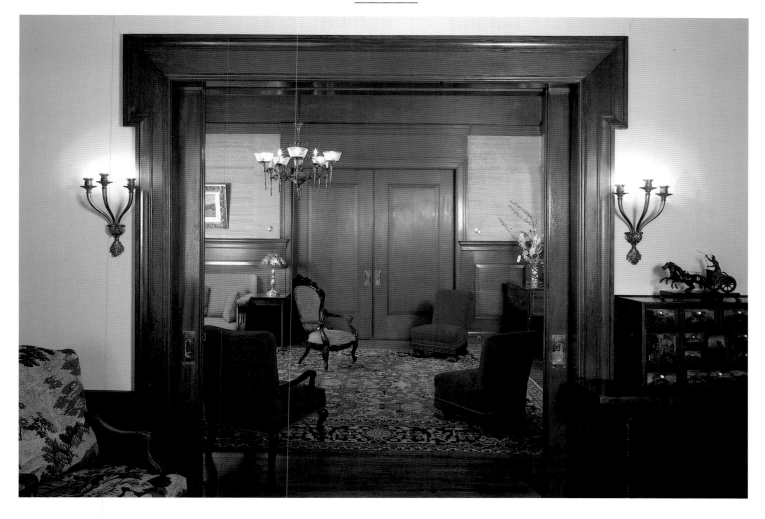

LIKE JEWELRY

The japanesque hardware on the pocket doors in Stanwood Hall's oriental parlor shows the perfection achieved in custom metalwork by the close of the Victorian era. The mansion was built for the son of a Nevada silver baron. (Opposite)

POCKET DOORS CLOSED AND OPEN

A view in the 1886 Haas-Lilienthal house, 2007 Franklin Street, in Pacific Heights, from the front parlor, through the center parlor, toward the closed pocket doors leading to the dining room. These doors are paneled in wide redwood boards. (Above)

A view in the Haas-Lilienthal house with center parlor doors to the dining room open. In 1890 the Newsom brothers wrote in their Picturesque Homes of California that "by throwing back the Sliding doors, the Lower floor of such a house can be made into one Large room—admirably suited for Receptions." (Below)

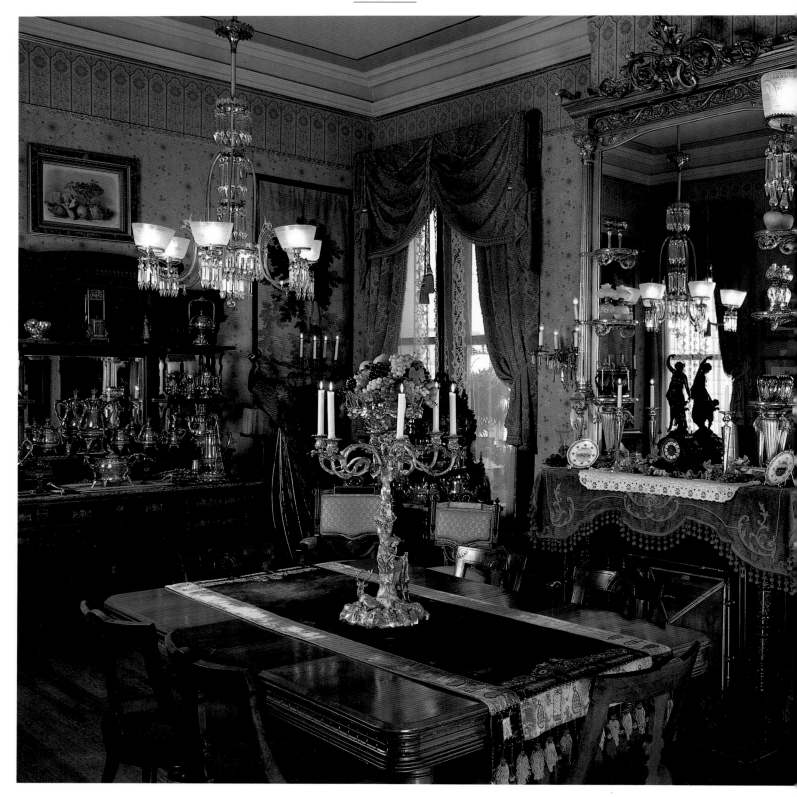

THE HIGH VICTORIAN DINING ROOM

Only the front parlor surpassed the dining room as a place of great importance in Victorian life. The dining room was the central stage, the heart of the theater. Here the family met each evening in genteel conversation, and here it put itself on display for its guests. Wealthy families displayed the massive silver and gold centerpieces they had commissioned from fashionable jewelers or had bought abroad. This Western Addition dining room boasts an impressive gold-plated silver candelabra from England.

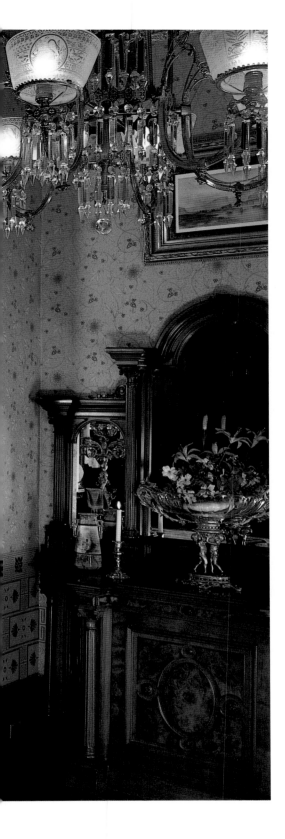

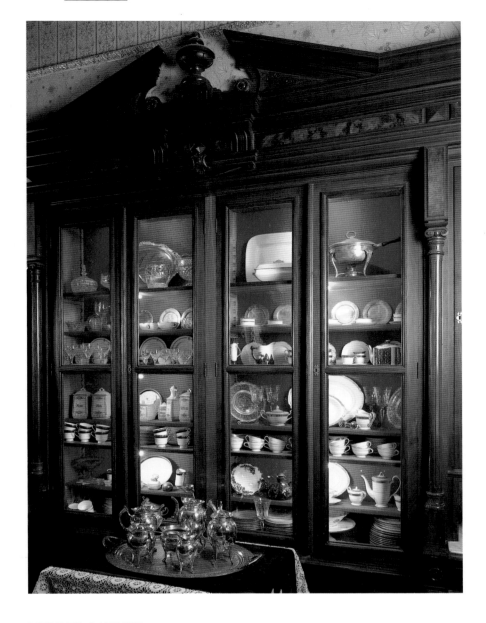

BUILT-IN CABINET
This built-in china cabinet stands in the dining room of the 1870s Western Addition house seen here. Each formal course had its own sets of china and cutlery.

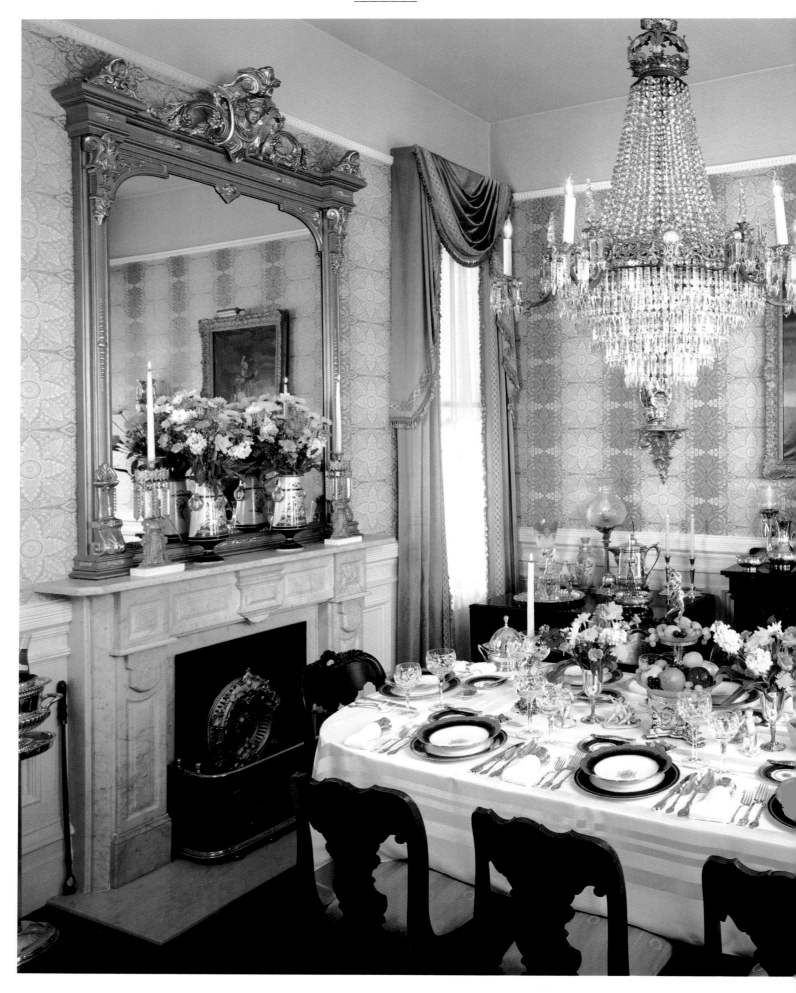

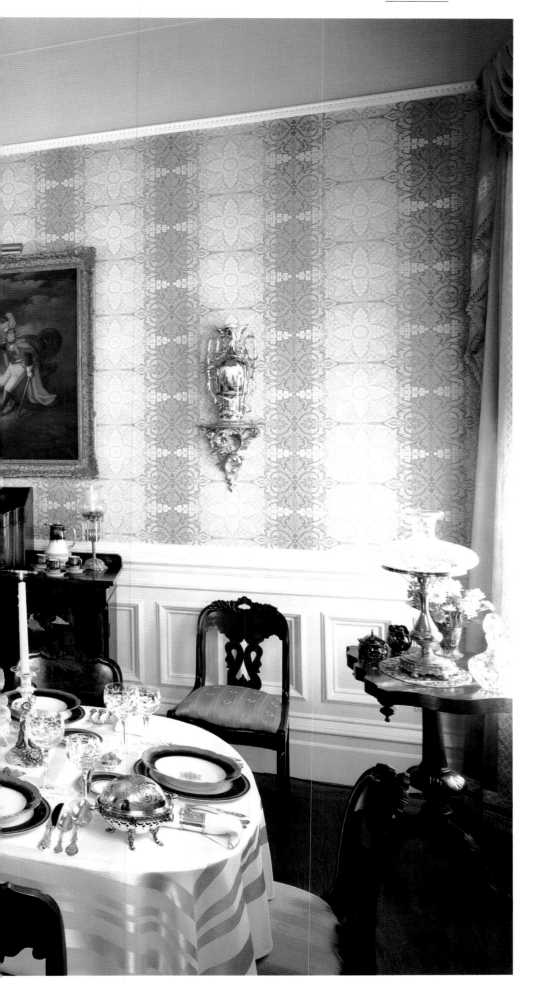

A DINING ROOM

The proper Victorian family gathered daily in the dining room for dinner. Sunday dinners drew members of the extended family. Elaborate meals were the summit of Victorian social intercourse. Gastronomy flowered. The novel Victorian practice of dining á la russe broke the meal into separate courses, each with its own china and silver.

The dining room in this 1884 Haight-Ashbury Italianate cottage orné captures the festiveness of the best Victorian interiors. Some of the flatware on the table was made in San Francisco from Nevada silver.

Stripped to the wood, the dining table was where the master of the house read or wrote letters if there was no library. Children did schoolwork there as well.

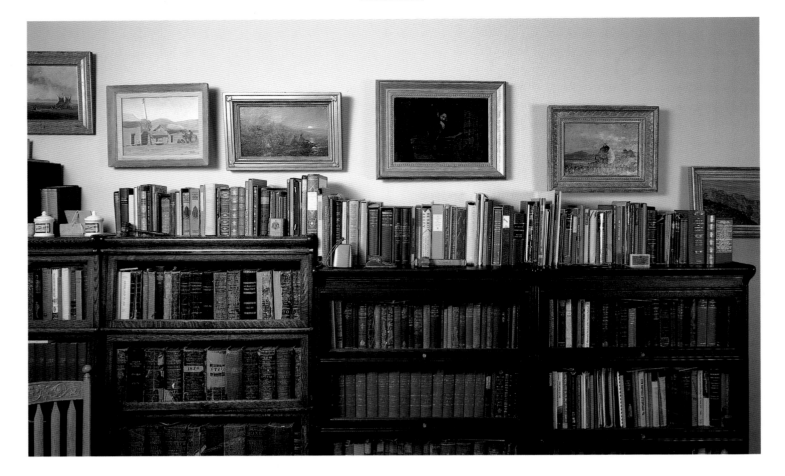

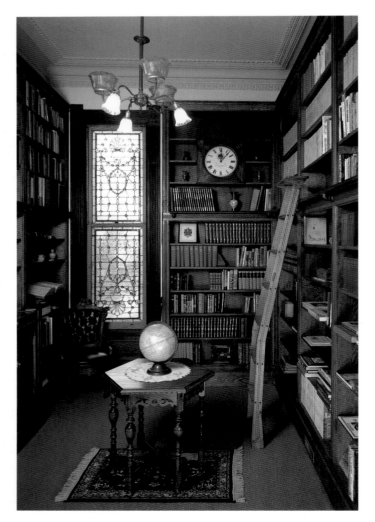

BOOKS AND MEMORIES

*A rare collection of San Franciscana.
Books, early paintings, and, in the
glassed-in bookcases, early San Fran-
cisco city directories fill a room in a
Western Addition Victorian. (Above)*

A LIBRARY

*In the Victorian age the library was
essentially a man's domain, his
retreat within the well-furnished
house. Here the father relaxed, read,
and wrote. Here too reposed Web-
ster's dictionary, a key book in Amer-
ican Victorian life. The home library,
with its accumulation of books and
picture magazines, was a window on
the world. The elite built opulent
libraries and used them as places
from which to conduct important
business. It was in the library that
family affairs were conducted, from
reprimanding a child to instructing a
servant. This is the library in an 1889
Mission District house. (Left)*

A CONSERVATORY

The conservatory often opened off the morning room on the sunniest side of the house. Here Victorians cultivated ferns, palms, and colorful flowers brought from around the world. Light wicker furniture blended with the plants. Conservatories and greenhouses abolished the seasons and let orchids bloom the year around in chilly San Francisco. (Right)

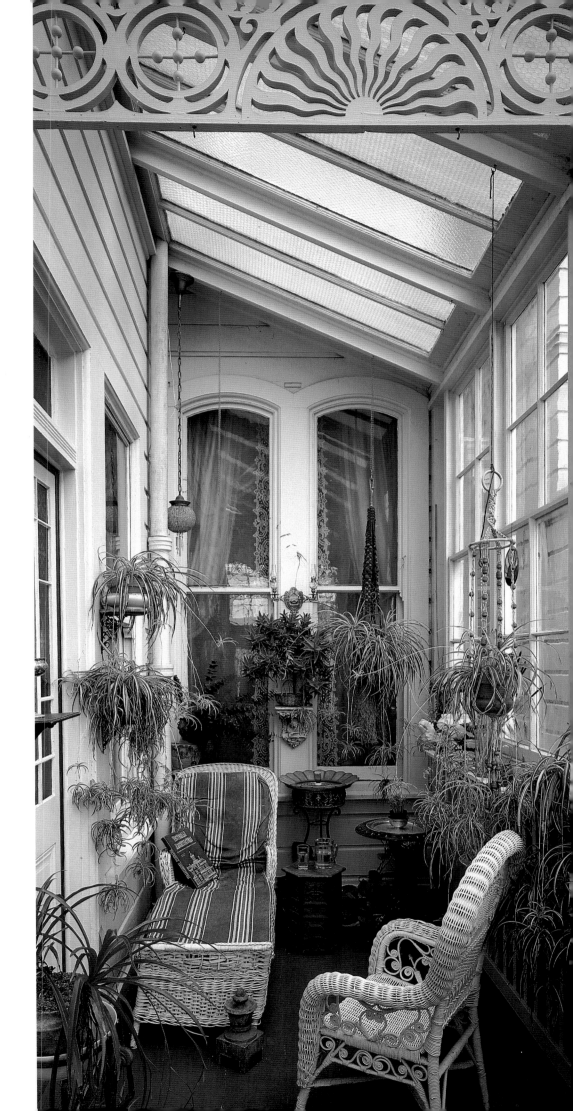

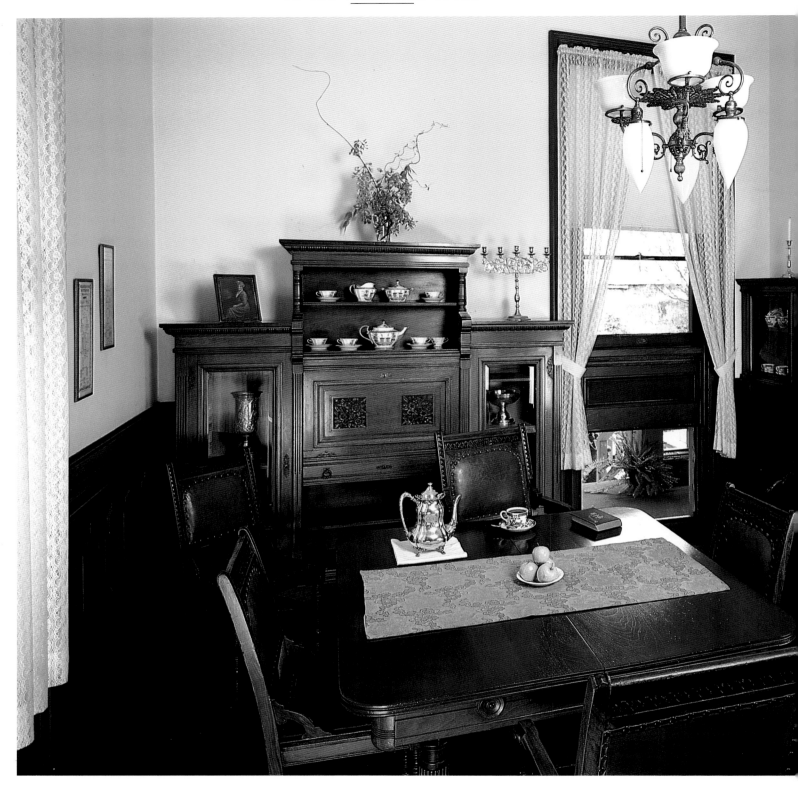

A BREAKFAST ROOM WITH A JIB DOOR

The 1886 Eastlake interior of the breakfast room of the Haas-Lilienthal house is paneled with American walnut and has its original built-in cabinets, table, and chairs. In this photograph the jib door-window is open, giving onto the back porch. It was useful for moving furniture into and out of the back of the house.

A BACK PARLOR

The family most often gathered in the center, or family, parlor. Sometimes it was called the music room, because in it sat that modern marvel, the piano. Furniture was comfortable here. "Cozy corners," places with couches and chairs set in intimate groupings, were features of the center parlor. Here is the back parlor of a Western Addition house. (Opposite, above)

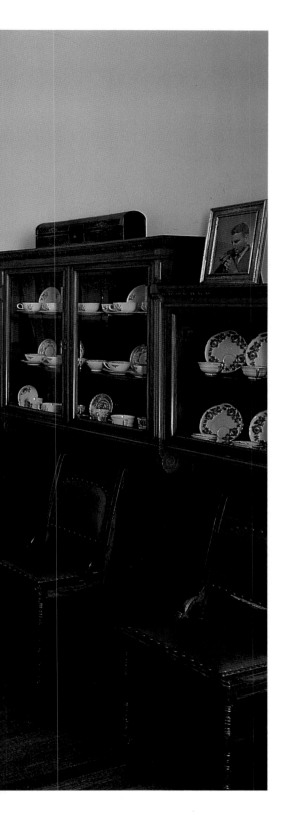

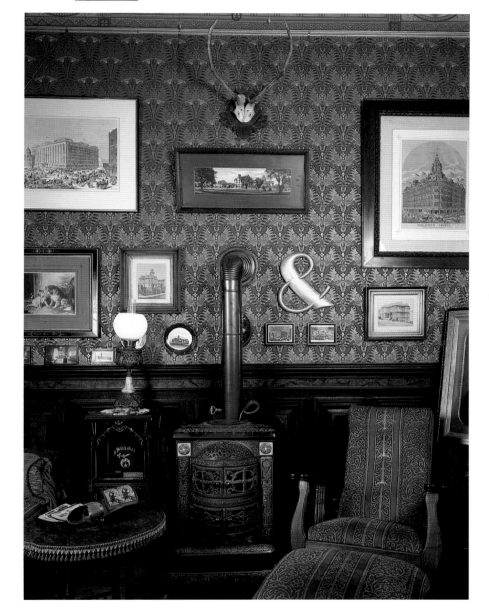

HOME COMFORTS

Not all Victorian furnishings were stiff and formal; some were the first modern comfortable furniture. Bentwood furniture, including light and graceful rocking chairs, was exported around the world by Thonet's Vienna factory throughout the last half of the nineteenth century. (Right)

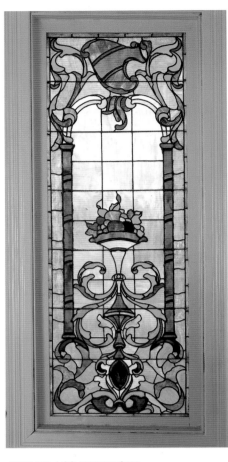

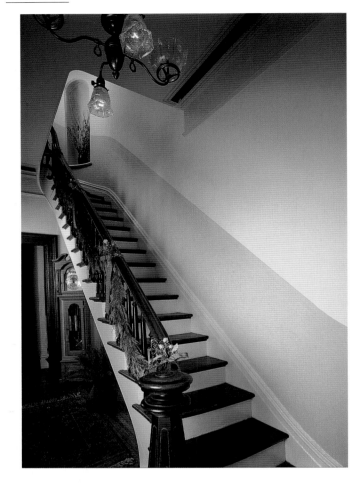

ART-GLASS WINDOW
Staircases often had stained- or
art-glass windows to obscure views of
the neighbors. This is a staircase art-
glass window in an 1889 Queen
Anne house in Pacific Heights.
(Above)

TYPICAL FRONT STAIRS
The front stairs inside this 1876 West-
ern Addition Italianate home are
decorated for Christmas. A tall case
clock with Westminster chimes stands
in the distance. The niche at the turn
in the stairs was often occupied by a
bronze sculpture. (Right, above)

TOP OF THE STAIRS
From the top of the stairs in this 1883
Italianate house there is a very San
Francisco glimpse of the flat rooftops
and metal chimneys of the Mission
District. The fog is moving in,
in patches. (Right, below)

A GRAND STAIRCASE·
This cascade of stairs was added to
an 1875 house by architect Henry
Geilfuss in 1904, when the house was
moved and expanded. Its wall-to-wall
carpet is typical of mid-Victorian floor
coverings. (Opposite)

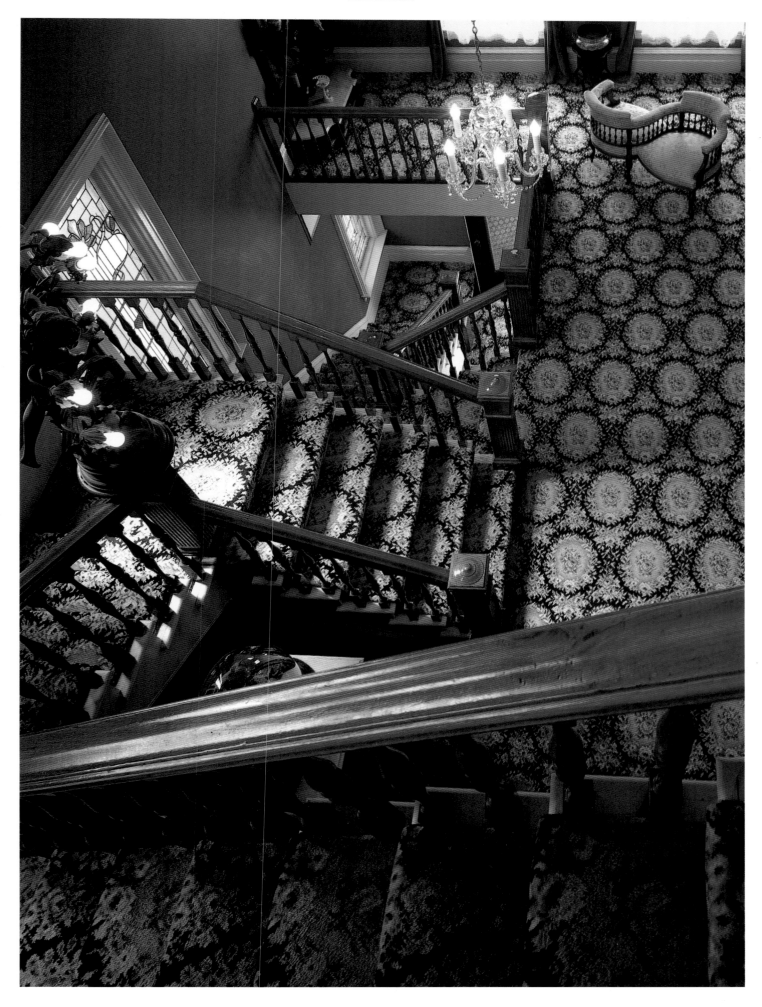

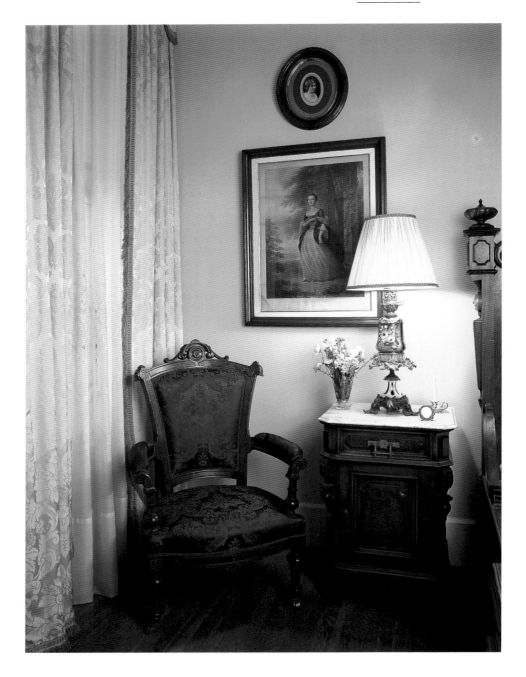

THE VICTORIAN BEDROOM
Victorian bedrooms often had a comfortable upholstered chaise or chair in the corner. Here is an 1870s purple silk-damask upholstered chair and a marble-topped 1870s night table in an Italianate house.

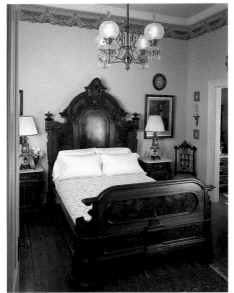

AN 1870S BED
Bedroom furniture was designed en suite, as a matched set of bed, night tables, wardrobes, chairs, dressing tables, and washstands. This 1870s American-made walnut bed is in an Italianate house.

A CHINESE-STYLE BEDROOM SET
The bedroom can be simply a sleeping place, or it can be a private sitting room with a bed in it. The fashionable world elaborated the bedroom and its furnishings in the Victorian period. This American-made half-tester bed and desk in the Chinese style probably date from the 1880s. San Francisco felt the pull of Asia in its household decoration.

Four-poster beds were succeeded by half-tester beds; they were considered healthier. Married couples shared massive double beds. The great bed was the altar of middle-class family life. Harriet Lane Levy remembered that, as a little girl, "the bed, dressed, was unapproachable in its ceremonial stateliness. It stood there, an object so fixed that daily experience with its morning disarray could not interfere with its later illusion of a permanent dignity." Here women gave birth and parents died surrounded by family. (Opposite, below)

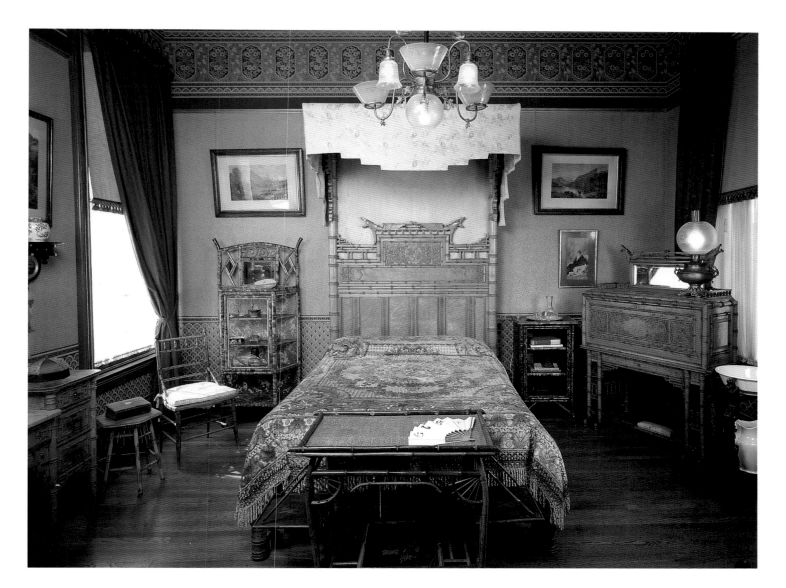

A SECOND-FLOOR CORRIDOR

The comfortably decorated second-floor corridor of the Spencer house, in the Haight-Ashbury, has never had its fine, warm-colored woodwork or Lincrusta-Walton wainscot painted. The lighting fixtures were originally gas and electric combined.

ABUNDANT WATER
Hot and cold running water were Victorian innovations. They made a revolution in personal hygiene possible and meant healthier, longer lives. (Right)

BATHROOM
Large bathtubs filled with warm water made bathrooms oases of grooming and relaxation. (Right, below)

TIME STANDS STILL
A lady's bureau top in a lovingly preserved San Francisco Victorian displays heirlooms, including a hairbrush, a mirror, a comb, powders, and a portrait by society photographer Arnold Genthe. (Overleaf)

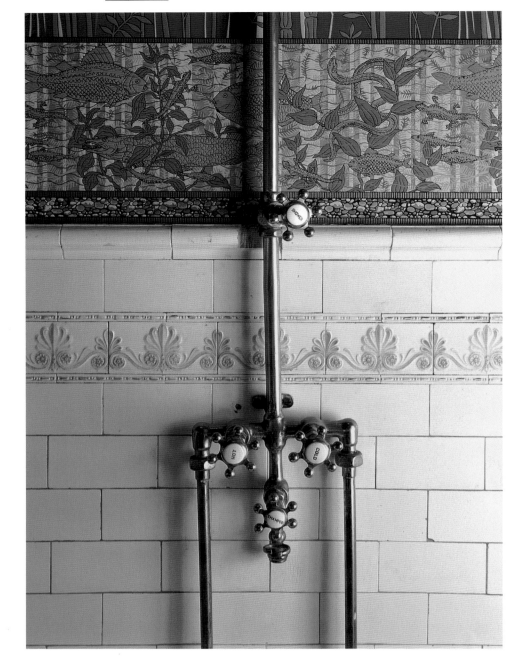

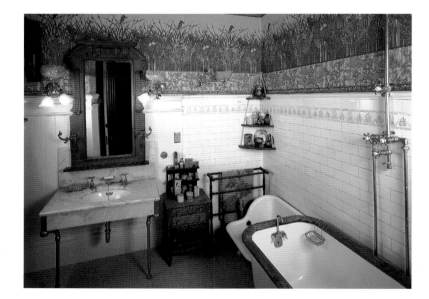

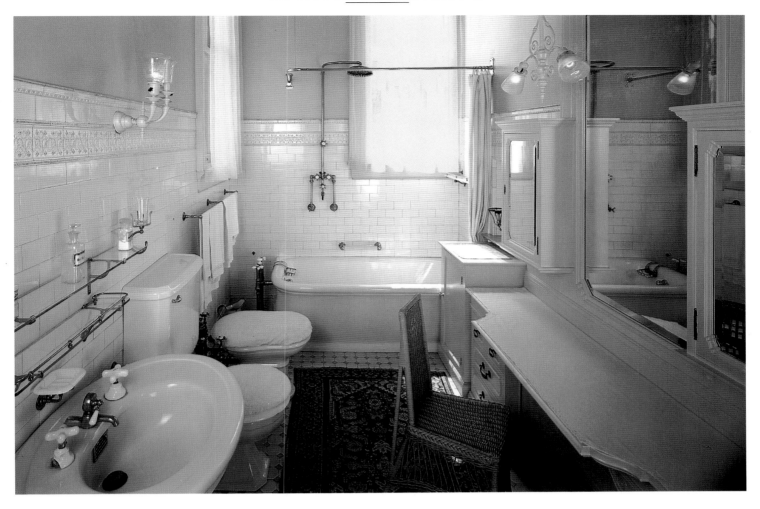

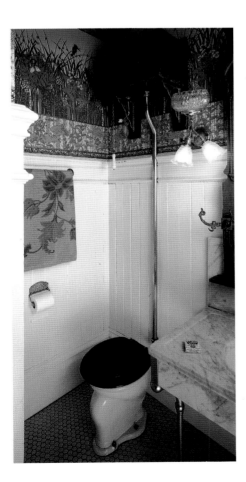

WHITE TILE

The beautifully tiled bathroom in the Haas-Lilienthal house was installed in 1886. The porcelain tub and bidet are probably original, the toilet is modern, and the sink is probably Edwardian. Early showers had huge "sunflower" shower heads. (Above)

VICTORIAN FIXTURE

Water companies and municipal sewers made the modern hygienic bathroom possible. Water-flush toilets were adopted more quickly in the United States than in Europe. This is a rare original toilet in a Western Addition Italianate. The fine aquatic-themed wallpaper by Bradbury and Bradbury is modern. (Left)

MARBLE SINK

The Victorians invented modern plumbing and hygienic fixtures. When simply executed, these pieces are among the best of nineteenth-century designs, functional yet graceful. This is a drawing of a marble, porcelain, and metal sink with hot and cold running water. It dates from the late nineteenth century.

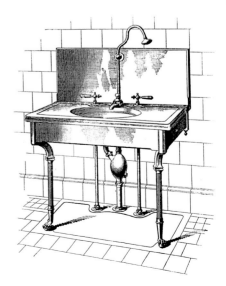

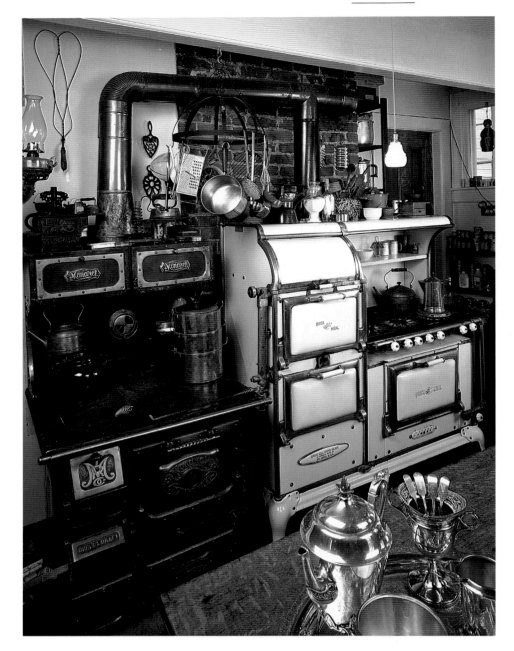

KITCHEN RANGES:
FROM COAL TO GAS

Kitchens are the rooms that have changed most drastically over time in Victorian houses; no original kitchens remain. Here a coal range from the 1870s sits next to a working white-enameled gas range from the 1920s. (Left)

THE BUTLER'S PANTRY

The butler's pantry in the 1886 Haas-Lilienthal house. There is a water filter on the shelf in the far corner. Very few houses had butlers, but that name was given to the pantry where china and glass were stored. The family silver was usually kept in a vault upstairs. (Above)

A COAL STOVE

Cast-iron stoves were important Victorian consumer goods. This coal stove was sold in nineteenth-century San Francisco.

NAPKIN RINGS
A collection of silver Victorian napkin rings in a Haight-Ashbury kitchen. (Above)

THE BACK STAIRS
The back stairs of this Queen Anne house, in the Haight-Ashbury, gave servants access to the various floors from the rear of the house. Back stairs were strictly for family and servants, never guests. (Right)

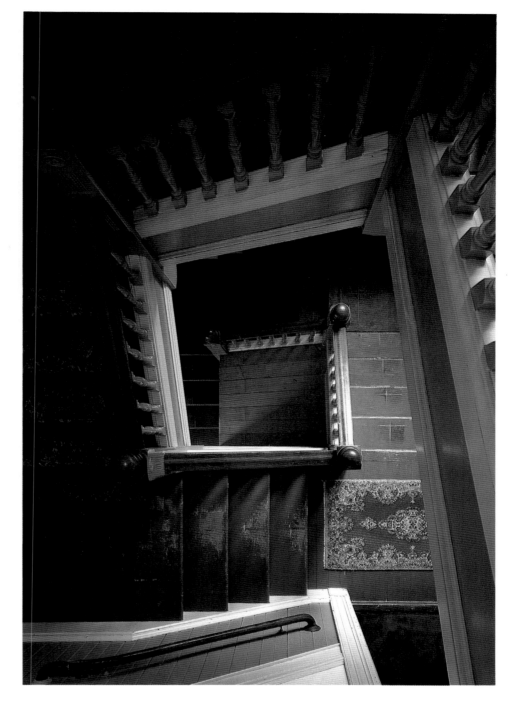

THE KITCHEN SINK
Two Victorian kitchen sinks, one of iron and one of cast iron and porcelain. Kitchen fixtures were sturdy and often surprisingly modern-looking Victorian designs.

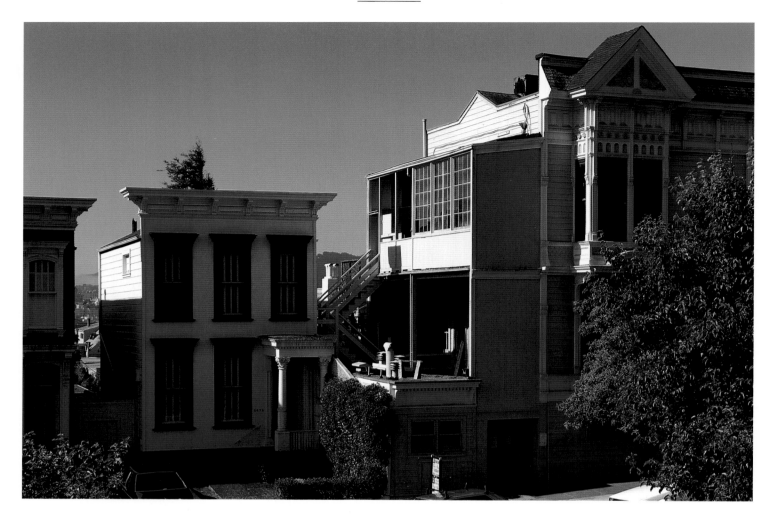

BACK PORCHES

The back of the Victorian house at 2140 Pierce Street, at Clay, has typical shed porches used for washing and storage. These extensions are original to the house, which was built by Michael J. Welsh in 1892.

8

Building and Servicing
the Victorian House

BUILDING AND SERVICING
THE VICTORIAN HOUSE

THE CABLE CAR

The new hill-conquering technology of the cable car, introduced in San Francisco in 1873, allowed the city to expand and to climb its steep encirclement of sand hills. Cable-car lines, sewers, and water mains pulled the city west away from the congested core. As one observer noted in 1902, street railways "aid a large fraction of the people in continuing the practice,

so characteristically American, of living in independent houses instead of tenements."

In San Francisco today, cable cars pass Victorian-style houses along only one block, the 2600 block of Hyde Street, between Bay and North Point streets. This Queen Anne–style row was built in 1902 by the Rivers brothers. (Opposite, above)

VICTORIAN UTILITIES

Cutaway view of the roadbed, cable-car system, and sewer in San Francisco in the 1880s. (Below)

THE CABLE CAR CITY

The cable-car and streetcar network in San Francisco in 1895. (Opposite, below)

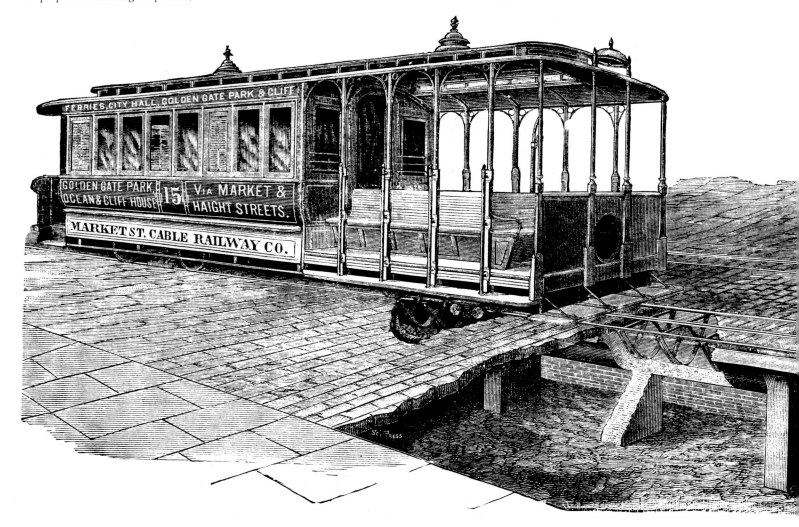

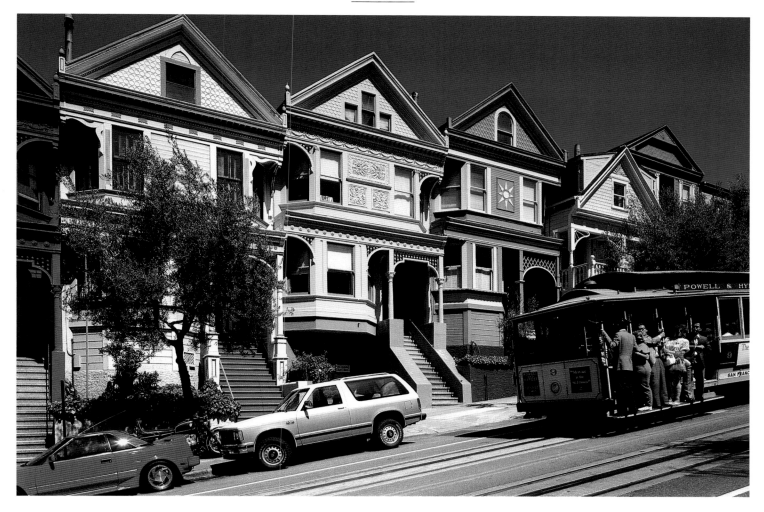

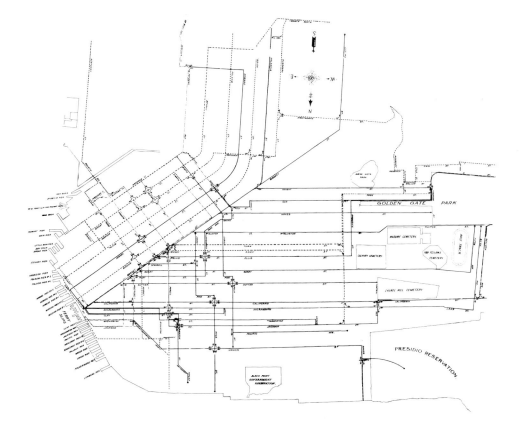

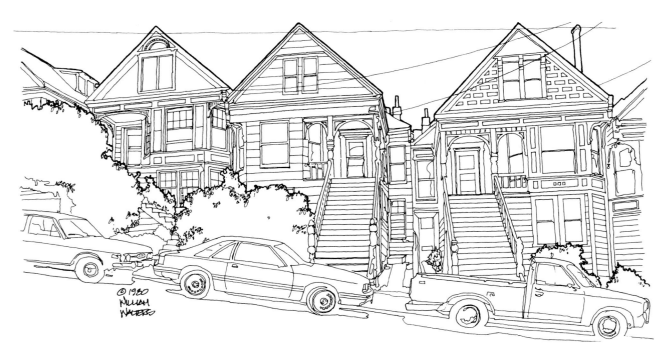

© 1980
William
Walters

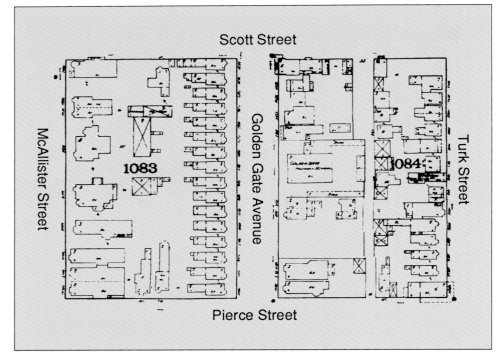

Scott Street

McAllister Street

1083

Golden Gate Avenue

1084

Turk Street

Pierce Street

COTTAGE ROW
The slot between 1890s Queen Anne
cottages on Liberty Street, above the
Castro District.
William Walters

*TWO VICTORIAN
BLOCKS*
Adapted from an 1886 Sanborn
insurance company map, this closeup
shows two Western Addition blocks.
A sixteen-house-long row stood on
Golden Gate Avenue, between Pierce
and Scott streets. (Left)

PACKING THEM TOGETHER
A freestanding corner mansion, a
large double-lot house, and a stan-
dard twenty-five-foot-wide row house
with a slot, a recess that allows light
and air into the front of the house.

Three row houses showing how the
slot allows light and air into the cen-
ter of the house. A service alley passed
under the projecting dining room bay
to give street access to the backyard.
(Right)

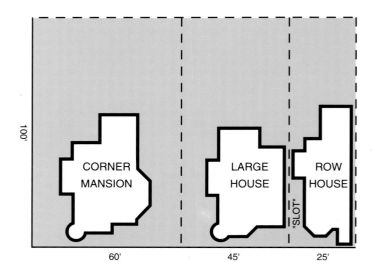

100'

CORNER
MANSION

LARGE
HOUSE

ROW
HOUSE

"SLOT"

60' 45' 25'

TWO FACING SLOTS

The slot between two two-story Victorian houses on Webster Street, in the Western Addition. The paired service alleys passing under the side bay windows to the backyards are here refreshingly landscaped with shade-loving ferns and a graceful fern tree. The fine cast-iron fence post and wrought-iron gates are rare survivors. The slot appears to be a feature unique to San Francisco row houses.

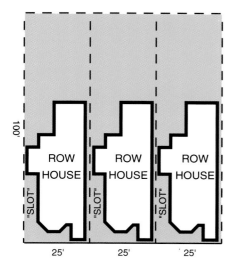

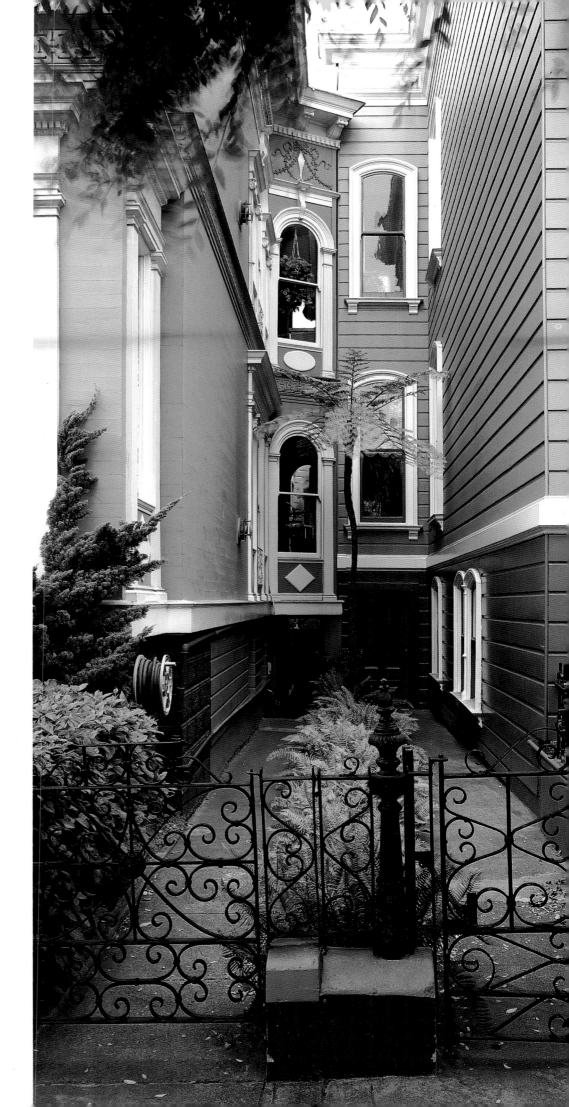

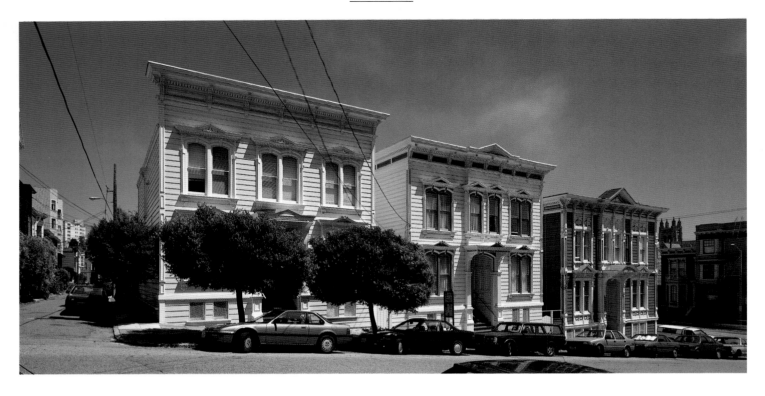

THREE BOXES IN A ROW

The 2000 block of Pierce Street, in Pacific Heights, has this fine cluster of taut Victorian clapboard boxes set in a stepped row. The two pairs of flats on the left are flat-front Italianates built in 1875. The flats building on the right is another flat-front Italianate, a bit fancier in its trim; it was constructed by owner-builder Thomas Rendell and dates from 1882. (Above)

NEW MACHINERY

An engraving of a woodworking machine used in San Francisco in the 1880s. (Left)

THE BASIC WOODEN BOX

This small cottage at Twenty-third Street and Mersey, in Noe Valley, shows the simple redwood box with an ornamented false front—the basic Victorian dwelling. (Left, below)

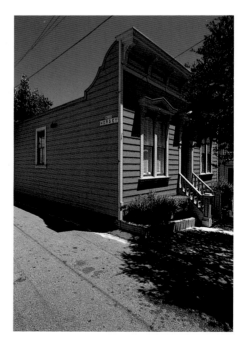

THE BALLOON FRAME

The balloon frame was invented in booming Chicago in 1832 and is credited to George Snow. It consisted of lightweight milled lumber (two by fours) that could be quickly nailed together rather than mortised and tenoned. One wit is said to have declared that Snow's frame made house building as easy as blowing up a balloon. This isometric perspective view of the balloon frame is from Woodward's Country Homes of 1865. The balloon frame made house building faster and cheaper. (Below)

WALLS: STUDS, LATH, AND PLASTER

The attic of the 1861 Octagon house at 2645 Gough Street, at Union, in Cow Hollow, reveals typical wall construction of studs (the vertical timbers), redwood lath (the narrow horizontal boards), and a plaster finish. Smooth, hard plaster was a great aid in sanitation, as it sealed rooms against vermin and drafts. The attic door is a simple four-panel design bought from a mill. The stair railing has an almost Shaker simplicity. Oregon pine was typically used for floors. (Right)

THE BACK OF THE HOUSE

The frame house was a thing of beauty in the hands of Victorian architects and carpenters. The back of the 1886 Haas-Lilienthal house at 2007 Franklin Street, in Pacific Heights, has three kinds of exterior surfaces. Rusticated clapboard is used on the first floor, shingles set in narrow bands cover the second floor, and fancy fish-scale shingles decorate the attic gable. There is an upward transition toward fineness in the design. Pronounced cornices visually separate the floors. It is typical in San Francisco to paint various surfaces the same color, as is done here. The lighter color of the window frames and woodwork is a contemporary, not a Victorian, touch. (Right, below)

WOOD SIDING

Three kinds of clapboard siding: left, ordinary clapboard; center, rusticated clapboard; right, shiplap siding. Rusticated clapboard siding was favored in San Francisco. The curved groove had an important purpose. Moisture on such a wall slides down the surface and drips over the gap; it does not enter the crack between the boards. (Below)

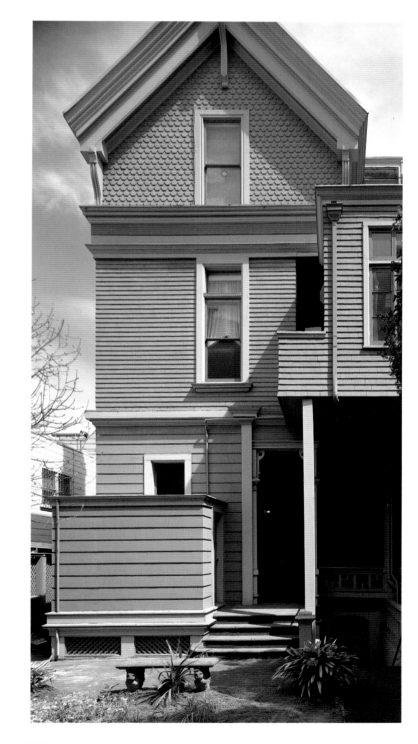

Clapboard Rusticated Siding Shiplap

SUNBURST BRACKETS

Machines were invented that could copy and reproduce endlessly in redwood all kinds of decorative ornament. This very fine fancy Victorian millwork is on an 1890 flats building at 1938–40 Scott Street, in the Western Addition, designed by John H. Littlefield. It is painted in a traditional light-softening off-white. Victorians themselves reserved strong colors for the bright flash glass, the vividly colored red, blue, and yellow small rectangular panes sometimes used around large upper-window panes. (Right)

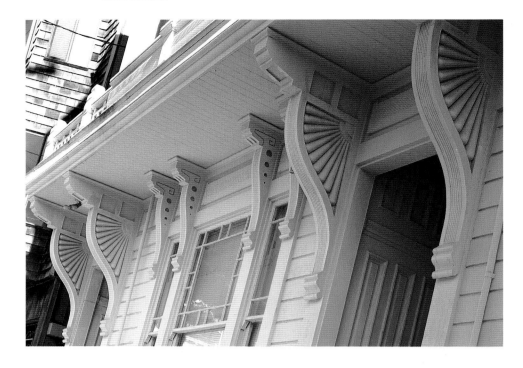

FINE INTERIOR WOODWORK

Honduran mahogany was custom milled for the banister of the John Coop house designed by Henry Geilfuss in 1889. The Victorians drew on the world for fine building materials and imported appliances, tile, and the like. This is probably the finest surviving banister in San Francisco. (Opposite)

ONE THIRD OF EXHIBIT OF PACIFIC SAW MANUFACTURING CO. AT MECHANICS INSTITUTE FAIR 1884

CATALOG BRACKETS

Designs for cornice brackets from a pattern book of the 1870s. Much joy and fancy is expressed here. (Below)

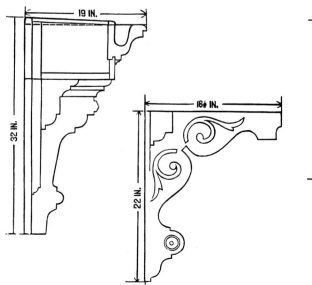

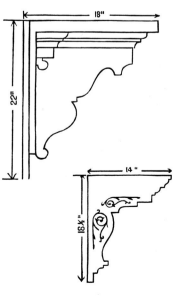

SAWS, SAWS, SAWS!

"Saws, saws, saws innumerable. The display of saws by the Pacific Saw Manufacturing Company forms one of the most beautiful and interesting exhibits in the [Mechanics'] Fair. . . . they have brought the manufacture of saws in San Francisco to a degree of perfection which challenges the world in competition, from the heavier circular, mill, hand, and other large saws, down to the finest and most delicately toothed blade."

So reported the California Architect and Building News in September 1882. A giant collage of saws depicted ornamented row houses, trees, and a comet-streaked starry sky.

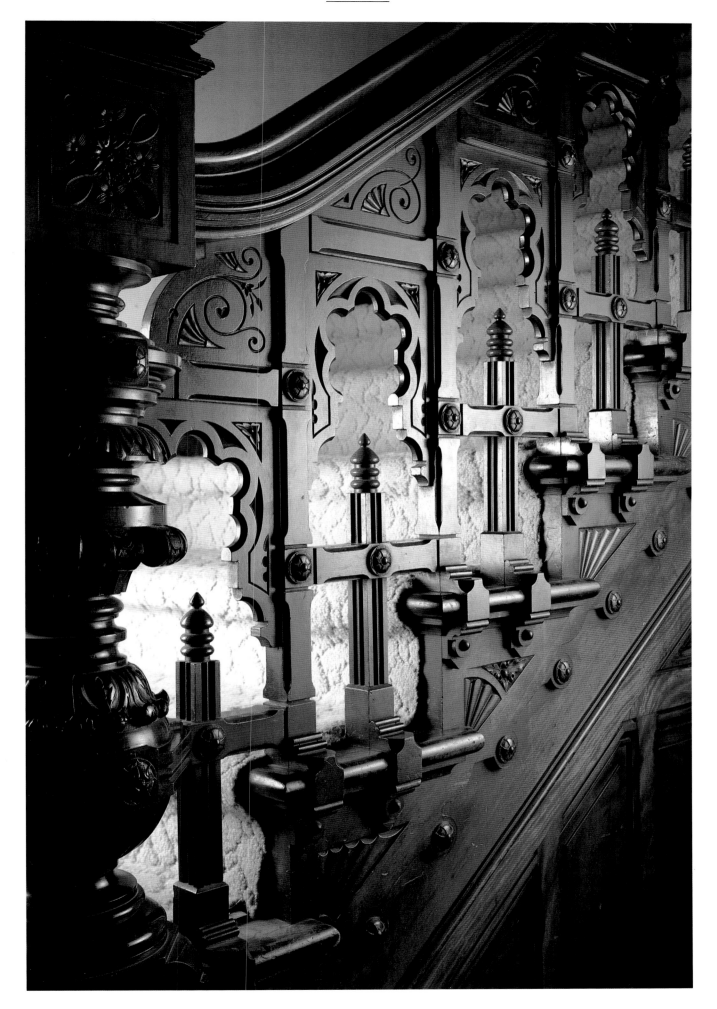

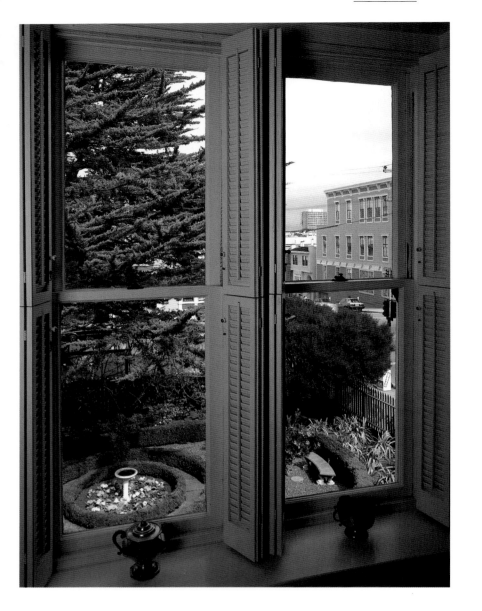

THE DOUBLE-HUNG SASH WINDOW

Early windows tended to be strongly vertical, such as this fine pair on the second floor of an 1861 Octagon house. White-painted interior wood shutters are one of the most practical San Francisco window dressings.

The double-hung sash window with two lights, or panes of glass, was one of Victorian San Francisco's finest products. Using redwood and other lumber from California's north coast, busy mills in the city made countless modern windows that easily stayed opened or closed because of cast-iron weights built into the frames. In San Francisco the overwhelming preference was for simple windows. Window panes subdivided into small panes were not usual. Large sheets of glass, now affordable for the first time, were set in narrow wood frames, the sashes. The sturdiness and simplicity of double-hung sash windows made them one of the unheralded innovations of the Victorian era. Restrained proportions and fine molding made Victorian windows very handsome. (Below)

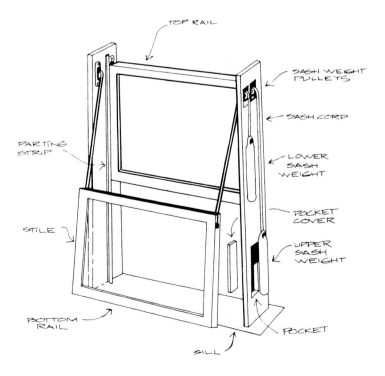

TOP RAIL

SASH WEIGHT PULLEYS

SASH CORD

PARTING STRIP

LOWER SASH WEIGHT

POCKET COVER

STILE

UPPER SASH WEIGHT

BOTTOM RAIL

POCKET

SILL

1860-1875
ITALIANATE

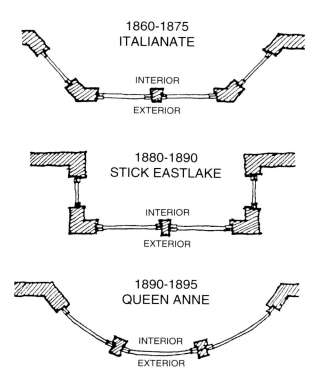

INTERIOR

EXTERIOR

1880-1890
STICK EASTLAKE

INTERIOR

EXTERIOR

1890-1895
QUEEN ANNE

INTERIOR

EXTERIOR

CHANGING SHAPES

Italianate, Eastlake, and Queen Anne bay windows in a section view. San Francisco was known as the "bay window city" in the nineteenth century. Roughly speaking, each decade saw its own variation on the theme. Italianate windows were slant-sided. Eastlake windows pushed out farther and became rectangular, capturing more space. In the 1890s, suave, costly semicircular bays with curved glass panes were invented. The photographs show the three kinds of Victorian bay windows.

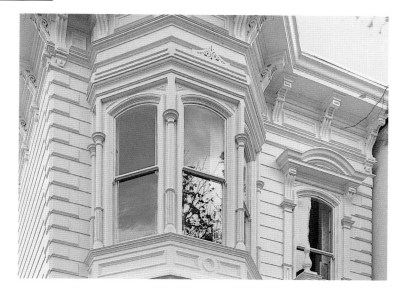

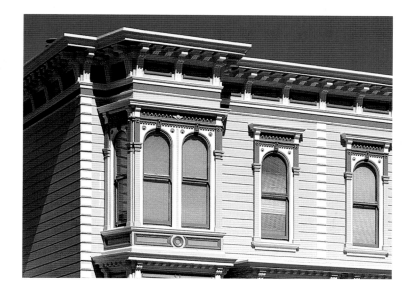

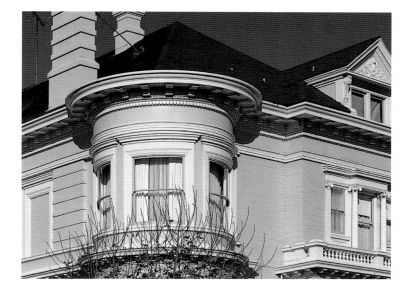

PLASTERWORK
A fine reproduced plaster medallion on the exterior of 1859 Scott Street, at Pine, in the Western Addition. (Above)

PLASTER MOLDS
Molds for plaster ornaments. (Above, right)

EXTERIOR PLASTER
The fine Queen Anne building at 1859 Scott, at Pine, was designed by Colley and Lemme in 1893. Restored in the late 1980s, it has fine modern cast-plaster ornaments. Queen Anne Victorian buildings often turned corners in an assertive manner. (Right)

INTERIOR BRACKETS
Female and male cast-plaster brackets. (Below)

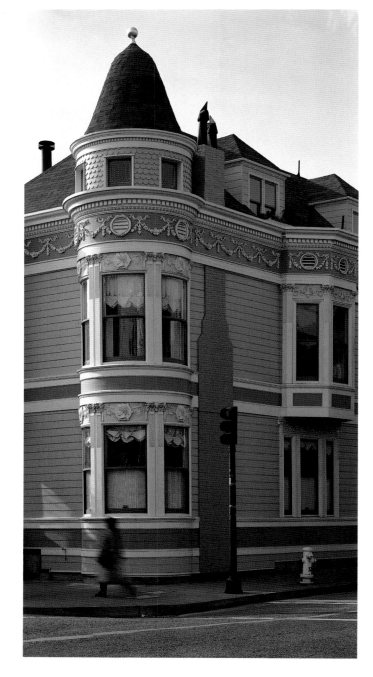

INTERIOR FINISH: PAINTING, GRAINING, VARNISHING, STENCILING, AND WALLPAPERING

The Hueter brothers' S.F. Pioneer Varnish Works was on Starret between Twenty-third and Twenty-fourth streets; its showroom was in the Grand Hotel at 601 Market Street, near Second Street, on the Victorian city's main stem. (Right, above)

CEILING PAPERS

A rich, unique survivor. This is the original ceiling paper, probably English, in the 1883 parlor of Frank G. Edwards, importer of English carpets and wallpaper. Through the foresight of the owners, The Foundation for San Francisco's Architectural Heritage holds a protective easement on this room to prevent the destruction of its rare Victorian features. (Right, middle)

WOOD GRAINING

Tools used for graining, the painting of inexpensive wood to look like costly hardwoods. (Below)

WAINSCOT DESIGN

A diaper pattern for stenciling on the wainscot of a wall. (Right)

EMBELLISHMENT

Stenciling patterns for Victorian interiors. (Far right)

VICTORIAN HARDWARE
A hinge, doorknob, and keyhole surround in an 1883 Haight-Ashbury Eastlake. (Above, left and right)

DECORATIVE WORK
Fine metalwork was a Victorian specialty. W. W. Montague & Company, on Market Street, offered fine decorative pieces for modern "household art rooms." (Left)

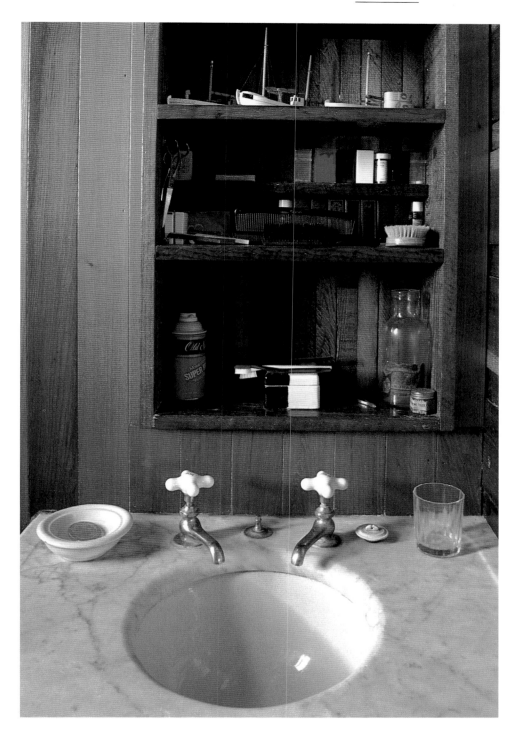

CLEAN DESIGN

New manufacturing processes made large ceramic pieces possible. The fully equipped Victorian bathroom, plain and functional, was the most modern environment in the house and was the one room that offered complete privacy, since it could be locked from the inside. As with industrial and clinic design, it was often clean and elegant. This bathroom has all the modern conveniences.

SIMPLE SINK

A simple marble-and-porcelain sink with easily gripped turn-of-the-century ceramic-handle fixtures. This Victorian invention is a timeless design. (Left)

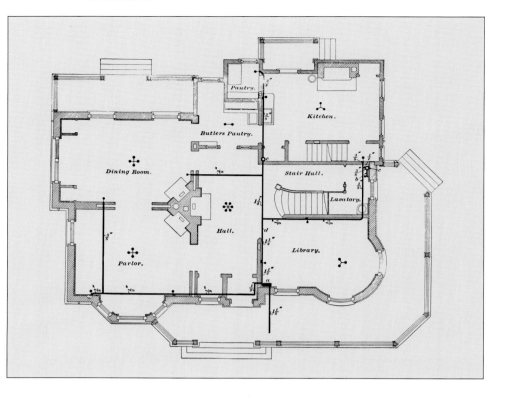

THE AGE OF GASLIGHT

After water and sewers, gas-lighting was one of the marvels of the Victorian age. Central coal-burning gasworks fed extensive systems of gas pipes under the city streets. Gas-lighting was installed in San Francisco as early as 1854. Downtown hotels, theaters, and streets were the first to enjoy the new technology. Close-in neighborhoods had the best utility service and were therefore favored by the middle class. This is a typical gaslight fixture that would have hung from the center of a parlor ceiling.

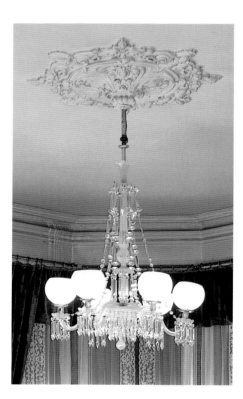

GAS LINES

Floor plan of an upper-class Victorian house with gas lines penetrating every room. Lighting fixtures were suspended from plaster medallions in the center of the ceiling, or projected from the walls. (Above)

AN 1876 FIXTURE

Lighting fixtures were ornamented and celebrated in Victorian interiors. This standing fixture designed for a newel-post was exhibited at the Centennial Exposition in Philadelphia in 1876. (Below)

AN 1870S CHANDELIER

The 1870s gas chandelier in this parlor was electrified in the twentieth century. Glass globes diffuse the light, and crystal prisms sparkle like jewels. The plaster medallion trapped soot and dirt and prevented the streaking of the ceiling.

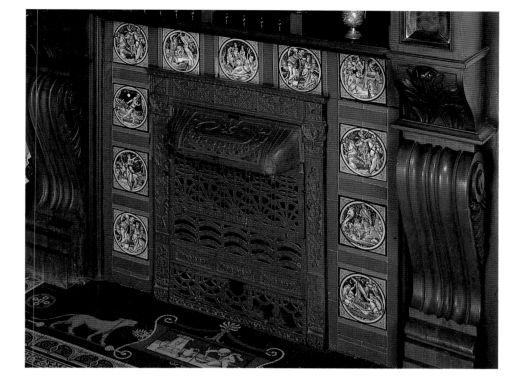

DECORATIVE TILE

The 1889 gas heater in the front parlor of the John Coop house, in the Mission District, has an enclosed front pierced by openings for the entrance of cold air and the exit of heated air. The English tiles around it depict La Morte d'Artur, a favorite Victorian legend. (Right)

GAS FIREPLACE

Like many innovations, gas heating systems at first imitated the technology they superseded. This drawing shows a traditional fireplace fitted with gas-burning ceramic logs. The advantages of gas were economy, ease of lighting, no tending, and no cinders or ash to remove. (Below)

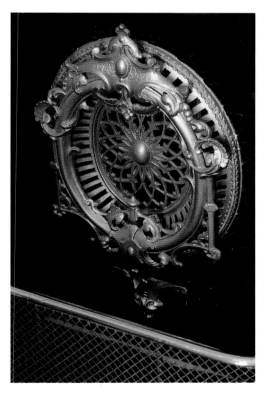

GAS HEATING

Gas was soon adapted for heating in the Victorian house. This is a detail from a metal grate in an Italianate dining room in the Haight-Ashbury.

EARLY GAS WATER HEATERS AND KITCHEN RANGES

Hot water at the turn of a tap was a Victorian advance and greatly increased domestic comfort. The small dark cylinder to the right is the gas water heater and the large cylinder is the storage tank. Cold water also circulated through the gas stove and into the storage tank. (Right, above)

NEW INVENTION

Gas cookers made food preparation quicker and cleaner. Even the poor in Victorian San Francisco could generally afford this two-burner appliance. San Francisco became a major manufacturer of stoves and other appliances, which it exported all over the West. (Right, below)

COOKING WITH GAS

A gas cast-iron kitchen range with four top burners and an oven made cooking much easier than on wood or coal stoves, which needed constant tending. Gas is still the best fuel for cooking. This range has an eye-catching asymmetrical, swirling design. Cast-iron ranges also helped to heat the kitchen. (Below)

ELECTRICITY, ANOTHER VICTORIAN MARVEL

In the second half of the 1880s, the new technology of electric lighting startled the world. Like gas, electricity was first used in hotels and theaters and for street lighting. Here two Parisians marvel at the hard, bright white light that made Victorian cities safer at night. (Above)

ELECTRIFYING GRAPHICS

This "shocking" advertisement in California Architect and Building News *announced the modern marvel of electricity. The California Electric Light Company was incorporated in San Francisco in 1879 and built a generating plant on Fourth Street, just south of Market Street. When electricity first came into use, the cost to the consumer was ten dollars per arc light per week, with the current cut off at midnight. Houses that continued to use cheaper gas for illumination sometimes employed built-in electric spark devices to light the gas automatically. (Above)*

ELECTRIC LIGHTS

The Victorians celebrated the electric light, which was much cleaner, easier, and safer than gas-lighting. Another advantage of electricity was portability. Table lamps, unlike gas "fixtures," allowed light to be brought to the task at hand, be it reading or sewing. Some designers saw the incandescent filament as the pistil in a flower and designed fixtures that looked like plants. These are some organic 1887 French designs. (Right)

LIGHTS ALOFT

Newel-post lighting fixtures, which had been highly elaborated during the age of gas, were soon electrified. A favorite late-nineteenth-century motif was a bronze statue of a shapely woman in swirling garments brandishing aloft a bouquet of electric lights. Here is one such Art Nouveau marvel atop a 1904 newel-post. (Above, right)

PAINTERS' TOOLS
Nineteenth-century paintbrushes.

ORIGINAL VICTORIAN PAINT SCHEME

The traditional way to paint a house in Victorian San Francisco was quite simple. White lead paint was used for the body of the building and all its ornament, no matter how elaborate. Jet black, dark green, or perhaps terra-cotta was used only for the narrow window sash. From the outside, window treatments were similarly restrained. Sheer, white "glass" curtains gave privacy, and dark green shades could be pulled down to blot out strong light and to prevent the fading of carpets and furniture. Gray was another favored San Francisco Victorian exterior color; it was made

by mixing lamp black into white lead paint. Victorians reserved rich colors for the interior of their houses.

Since the Victorian revival that began in the 1970s, the colors of San Francisco's Victorian houses have changed. Today very few Victorians show their original colors. The Tillman-Cline house, a fine Italianate house at 2826 Van Ness Avenue, was built in 1875 at Larkin and Broadway and moved to its present site in 1904. Architect Henry Geilfuss added a "modern" Doric-columned porch. This grande dame proudly eschews passing fads and preserves her elegant original colors.

White, off-white, beige, and pastel colors are especially appropriate in San Francisco. They are first of all economical. Unlike polychrome exteriors, a single color fades at the same rate under the hard California light and the house looks better far longer. Also, the foggy atmosphere quickly gives houses a chalky surface that softens reflected light. White houses look rose at dawn, white at noon, and lavender at twilight.
(Below)

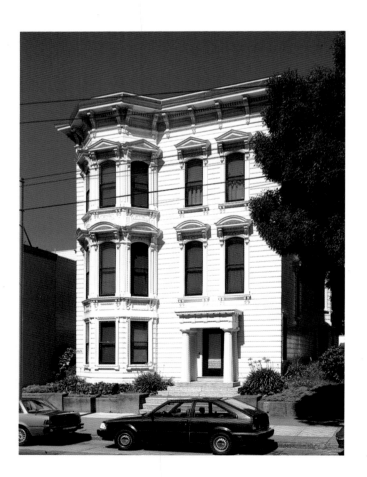

GATES AND PRIVACY

Victorian houses both great and small were usually surrounded by a fence with a gate. The gates for mansions became splendid works of art. Architect Augustus Laver's bronze fence and gate for the 1886 James Leary Flood mansion at 1000 California Street, at Mason, atop Nob Hill, is the finest example of this art in San Francisco. This is the back gate facing Sacramento Street.
(Above)

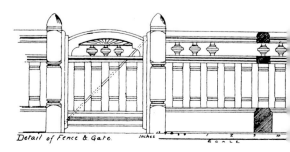

Detail of Fence & Gate.

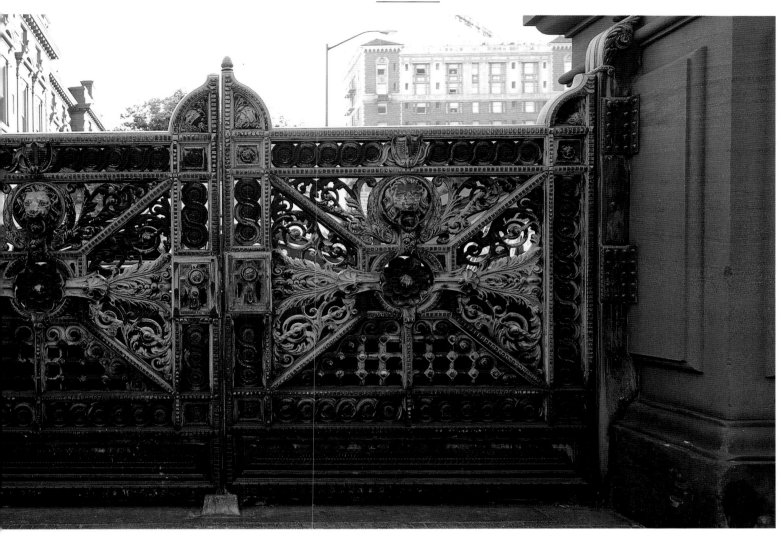

BOARD FENCES

While iron or wood fences in the front of a house were usually transparent, board fences at the side or back were solid. To the left of this elaborate, long-lost house at the corner of Pacific Avenue and Pierce Street, in Pacific Heights, is an empty lot and beyond it the board fence surrounding the neighboring house. Redwood board fences were an essential part of the Victorian house and provided privacy and security. (Right)

WOODEN FENCE

The Newsom brothers designed this fancy fence and gate in 1884.

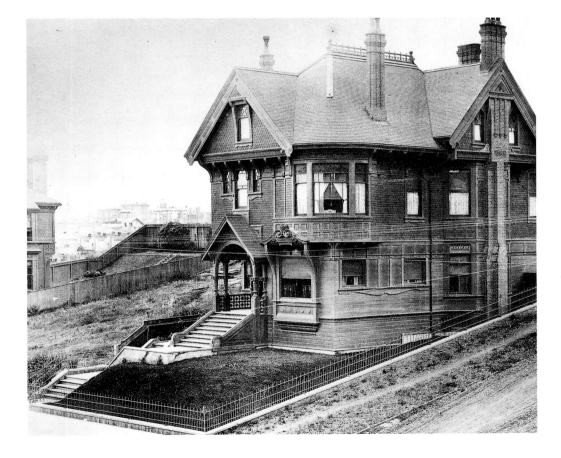

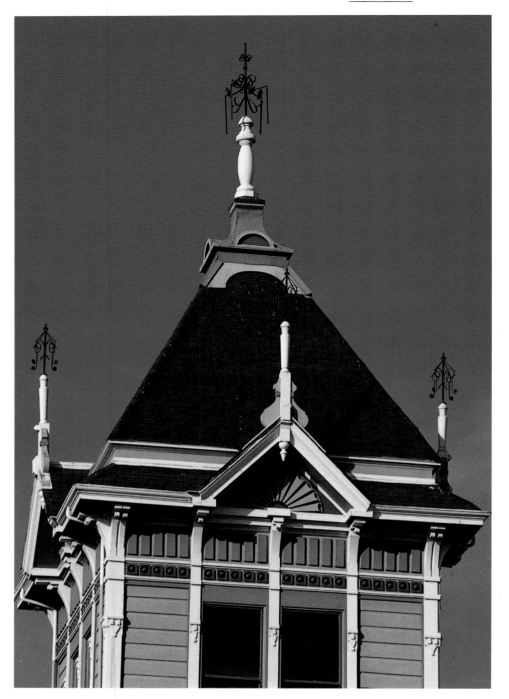

FINIALS
The exclamatory tower of the 1889 Westerfeld house at 1198 Fulton Street, at Scott, facing Alamo Square, was designed by Henry Geilfuss in the Eastlake style. It affords a sweeping view of the city. Its cast-iron finials are rare survivors. (Left)

THE FINESSE OF THE VICTORIAN SKYLINE: CAST-IRON CRESTING AND FINIALS
Victorian architects were especially concerned with how their buildings met the sky. Roofs were often edged with a delicate filigree of cresting, such as this vigorous design available from San Francisco's Phoenix Iron Works in 1884. (Below)

9

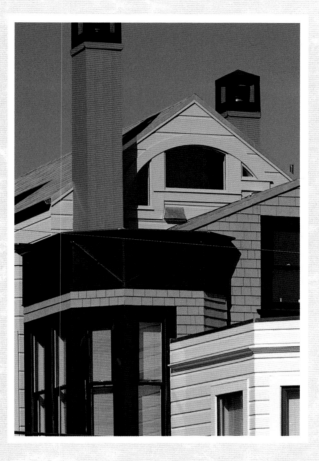

OPENING THEM UP:

LIVING IN

VICTORIAN HOUSES TODAY

OPENING THEM UP:

LIVING IN

VICTORIAN HOUSES TODAY

From Junk to Antiques

What is constant in American life is change—rapid, unceasing, unsettling change. The population of San Francisco kept growing and moving. As the city grew, it left behind its Victorian neighborhoods; the upper and middle classes sought out ever more modern houses on the expanding periphery. By the end of the nineteenth century, advanced tastemakers began to attack the architecture of the buildings their parents and grandparents had lived in. Gelette Burgess, the editor of *The Wave*, looked at the city in 1897 and claimed that the intelligent visitor to San Francisco would take away two impressions, the fancy women along Kearny Street and the houses in the Western Addition:

the painted faces of the women and the abominations of our so-called "architec-

SKYSCRAPERS AND VICTORIANS
As the San Francisco Bay Area continued to grow, the Victorian districts lost their appeal. In the 1970s, however, a massive new wave of investment rebuilt much of downtown San Francisco with modern high-rises. This revived core drew new people to San Francisco who discovered the faded Victorian neighborhoods and revitalized them.

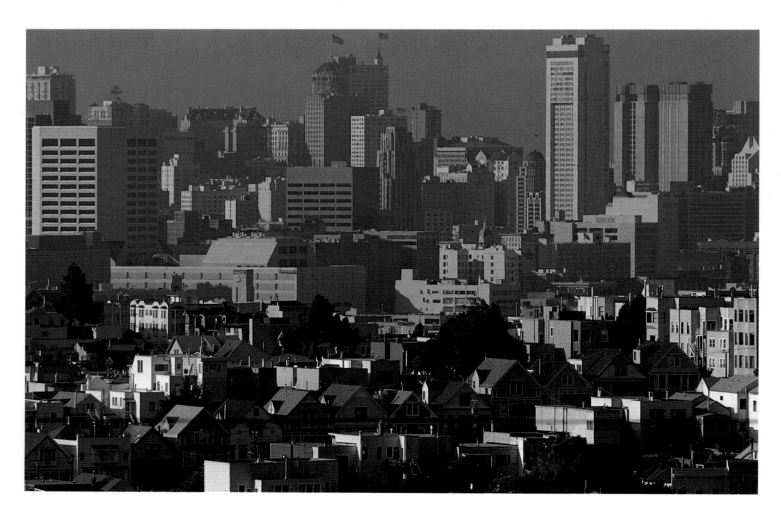

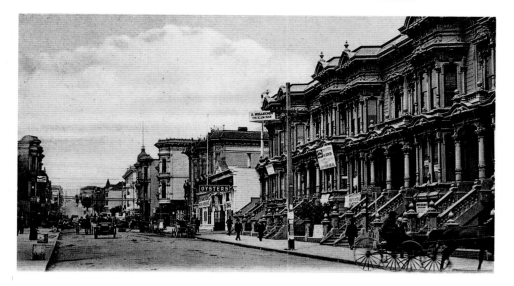

ADAPTION: SUBDIVISION OVER TIME

San Francisco's Victorian houses survived the long years of disfavor through subdivision. Immediately after the earthquake and fire in 1906, the surviving Victorian houses in the Western Addition were quickly subdivided and converted to office and retail use. Residential Golden Gate Avenue, along with many other streets, suddenly became commercial.

ture," and if a moralist as well as an observer, he sees a subtle analogy between the two which proves San Francisco to be a City of Shams. For as the women seek to counterfeit the charms denied them, by the use of rouge and enamel, so the men daub and spatter redwood to imitate marble and granite, copy wood-carving by machinery, and carry the deceptions of concrete and cement to indecent limits.

In 1899 another San Francisco journal wrote of the "high architectural crimes and misdemeanors" rife in the city. With the change in lifestyle and fashions at the turn of the century, all things Victorian fell from favor. None tumbled more dramatically than the Golden Gate city's fanciful redwood row houses. By the 1920s the very word *Victorian* was a term of contempt. Critic Lewis Mumford wrote about "towers that no one ever climbed, turrets that no one could enter, and battlements that no one rose to defend." By 1939 the Works Progress Administration guide to California looked at San Francisco's rich nineteenth-century architecture only to decry the "epidemic of the Victorian pestilence" that had seized the state in those years and produced "thousands of Victorian horrors." The word *Victorian* became wedded to the word *monstrosity.*

Very few San Franciscans resisted the lure of newer neighborhoods. When the automobile displaced the streetcar,

and the country club the city parks, the old districts began their rapid decline. During the population peak of World War II, roomy old houses were subdivided and working-class families rented the once formal parlors of the now dispersed middle class. Old houses became hand-me-downs and upkeep levels fell drastically. Absentee landlords cared little about unfashionable architecture and tore off crestings and finials. "Improvement-minded" landlords tried to keep their properties modern by stripping away ornate gingerbread and covering their buildings with stucco or asbestos shingles in a search for low maintenance costs.

After World War II, money and people began to migrate out of American cities. The rapid growth of new suburbs in the Bay Area in the 1950s and 1960s drew the middle class away from San Francisco. Widespread automobile ownership, new freeways, plentiful ex-urban land, new one-story ranch-style houses, and FHA mortgages created the suburban boom. Conversely, redlining by lending institutions—the refusal to lend money in the city's traditional neighborhoods—cut off the necessary flow of capital into older housing stock. San Francisco, like all older American cities, began to decline.

The city responded with a sweeping program of federally subsidized urban renewal and declared war on the "blight-

ROOMING HOUSE

The elaborate single-family Vollmer house at 773 Turk Street, in the Western Addition, survived the 1906 fire, only to be later converted to a roominghouse. A small manager's unit with its own front entrance was tucked into the basement under the projecting bay window. The house was moved in 1975 to 1735–37 Webster Street, at the far west edge of the Western Addition, and restored. Richard Scott.

REAR ADDITIONS

The Officers' Quarters on Funston Avenue, on the Presidio, have had a complex history. Built in 1862, they originally faced the Parade Ground to the west. In 1878 the houses were "turned around" to face east and new front doors and bay windows were added. In 1883–84 modern indoor plumbing was installed; in 1912 electricity was hooked up; and in 1947 the houses were cut up into duplexes. In 1951 carports (not visible here) were added, and in 1965 new concrete foundations were poured. Over time kitchens, work areas, and spare rooms were added at the rear, giving the houses a telescopelike profile. (Below, right)

FLEXIBILITY: ADDITIONS TO THE WOOD BOX

It has always been easy to add onto frame Victorian houses. Bathrooms in particular were favorite additions. Many houses had been built with only one bathroom and a separate water closet. Over time, small baths were often installed alongside bedrooms. The side addition to 1911 Sacramento Street, an 1870s Italianate house in Pacific Heights, has a blind window. (Below)

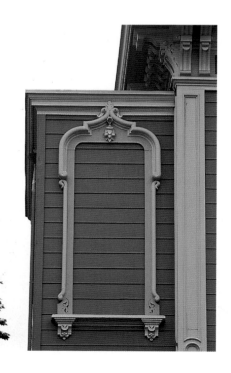

ed" Western Addition. Hundreds of "obsolete" Victorians were demolished. (At one point in the early 1970s, the San Francisco Fire Department set fire to a Victorian—accidentally, it was later claimed—just to practice fire fighting!) Once resistance mounted to this meat-ax approach, a second wave of urban renewal was launched in the mid-1970s. This time owners were provided with subsidized loans in order to rehabilitate old buildings in designated neighborhoods.

Outside the city other changes were taking place. As most of the easily built land in the region filled with tract houses, cheap land evaporated. Then the costs of suburban houses exploded. Between 1975 and 1980, average house prices more than doubled in the San Francisco Bay Area. The construction of a brand-new high-rise downtown in the booming 1970s revitalized the urban core and led many new San Franciscans to discover the city's faded Victorian heritage. Some general contractors who survived the shake-out in the house-building industry switched from constructing new houses to rehabilitating old ones. Another part of this process was the migration of young gay men to San Francisco. They found that they could make a living buying, restoring, and then selling Victorians, only to buy another salvageable house to continue the process. Buying, improving, and then selling well-located Victorians within a two-year timespan, these small builders and urban pioneers had a major impact on the city's nineteenth-century neighborhoods. Between 1973 and 1976, vintage houses in San Francisco quintupled in value.

At the same time, among house buyers, there was a rebirth of interest in ornament, color, texture, and fancy that found its expression in a new appreciation for what the Victorians had built. Old neighborhoods came back into vogue. That old cycle that things go through—from new, to old, to junk, and,

if they survive, to precious antiques—caught up with San Francisco's nineteenth-century houses.

San Franciscans have evolved a distinctly San Franciscan way of reviving these buildings. Their facades are restored, but their interiors are modernized, opened up. Restoration architects emerged who could "bring back" damaged buildings while accommodating modern needs. By the mid-1970s there were specialized craftspeople in San Francisco who could reproduce redwood ornament and reconstruct damaged facades. Other local businesss flowered, from restorers of Victorian lighting fixtures to painters who can do authentic stenciling work.

Today, San Francisco's Victorian houses are a treasured part of the Golden Gate city.

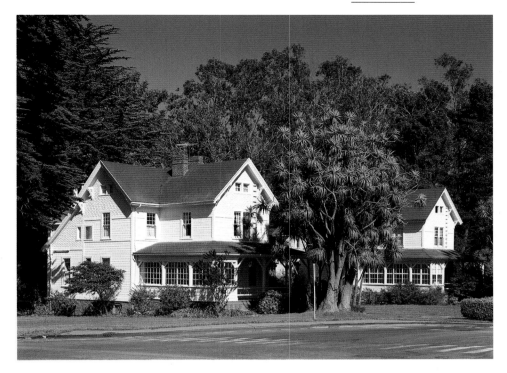

GLASSED-IN PORCH
Houses that had originally been built with open porches, such as the 1885 Officers' Quarters on Presidio Boulevard, on the Presidio, often saw those porches eventually glassed in. This made the spaces more practical in San Francisco's cool, but sunny, climate.

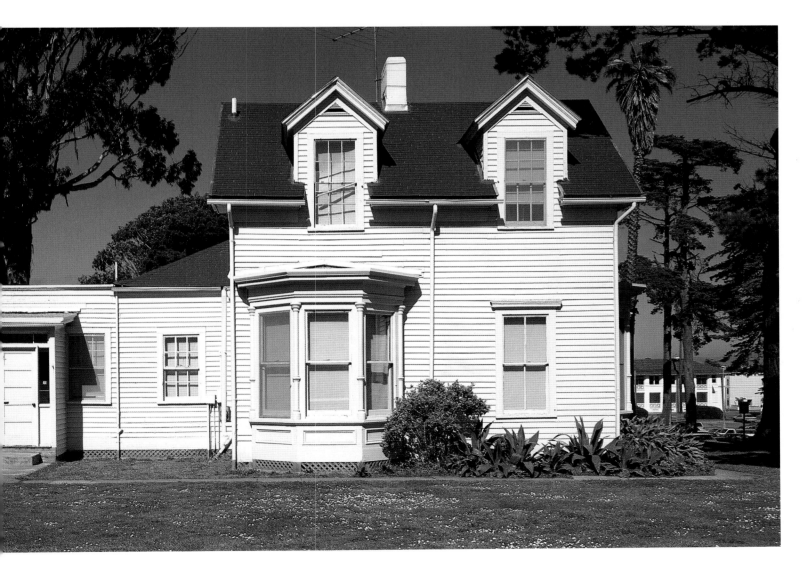

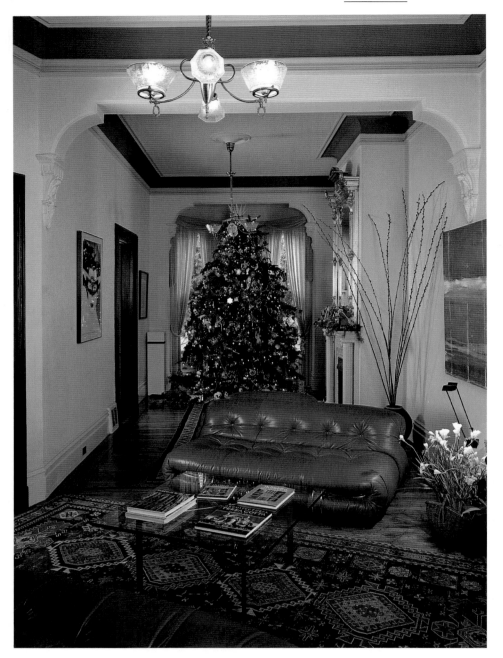

PARLORS INTO LIVING ROOM

In this 1876 Western Addition Italianate house, two parlors were made into one, white-painted living room. Restored in the 1970s, it is characteristically furnished with modern furniture and art.

OPENING UP THE PARLORS

Twentieth-century owners of nineteenth-century houses live lives different from the Victorians and change their houses accordingly. The formal separation of the front parlor from the center parlor is not wanted in our informal age. What were two separate rooms are often thrown together into one large living room. When the 1870 Ortman-Shumate house at 1901 Scott Street, in the Western Addition, was remodeled in 1915, its two parlors were transformed into one large parlor with glass doors to let in more light. (Below)

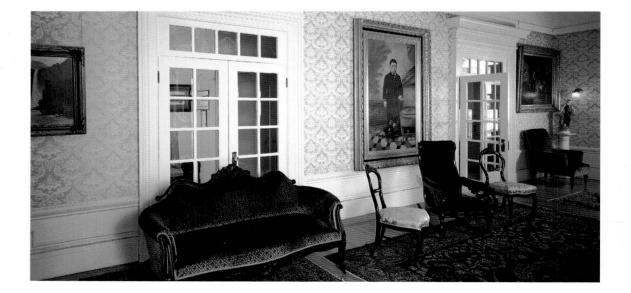

Original
First Floor
Plan

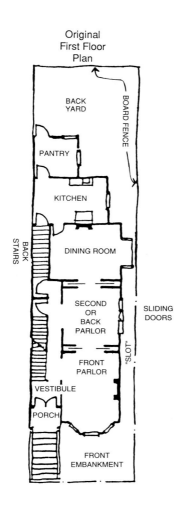

Modernized
First Floor
Plan

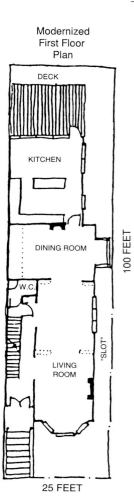

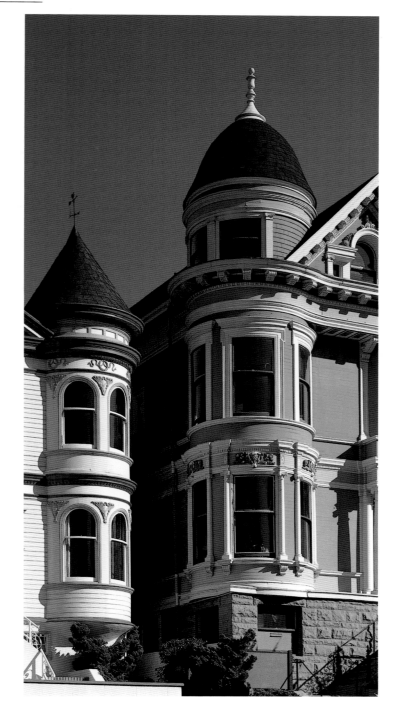

ORIGINAL AND
MODERNIZED FLOOR
PLANS OF THE FIRST
FLOOR OF A TYPICAL SAN
FRANCISCO VICTORIAN
*Behind restored nineteenth-century
facades, twentieth-century owners
have opened up the first floor of their
houses by removing the pocket doors
and combining the two parlors,
expanding the kitchen (today an im-
portant family room), and adding
rear windows, glass doors, and decks.*

"PAINTED LADIES"

*The rediscovered Victorian houses
became canvases for their new
owners. Staid, traditional white and
gray houses were enlivened with
polychrome paint schemes that now
picked out the building's ornament.
An interesting reversal took place.
While the dark, rich paint and wall-
paper schemes of Victorian interiors
were replaced with light-reflecting
white, the white exteriors were given
multicolor paint schemes. These
1890s Queen Anne "painted ladies"
stand on Steiner Street, facing Alamo
Square, in the Western Addition. To*

*the right is 818 Steiner Street, designed
by Martens and Coffey in 1899; on
the left is 850 Steiner, designed by
Tom P. Ross in the same year.*

*Real-estate speculators were among
the first to adopt the exuberant new
paint schemes. It was a low-cost way
to make old buildings look new. Color
consultants then emerged who con-
cocted complex color schemes and
even employed gold leaf. Many such
consultants had the disfiguring habit
of attaching permanent signs to
repainted houses with their names
and telephone numbers. This gaudy
trend peaked in the mid-1980s with*

*circus-wagon-like paint schemes.
Time and weathering soon proved
these paint jobs impractical: Strong
colors fade quickly in San Francisco,
and various colors fade at different
rates, which soon gives houses a
splotchy look. In the 1990s the trend
is back toward simple, light-reflecting
colors. Off-white is now usually used
for all the ornamental woodwork, a
light tan or beigelike color for the
clapboard body of the house, and a
strong related color for the narrow
window sash. (Above, right)*

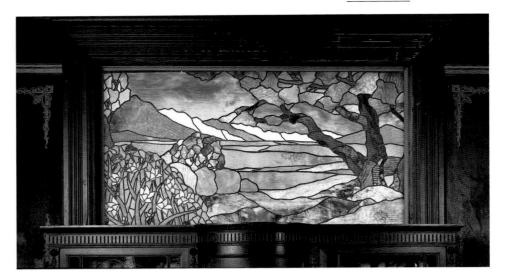

BRINGING COLOR BACK TO RESTORED INTERIORS

Many Victorians had lost their stained-glass windows in the 1960s to antique hunters and fern bars. New owners later commissioned modern art glass to replace what was lost. This 1975 stained-glass window designed by Raymond Centanni is in a Pacific Heights Queen Anne and is entitled "Fog over the North Bay."

BRADBURY AND BRADBURY

Perhaps the most remarkable recent development in the restoration of San Francisco Victorians is the rebirth of artistic wall and ceiling papers. Bradbury and Bradbury in Benicia, California, has brought back the art of designing and manufacturing rich wall coverings. This remarkable ceiling paper was custom designed for a Western Addition Victorian in 1988. The sunflower was a favorite late-Victorian motif. (Below)

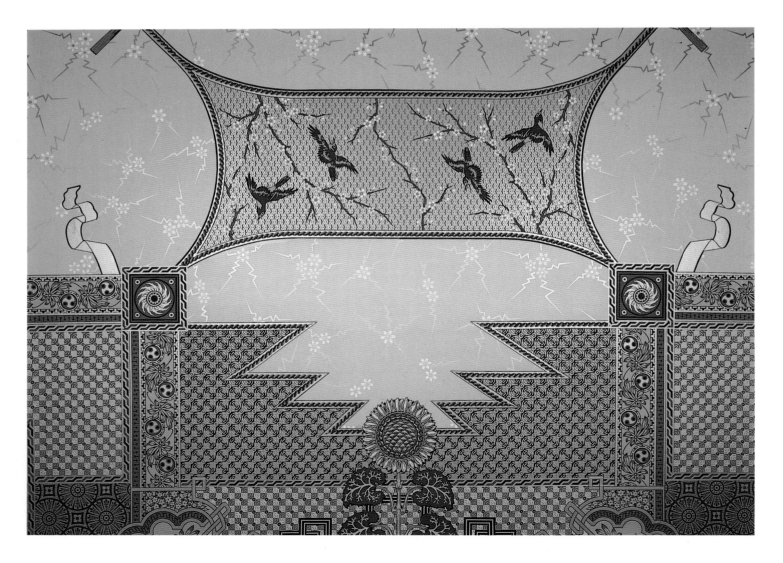

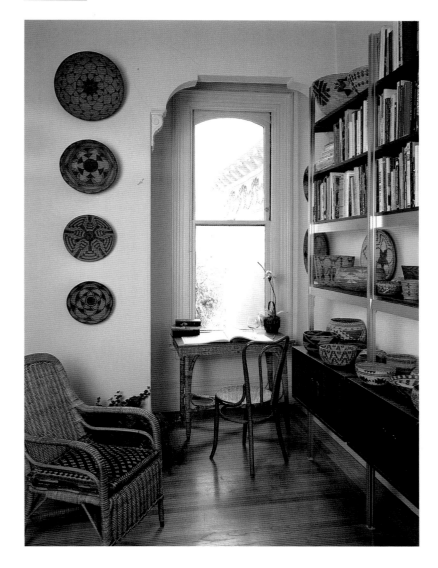

NEW BATHROOMS

Even grand Victorian houses frequently had only one bathroom, and it was upstairs in the private family area. Modern restorations often involve the addition of guest facilities on the first floor. At the Spencer house, in the Haight-Ashbury, the silver pantry off the breakfast room now has a small bathroom tucked away inside it. The fine golden oak door and its Queen Anne–style surround have their original finish.

UPSTAIRS DEN

The upstairs den in this 1879 Victorian has plain wood floors and wicker and bentwood furniture to better show off a fine collection of Native American California baskets. The window in the alcove looks out the slot to the street. (Above, right)

UPSTAIRS ROOMS

Modern interiors in many Victorian houses strip away the heavy ornament of the past, such as wall-to-wall carpets and heavy drapes, to reveal more directly the architecture of the room. This office in the Haight-Ashbury home of a fine-arts consultant has modern bleached floors, plain walls, and simple narrow blinds in its bay window. (Below, right)

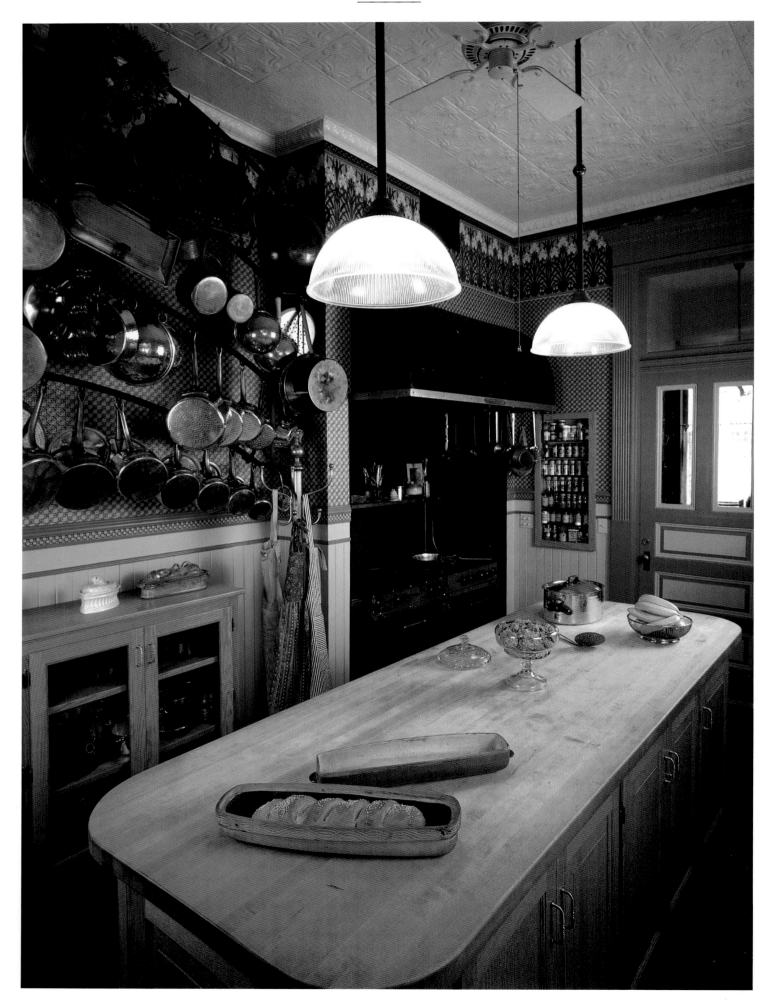

A NEW KITCHEN

Victorian kitchens were starkly utilitarian affairs, especially in houses with servants. Moderns, on the other hand, find the kitchen one of the most congenial spaces in the house and lavish attention on it. The Spencer house, in the Haight-Ashbury, has a welcoming contemporary kitchen with a maple-topped island counter, a restaurant range, and an iron rack to hold shiny copper pots and pans. The ceiling is of pressed tin and the walls have elaborate wallpaper borders. Behind the door is a former pantry now used as a small office. (Opposite)

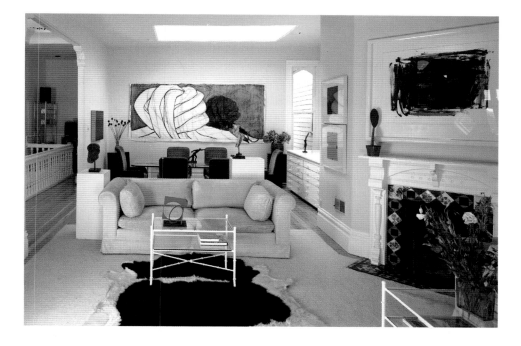

A PANTRY

The pantry in this 1883 Mission District house has been stripped of its paint to show the wood. Victorians liked to paint and grain surfaces; moderns prefer to display the underlying wood. (Below, left)

WINE CELLAR

This Queen Anne house had a commodious wine cellar built in its basement when it was made into a bed-and-breakfast inn. (Below, right)

REWORKED AND RE-VERSED FLOOR PLANS

Many large, two-story Victorians have been subdivided into two or more units. Where there is a view from the back of the building, the floor plan is usually reversed and the living room is placed in the back of the house rather than facing the street. This Queen Anne in the Haight-Ashbury is such a house. It was made into three units, and the back bedrooms on the second floor were opened up and transformed into a spacious, white living-and-dining room to display better a collection of contemporary art. A skylight was added to bring in more light. This is very much the way San Franciscans live in old houses today. (Above)

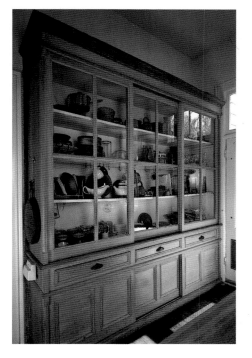

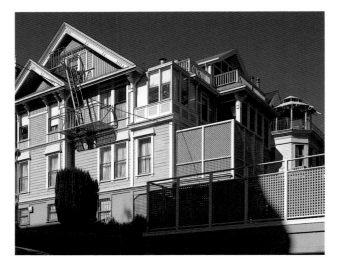

ADDING BACK DECKS
Victorian houses in San Francisco have broken out of the confinement of the wooden box and added decks to the rear. This fine house at 2000 Gough Street, at Clay, has grown with additions and back decks like a living thing reaching out for light and views. (Above)

A MODERN DECK
The back deck of this Haight-Ashbury house brings modern outdoor California living to an old Victorian house. This view reveals the simple clapboard backs of fancy Victorians. To the right is a three-story back bay window typical of San Francisco construction. The edge of green on the horizon is the tops of the trees in the Golden Gate Park panhandle. (Left)

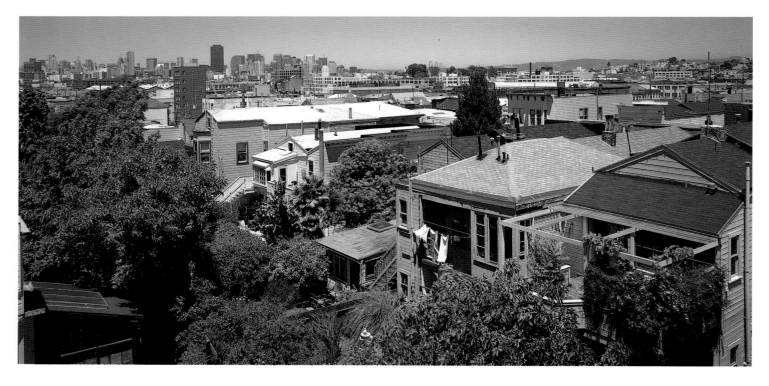

RESTORED COTTAGE

This compact cottage at 530 Liberty Street was designed by the prolific Fernando Nelson in 1897. Its facade is a simple composition of a window, a door, and a bay. The front and garage doors date from the 1920s. Missing redwood ornament has been replaced, a pleasing contemporary paint scheme applied, and a new street tree planted in front. It is ready for another century of domestic comfort. Stucco "improvements" still mar its neighbor to the right. But this is such a beautiful neighborhood, and these houses are now so valuable, that no doubt some future owner will someday restore its Eastlake facade.

FACADE RESTORATION

This Eastlake house at 2588 Pine Street, in the Western Addition, originally designed by Harry S. Munson in 1890, is having its asbestos shingles and modern metal-framed windows removed in preparation for the restoration of its facade. Along the cornice, the "shadows" of its lost ornament are visible. The house to the left, at 2590 Pine Street, was designed by John H. Littlefield in 1885. (Below, right)

OLD AND NEW BACKS

The hidden interiors of many Victorian blocks are now a forest of greenery. A number of houses have been redesigned with preserved historic facades but modern rear additions. This block in the Mission District is a typical oasis in the city. The house at center right has its original back wash porches. Its neighbor on the far right has had a new open deck added to expand the usable living space and to look down on the back gardens. The low-rise South of Market district is in the middle distance; the high-rises of the Financial District mark the horizon. (Opposite, below)

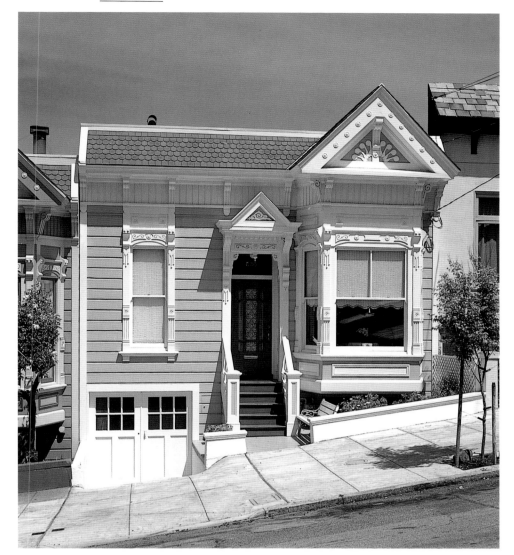

COMPATIBLE NEW DESIGN IN VICTORIAN NEIGHBORHOODS: ONE FENCE AND ONE IN-FILL BUILDING

Many city streets are much noisier today. This Noe Street house, in Noe Valley, has a modern fence that adds to its privacy and security while not detracting from its Victorian neighborhood. Typical rusticated clapboard and latticework have been combined to create a modern, but compatible, design. (Above)

Building new structures in Victorian neighborhoods is no easy task. Fake Victorians are almost always a bad idea because of their weak designs. Kotas-Pantaleone Architects designed this superb in-fill apartment building at 2910 California Street to fit between the Italianate house to the left and a 1920s bay-windowed apartment building to the right. Without directly copying any Victorian model, the building captures the complexity and exuberance of San Francisco Victorian architecture while still being its own design. (Right)

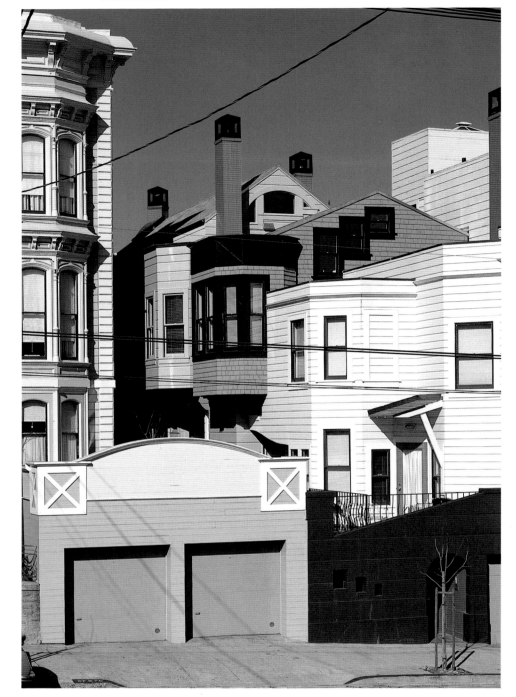

BACKYARDS AND GARDENS

A plum blossom–strewn path alongside a Mission District Victorian is lined with camellias. Baby tears carpet the foreground.

At the end of the path is part of an old carriage house now used as a writer's studio. A magnolia blooms in the peace and quiet of a secluded backyard.

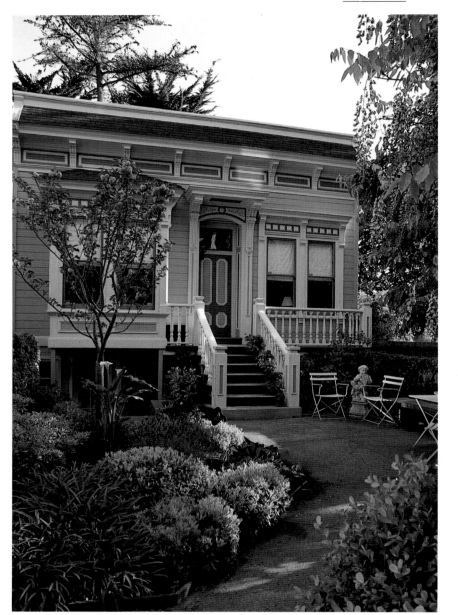

A MODERN GARDEN
This hidden garden in front of an Eastlake cottage in the Western Addition epitomizes the modern taste in San Francisco landscaping. After more than a century of unceasing, churning change, San Francisco's Victorian houses are now prized and cared for, and lovingly landscaped.

NATURE AND ART
The old wisteria that drapes the 1886 Haas-Lilienthal house in Pacific Heights forms a living counterpoint to the carved redwood ornament of this grand San Francisco Victorian. (Below)

SAN FRANCISCO VICTORIAN

NEIGHBORHOOD MAP

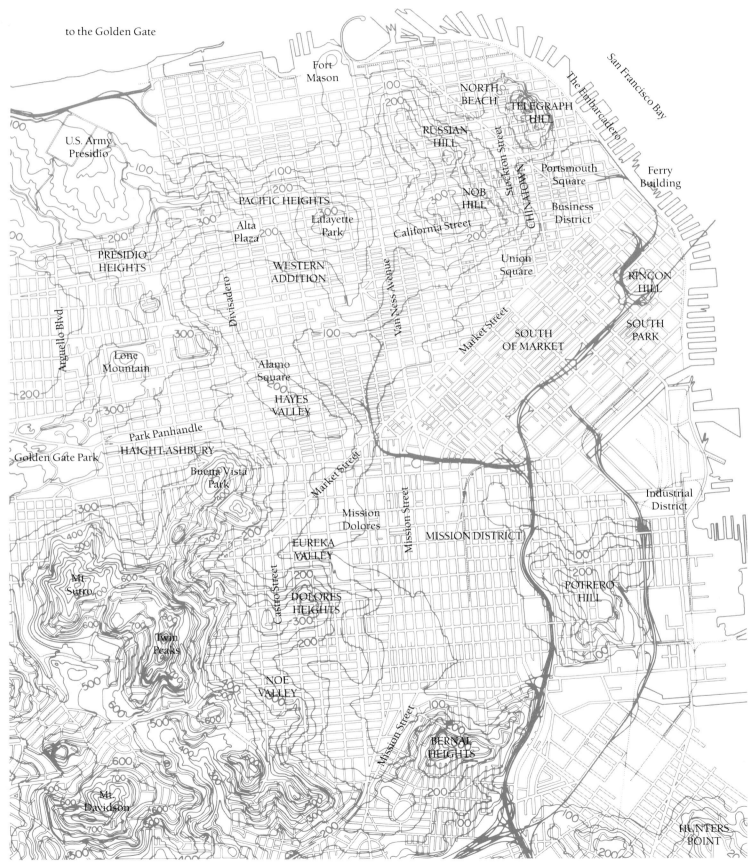

to the Golden Gate

Fort Mason

San Francisco Bay

The Embarcadero

NORTH BEACH

TELEGRAPH HILL

RUSSIAN HILL

CHINATOWN

Stockton Street

Portsmouth Square

Ferry Building

U.S. Army Presidio

PACIFIC HEIGHTS

NOB HILL

Business District

Alta Plaza

Lafayette Park

California Street

Union Square

PRESIDIO HEIGHTS

WESTERN ADDITION

Van Ness Avenue

RINCON HILL

Arguello Blvd.

Divisadero

Market Street

SOUTH OF MARKET

SOUTH PARK

Lone Mountain

Alamo Square

HAYES VALLEY

Park Panhandle

HAIGHT-ASHBURY

Golden Gate Park

Buena Vista Park

Market Street

Mission Dolores

Mission Street

MISSION DISTRICT

Industrial District

Mt. Sutro

Castro Street

EUREKA VALLEY

DOLORES HEIGHTS

Twin Peaks

POTRERO HILL

NOE VALLEY

Mt. Davidson

Mission Street

BERNAL HEIGHTS

HUNTERS POINT

San Francisco Department of City Planning, 1967

Fifty-foot contour interval

How to Research
Your San Francisco House

Prepared by the San Francisco Archives of the San Francisco Public Library

The San Francisco History Room at the Main Branch of the San Francisco Public Library, Civic Center, is the official archive of the City and County of San Francisco. It also houses a fine collection of books, pamphlets, and photographs on San Francisco. Other local collections, especially useful for photographs, are the California Historical Society Library in San Francisco, and the Bancroft Library at the University of California, Berkeley.

How Old Is It?
Who Built It?

1. San Francisco Water Department, 425 Mason Street. The Water Department has the date that a water connection was first made at your address as well as the name of the owner or applicant. This date may reflect the start of construction, the first date of occupancy, or the date water was provided to an already existing house.

2. Junior League *Here Today* Files, San Francisco History Room. Thousands of houses were researched by the Junior League in the 1960s. Buildings are filed alphabetically by street. These files are not always accurate.

3. *Real Estate Circular,* San Francisco History Room. Issues from 1868 to 1921 are on microfilm. Using the date from the Water Department, look for property sales, transfers of ownership, and cost of the house and the land.

4. *Edward's Abstracts,* San Francisco History Room. A broken file exists from 1906 to 1977. Issued daily, this is a listing of documents recorded with the City and County of San Francisco. Under Miscellaneous Papers you may find building contracts that will give you the owner, contractors, architect, and cost of construction.

Who Lived in It?

1. City Directories, Periodical Room, Main Branch of the San Francisco Public Library. Once you have the date and possible owner or occupant of your house, you can check the City Directories that were published each year to determine how long that person lived there. The directories will also give you the person's occupation and, often, the spouse's name. Reverse directories, which list the owner or occupant by street address, begin in 1953.

2. *San Francisco Our Society Blue Books,* San Francisco History Room. Published annually from 1890 to 1931; some issues list residents by street address.

3. *Handy Block Book of San Francisco,* San Francisco History Room. These block maps indicate lot sizes and property owners. Block Books exist for 1894, 1901, 1906, 1907, 1909, and 1910.

4. Assessor's Office, City Hall, Room 101. The *Realty Index* lists the block and lot numbers used by the city assessor. Ownership records and transfers of property from 1914 to the present are on file.

5. *Index to the Great Register of Voters,* San Francisco History Room. Using the assembly district in which your house was located, you may find your address and the name of the occupant for that year, his or her age, occupation, and political party. The *Great Register* covers the years 1900 to 1928.

Preservation Groups in San Francisco

San Francisco is a city of sharply defined neighborhoods, almost every one of which has at least one active neighborhood organization. They are the front line of defense for the city's architectural character. There are so many that it is not practical to list them. New ones keep forming all the time.

Two organizations are active citywide. One is The Foundation for San Francisco's Architectural Heritage, a nonprofit member-supported organization dedicated to the preservation and adaptive reuse of architecturally and historically significant buildings in San Francisco. It publishes a newsletter and conducts programs for its members and the public. Contact:

The Foundation for San Francisco's
Architectural Heritage
The Haas-Lilienthal House
2007 Franklin Street
San Francisco, CA 94109
415-441-3000

Another active preservation group with a special interest in Victorian buildings is The Victorian Alliance. It is a nonprofit all-volunteer organization dedicated to learning about, enjoying, and preserving the old houses of San Francisco. The alliance publishes a newsletter, conducts annual house tours, and has programs for its members and the public. Contact:

The Victorian Alliance
824 Grove Street
San Francisco, CA 94117
415-824-2666

The National Trust for Historic Preservation has its western regional office in San Francisco. Contact:

The National Trust for Historic
Preservation
1 Sutter Street
San Francisco, CA 94104
415-956-0610

AFTERWORD

From the Writer

It is the distinct pleasure of the writer to come to the end of a manuscript, especially one like this, which draws on a substantial part of my life. There is a sense of what psychologists call closure.

I have looked at most of these streets and facades under all skies, during all seasons, at all hours of the day and night, and in many different moods. To me these redwood rows are like carved masks along a high shelf whose intimate lives I, as an historian, often ponder. I see these old houses and complex streets as external evidence of past lives, nearly all of which must always remain unknown.

I found that exploring my familiar city with photographer Richard Sexton made me look at these old friends afresh, this time with the serious purpose of recording and interpreting them for others, many of whom will be making their acquaintance for the first time. I have sought to get under their skin, beneath their facades, inside their rooms that whisper of the past. I have tried to look actively and listen quietly. I have tried to explain the times that gave these houses birth, and the singular city of which they are such an important part. I wanted more than a superficial book of painted faces; I wanted an important part of my city's life and soul to be caught in words and pictures. I wanted in the quotations to let the highly articulate Victorians speak for themselves. It is for readers now and in the future to judge how close I have come.

Working with Richard Sexton was very much to my liking. He, too, approached these facades, streetscapes, and interiors with a craftsman's respect and an artist's eye. I trust that some measure of the joy and fancy I find in these lively Victorians pleases my readers and persuades them to love and cherish this wonderfully human city on the Golden Gate.

Randolph Delehanty

From the Photographer

I once heard it said about Greta Garbo that for all her striking presence on camera, a careful examination of her face would reveal that it was actually quite flawed and without a single outstanding feature. I realized while undertaking this project that San Francisco is very much like Garbo's face. The complete statement is very compelling, although close analysis reveals undermined, incongruous, and incompletely conceived components. Much of this tension is the effect of the toll of time on the Victorian city. But some of it, I've learned, is original—created by the Victorians.

When Randolph Delehanty approached me to collaborate on a book about Victorian houses in San Francisco, I came to the project with little prior knowledge of the subject. Undertaking this task was more than anything else a learning experience. Once the book was complete, I saw not just San Francisco's Victorian architecture and neighborhoods in a new light, but the entire city. The foundation that was laid in Victorian San Francisco continues to influence the way the city is today and always will be. The street grid that ignores San Francisco's hilly topography, the row house, Golden Gate Park, and the cable car are all Victorian innovations.

Before this project I perceived the city's Victorians as rows of boxes with ornately decorated facades and archaic, although richly embellished, interiors. Now I realize that this superficial view failed to recognize the full significance of the Victorian achievement. I hope that this book will be as enlightening for the reader as the process of helping to create it was for me.

One of the more devastating things I have discovered is how little is actually left of the Victorian city. The toll of the earthquake in 1906 and urban renewal in the 1960s destroyed much of it. There were once thousands of blocks of contiguous Victorians in San Francisco. We have disrupted these pristine stretches to make way for buildings as mundane as filling stations and supermarkets—all in the name of progress.

On the positive side I learned just how much many San Franciscans love their Victorians. Scrapbooks document home-remodeling odysseys that span decades. Timetables for renovation carry forward to the twenty-first century. The Victorian house is treasured in the same way one values irreplaceable family heirlooms. Without the maniacal devotion some contemporary San Franciscans have for their Victorian architecture, saving it for future generations would be an insurmountable task.

I also learned that the Victorian house is far from archaic. Indeed, it is malleable and more readily modifiable than many architectural styles that have followed it. It is this feature that is perhaps most important to its long-term survival. For any housing type to continue to exist, it has to perform the functions expected of a house and it has to do it as well as those houses we are building today. Victorian houses achieve functionality with panache. I think the sustained popularity of Victorian houses is the greatest testament to the appropriateness of their original designs.

My primary responsibility in this joint undertaking was the photography. My goal was to illustrate fully the Victorian city as it exists today. I openly embraced Randolph Delehanty's concept to photograph all surviving aspects of the Victorian city. That meant recording not just exterior views of individual houses, but groupings of houses in rows, city blocks, and neighborhoods. Of equal importance was the microcosm within the macrocosm—such details of Victorian interiors as woodwork, wallpaper, and hardware. Victorian objects as tiny as door hinges appear here alongside grand vistas of neighborhood clusters. I hope that the photographic result is a clear picture of what the Victorian city was about in its own time and what it is for us today. *Richard Sexton*

Art glass Colored glass used for windows in either ornamental or scenic designs. Often used for front-door transom windows and for windows in staircases facing neighboring houses.

Arts and Crafts In 1888 the Arts and Crafts Exhibition Society was founded in London as part of a reform movement in the decorative arts. Often associated with designer William Morris, the movement was a reaction against the overdecorated, machine-made furnishings of the late Victorian era. It sought honest use of materials and elevated handcraftsmanship.

Balustrade A row of short posts supporting a coping or handrail.

Bay window An angular or curved projection of a house filled by windows. A bay window can be rectangular, polygonal, or semicircular in form. If semicircular, also called a bow window. If on an upper floor only, called an oriel or an oriel window. Bay windows changed shape in San Francisco as styles changed. *See also* Italianate, Eastlake, and Queen Anne.

Blind window A "window" with no opening for light; a purely decorative addition to an otherwise blank wall.

Bracket An angled support or pseudosupport placed under roof eaves, cornices, or porch, door, or window hoods. In Victorian San Francisco, often of variable decorative character.

Capital The head or crowning feature of a column or pilaster. In classical architecture, capitals, depending on their design, are either Doric, Ionic, Corinthian, or Composite. In Victorian San Francisco many fanciful, eccentric capital designs were employed.

Clapboard Pronounced klăb′érd. Overlapping horizontal boards covering the exterior of a wood-frame wall. Also called weatherboard. Clapboards are usually wedge shaped in section, with the upper edge being thinner. In San Francisco, rusticated clapboard was standard. It is uniform in section except at its upper edge where a concave edge is milled. This has the effect of emphasizing the joints between the boards. The purpose of the rusticated joint is to prevent water from seeping into the wall as it slides down the exterior of the building. Also called channel rustic siding. Shiplap clapboard has a notched upper edge and is set flush. It was popular from the late 1890s to the early 1900s.

Colonial Revival Also called Georgian Revival. The roots of this style lie in McKim, Mead and White's Taylor house of 1885–86 in Newport, Rhode Island. The style came to San Francisco in the late 1890s and lasted until about 1915. The houses often had a rectangular plan, strictly symmetrical facades, hipped roofs with dormer windows, classical ornament, and Palladian windows, and were painted light colors. They sought a sense of quiet and restraint. It is a rare style in San Francisco and is found mostly in costly houses in Pacific Heights. The Dunsmuir house in Oakland, designed by Eugene Freeman in 1899, is the best example open to the public (telephone 415-562-0328).

Colonnette An attenuated column, tall and thin, usually found framing Italianate bay windows.

Cornice In classical architecture, the top, projecting section of an entablature; also any projecting ornamental molding along the top of a building or wall that finishes or crowns it.

Cresting An ornamental finish along the top of a roof made of wood or cast iron.

Cupola A small dome on a circular or polygonal base crowning a roof or turret.

Dentils Toothlike ornaments of stone, wood, or plaster in a row or course along a molding.

Dormer window A window projecting from the side of a sloping roof with a roof of its own. So-called because they often serve as sleeping quarters.

Double-hung window A window with two parts, an upper and a lower sash, both of which are hung with weights and cords inside the frame so that they stay in place when opened or closed. In the 1850s each sash consisted of several pieces of glass, or lights. By the 1870s each sash held but one piece of glass, and this became the standard window in Victorian San Francisco.

Eastlake Also called Stick style, or Stick-Eastlake. Charles Lock Eastlake (1833–1906) was a London furniture and interior designer and a critic of the Gothic Revival style. He was the author of *Hints on Household Taste*, published in 1868 and widely circulated in America. He advocated an "Early English" style of furniture that was relatively simple, rectangular, massive, and held together by pegged joints rather than glue. In the United States, Eastlake came to mean furniture and house facades that were tall in their proportions, rectangular in design, structural in appearance, and often decorated with beveled corners and shallow-carved or incised, geometric floriated ornament. Stick-Eastlake bay windows were rectangular in plan with right-angled corners. The Eastlake style was widely popular in San Francisco in the 1880s. When the editor of the *California Architect and Building News* sent drawings of local "Eastlake" houses to Eastlake, he protested: "I now find, to my amazement, that there exists on the other side of the Atlantic an 'Eastlake style' of architecture, which, judging from the specimens I have seen illustrated, may be said to burlesque such doctrines of art as I have ventured to maintain." To him these houses were "extravagant and *bizarre*." The Haas-Lilienthal house in San Francisco, designed by Peter R. Schmidt in 1886, is a mixed Eastlake–Queen Anne

house open to the public (telephone 415-441-3004).

Edwardian A period term named after Edward VII, the son of Queen Victoria, who reigned from 1901 to 1910. The Edwardian period is usually considered to last until the outbreak of World War I in 1914. This is a key period in San Francisco history because it straddles the boom of 1900–1905, the great earthquake and fire of 1906, and the phenomenal reconstruction of the downtown between 1906 and 1909. It was a period of great prosperity in San Francisco and saw the construction of many two- to four-story flats and apartments marked by bay windows and restrained classical ornament.

Egg-and-dart molding A decorative molding in stone, wood, or plaster of alternating ovoid shapes and darts or arrowheads.

Elevation The external faces or walls of a building. The front elevation is the facade.

False front A high front, or parapet, often rectangular, masking a flat or gable roof.

Fashion According to San Franciscan Ambrose Bierce's *The Devil's Dictionary:* "A despot whom the wise ridicule and obey."

Finial A terminal ornament of wood or cast iron found at the apex of a tower or gable. The exclamation points of architecture.

Fish-scale shingle A wood or slate shingle with a curved edge resembling the scales of, yes, a fish.

Flats In San Francisco usage, a living unit in a multiple-family dwelling with its own entrance from the street, even if that entrance vestibule is shared with another or several other units. As distinct from an apartment house, which has one entrance and whose living units are entered from a common hallway. Flats are, of course, more desirable.

Flat front In San Francisco usage, not having a bay window.

Flatiron A building whose plan is that of an isosceles triangle. So-called after the shape of the heated iron instruments used to press or smooth cloth.

Gable The triangular upper portion of a wall at the end of a pitched roof.

Gabled roof A sloping roof with a gable at either end. As distinct from a flat roof. (In actuality "flat" roofs are usually slightly pitched to shed rain.)

Georgian A period term derived from the reigns of the four English monarchs named George who ruled from 1740 to 1830. (Victoria reigned from 1837 to 1901.) Georgian architecture was classicistic Baroque in general character. Its forms were revived in the late-nineteenth-century Georgian, or Colonial, Revival. A great Georgian Revival mansion and garden open to the public is Filoli in Woodside designed by Willis Polk in 1916 (telephone 415-364-2880).

Gingerbread A popular term for fancy architectural ornament, usually of sawn wood. So-called after a traditional sweet cake flavored with ginger and often made into fanciful shapes.

Gothic A style of European art and architecture of the twelfth to the fifteenth century. First developed in northern France, it is characterized by pointed arches and vaulting, slender vertical piers, large windows with stone tracery, and pinnacles.

Gothic Revival The movement to revive the Gothic style that began in England in the late eighteenth century. Its greatest example is the Houses of Parliament in London designed by Sir Charles Barry in 1835–36. In America the style was popular from about 1830 to 1860 (much longer for churches, where it was considered peculiarly "Christian"). The Gothic

Revival house was among the first styles popular in Yankee California in the 1850s and was marked by a central hall plan, steeply pitched roofs, dormers, hood molds over windows, windows with pointed arch tops, crenellations, and curvilinear trim along the eaves and gable edges. Usually painted white, such houses are extremely rare in San Francisco but are found in rural California, particularly in the Gold Country. The home of General Mariano Vallejo in Sonoma, Lachryma Montis, is a prefabricated Gothic Revival cottage built in 1850–51. It is open to the public and contains its original furnishings (telephone 707-938-4779).

Greek Revival The Greek Revival adapted the classic Greek temple front with columns supporting an entablature and a low-pitched pediment. The style was popular in the United States from the 1820s to the 1860s. Very few examples survive in San Francisco and those that do are very simple.

High Victorian Gothic In England the style was popular in the 1850s and 1860s, where its philosopher was John Ruskin. In the United States its heyday came in the 1870s. Unlike the earlier Gothic Revival, High Victorian Gothic was massive, vigorous in the extreme, and polychrome. Massing was agitated. Rooflines were complex, often erupting in a profusion of gables, dormers, and turrets with a flourish of cresting and finials. The lost Mark Hopkins mansion atop Nob Hill, designed by Wright and Sanders in 1878, was the high point of this style in San Francisco.

Hip roof A roof that slopes in on all four sides like a pyramid; it may or may not have a flat top.

Italianate The Italianate style took its name and its ornamental inspiration from Italian Mannerist architecture of the fifteenth and sixteenth centuries. In San Francisco the Italianate style was dominant in the late 1860s and into the 1870s. When large and free-

standing, often with a square tower, such houses were termed Italian villas. Italianate row houses in San Francisco have either flat fronts or bay windows. The typical example has a vertical emphasis, rounded classical ornamental details, slant-sided bay windows, projecting porches with paired Corinthian columns, cornices with heavy pseudobrackets, quoins, and a low-pitched roof. They were San Francisco's wooden version of the New York brownstone, and many survive, especially in the Western Addition. An Italianate villa open to the public is the John Muir house in Martinez built in 1882 (telephone 415-228-8860). A large Italianate house open to the public is the 1875 Cameron-Stanford house on Oakland's Lake Merritt designed by Samuel Merritt (telephone 415-836-1976). A superb Italianate interior reminiscent of the lost Nob Hill mansions is the Crocker Art Gallery in Sacramento designed by Seth Babson in 1883–84 (telephone 916-446-4677).

Jib door A concealed door flush with the wall surface made to seem part of the wainscot. Can be combined with a window that slides up as a door.

Mansard, mansarded A roof form named after the French architect François Mansart (1598–1666). A mansard is a roof with a steep slope on each of its four sides and either a flat top or a second slope not as steep as the first. Often with dormer windows. It permits an attic story with walls that are almost vertical.

Mission style California's own "Colonial Revival," the Mission style emerged in the 1890s in an attempt to create a distinctly California style. It took its inspiration from the primitive adobe, red-tile-roofed Franciscan missions of eighteenth-century California. The style is marked by simplicity of form, arches supported by piers, white stucco walls, broad roof eaves with exposed rafters, and red-tile roofs. Curvilinear parapets are

also common. McLaren Lodge in Golden Gate Park, designed by Edward R. Swain in 1896, is an early masonry example.

Mortise-and-tenon joint A joint consisting of a hole (mortise) cut into a piece of wood to receive another correspondingly shaped piece of wood (tenon). A difficult kind of carpentry supplanted by the invention of cheap wire nails.

Neoclassical A style based on Greek and Roman architectural orders. It is usually marked by regular plans, symmetry, monumentality, and smooth exterior surfaces. Pedimented porticoes and colossal pilasters are often used for the facade. Windows are large and simple. Attic stories and parapets are common. In San Francisco the style banished the bay window from the facade.

Newel-post The main vertical support at the top or bottom of a flight of stairs. In the Victorian period often highly ornamented and used to support elaborate gas or electric lighting fixtures, sometimes in the shapes of figures.

Overmantel Ornamental cabinetwork above a mantelpiece consisting of tiers of shelves and used for the display of *objets d'art*.

Palladian window Named after the influential Italian architect Andrea Palladio (1508–80). A window with a high arched central section and flanking rectangular sections. Extensively used in Colonial Revival buildings.

Parapet A low wall. The term is used to refer to the part of a wall that projects above the roof and masks it.

Pediment A triangular section above porticoes, doors, and windows. In classical architecture, a low-pitched gable on a portico.

Piano The mass production of upright pianos was a signal Victorian achievement. A piano in the parlor, or better, the music room,

was a clear sign of middle-class gentility. "What is a home without a piano?" was a famous Victorian advertisement. Ambrose Bierce defined the piano in *The Devil's Dictionary* as "a parlor utensil for subduing the impenitent visitor. It is operated by depressing the keys of the machine and the spirits of the audience."

Picturesque A favorite Victorian adjective that was originally a landscape term meaning wild ruggedness. In architecture it came to mean interesting asymmetrical or irregular dispositions of forms and a variety of exterior textures.

Plan The floor plan of a building.

Pocket door A door that slides into the wall. In San Francisco Victorians these doors are often found in pairs between the front and middle parlors, and between the middle parlor and the dining room.

Queen Anne Queen Anne reigned in England from 1702 to 1714 and had nothing to do with the Queen Anne style in either England or America. In England the name seems to have emerged first in 1874 in an address by architect J. J. Stevenson, who characterized the style as "modern wants picturesquely expressed." The Queen Anne house in England was usually built of red brick with small-pane sash windows and a roof with numerous gables. English architect Richard Norman Shaw (1831–1912) designed a Queen Anne named Leyswood in Sussex in 1868. As used in this country, the style consists of asymmetrical massing and a wide variety of forms, textures, materials, and colors. Towers, turrets, tall chimneys, projecting pavilions, porches, and bay windows (often semicircular, or even three-quarter circles at corners, with curved sheets of glass) mark the style. In San Francisco its heyday was the late 1880s and early 1890s. Many examples survive. Roughly three quarters of the 1,160 surviving Victorian houses in the

Haight-Ashbury are Queen Annes. Grand examples are also found in Pacific Heights. The Falkirk mansion in San Rafael, designed by Clinton Day in 1888, is open to the public (telephone 415-485-3328).

Quoin Derived from the French *coin,* or corner. Stones (or their imitation in wood blocks) in vertical rows placed along the corners of buildings to give the appearance of strength.

Rectangular bay window A bay window whose corners meet at right angles; usually associated with the Stick, or Eastlake, style of the 1880s.

Romanesque Revival An architectural revival inspired by the Western European architecture of the ninth to the twelfth century. It was the style current until the advent of the Gothic and is characterized by robust, round arches and clear, easily comprehended plans and elevations. On the East Coast the Romanesque Revival appeared in the 1840s and was used chiefly for stone and brick churches, courthouses, and prestigious office buildings. Its high point is Henry Hobson Richardson's Trinity Church of 1872 on Copley Square in Boston. In California the Romanesque Revival came later, in the late 1880s and the 1890s. No examples survived the destruction of downtown San Francisco by the earthquake of 1906. Traces of its influence can be found in the squat, compressed columns and semicircular porch arches of some wooden San Francisco Victorian houses. Seattle's Pioneer Square area, dating from the rebuilding after the great fire of 1889, has the best cluster of Richardsonian Romanesque office blocks on the West Coast.

Row house In England, a terraced house. In San Francisco, one of a pair, or larger number of houses, built to similar plans and whose side walls almost touch. Row houses do not share party walls in San Francisco; they are actually freestanding. *See* Slot.

Rusticated clapboard See Clapboard.

Second Empire Named after styles popular under Napoleon III in France (1852–70). The hallmark of the style is the high mansard roof with dormer windows. It is a boldly modeled and richly ornamented style. It was chiefly employed in the houses of the wealthy. Few examples survive in San Francisco. One of the best examples in California open to the public is the governor's mansion in Sacramento designed by Nathaniel Goodell in 1877–78 (telephone 916-445-4209).

Shingle style These houses, as the name says, are clad in a uniform covering of (usually) cedar shingles. They are boldly modeled with pitched roofs with broad gable ends and, often, dormers. Some of the windows usually have small panes. These houses rejected the structuralism of the Stick style. They introduced a new openness in interior plans and were popular among the wealthy in San Francisco's suburbs in the 1890s. The Shingle style was also employed for row houses during the first decade of the twentieth century, especially in Presidio Heights.

Shiplap siding See Clapboard.

Slant-sided bay window A three-sided bay window with two slanted sides; often seen in Italianate-style row houses of the 1860s and 1870s.

Slot A term coined in this book to describe the space created by pulling in one of the side walls of a row house some three to five feet for about one third of the depth of the building. Its purpose is to let light and air into the middle of closely packed row houses. It seems to be a plan uniquely San Franciscan and differentiates San Francisco row houses from those on the East Coast whose two side walls abut.

Stick style See Eastlake.

Swelled bay window Also called bow window. A bay window projecting from a wall in a flattened curve, usually with curved panes of glass. Popular in the 1890s and early 1900s.

Turned Wood that has been turned, or carved, on a lathe.

Turret A small, windowless tower.

Victorian A period term usually taken to mean the second two thirds of the nineteenth century. Queen Victoria reigned in England from 1837 to 1901. *See also* Edwardian.

Wainscot Also called dado. The wooden lining usually along the lower part of interior walls.

A SELECT BIBLIOGRAPHY

The San Francisco History Room at the Main Branch of the San Francisco Public Library is the most accessible specialized library for San Francisco research. Items in this bibliography most conveniently found there are marked SFHR. The Bancroft Library and the Documents Collection at the College of Environmental Design, both at the University of California, Berkeley, hold unique materials. The State Library at Sacramento, and the California Historical Society Library, the Society of California Pioneers Library, and the Sutro Library, all in San Francisco, are also important. Unpublished doctoral dissertations are available from University Microfilms, Ann Arbor, MI 48106.

The Annals of San Francisco, see Frank Soulé.

"Artistic Homes of California." *San Francisco News Letter,* 1887–88. Reprinted with an introduction by Alex Brammer as *Victorian Classics of San Francisco.* Sausalito, CA: Windgate Press, 1987.

Baird, Joseph A., Jr. *Time's Wondrous Changes: San Francisco Architecture, 1776–1915.* San Francisco: California Historical Society, 1962.

Bancroft, Hubert Howe. *History of California.* 7 vols. San Francisco: The History Company, 1886–90.

Barth, Gunther. *City People: The Rise of Modern City Culture in Nineteenth-Century America.* New York: Oxford University Press, 1980.

Beach, John. "The Bay Area Tradition, 1890–1918." In *Bay Area Houses,* edited by Sally Woodbridge. New York: Oxford University Press, 1976.

Bloomfield, Anne. "The Real Estate Associates, A Land and Housing Developer of the 1870s." *Journal of the Society of Architectural Historians,* vol. 37, March 1978, pp. 13–33.

Blumin, Stuart M. *The Emergence of the Middle Class: Social Experience in the American City, 1760–1900.* Cambridge and New York: Cambridge University Press, 1989.

Bowden, Martyn J. "The Dynamics of City Growth: An Historical Geography of the San Francisco Central District, 1850–1931." 2 vols. Ph.D. dissertation, University of California, Berkeley, 1968.

Boyer, Paul. *Urban Masses and Moral Order in America, 1820–1920.* Cambridge, MA: Harvard University Press, 1978.

Briggs, Asa. *Victorian Things.* Chicago: University of Chicago Press, 1989.

California Architect and Building News, 1879–1900. Index by John William Snyder, 1973, in SFHR.

Castells, Manuel. *The Urban Question: A Marxist Approach.* Cambridge, MA: The MIT Press, 1977.

Clary, Raymond H. *The Making of Golden Gate Park: The Early Years, 1865–1906.* San Francisco: Don't Call It Frisco Press, 1984.

Coontz, Stephanie. *The Social Origins of Private Life: A History of American Families, 1600–1900.* London and New York: Verso, 1988.

Corbett, Michael R. *Splendid Survivors: San Francisco's Downtown Architectural Heritage.* San Francisco: The Foundation for San Francisco's Architectural Heritage, California Living Books, 1979.

Cranz, Galen. *The Politics of Park Design: A History of Urban Parks in America.* Cambridge, MA: The MIT Press, 1982.

Cross, Ira B. *Financing an Empire: History of Banking in California.* 4 vols. Chicago and San Francisco: S. J. Clarke Publishing Co., 1927.

Decker, Peter R. *Fortunes and Failures: White Collar Mobility in Nineteenth Century San Francisco.* Cambridge, MA: Harvard University Press, 1978.

Delehanty, Randolph. *A Victorian Sampler: A Walk in Pacific Heights and The Haas-Lilienthal House.* San Francisco: The Foundation for San Francisco's Architectural Heritage, 1978.

————. *San Francisco: The Ultimate Guide.* San Francisco: Chronicle Books, 1989.

————, and McKinney, E. Andrew. *Preserving the West: California, Arizona, Nevada, Utah, Idaho, Oregon, Washington.* New York: The National Trust for Historic Preservation, Pantheon Books, 1985.

Dennis, Richard. *English Industrial Cities of the Nineteenth Century.* Cambridge: Cambridge University Press, 1984.

Erie, Stephen P. "The Development of Class and Ethnic Politics in San Francisco, 1870–1910: A Critique of the Pluralist Interpretation." Ph.D. dissertation, University of California, Los Angeles, 1975.

Fritzsche, Bruno. "San Francisco 1846–1848: The Coming of the Land Speculator." *California Historical Quarterly,* vol. 51, Spring 1972, pp. 17–34.

Gash, John. *A Catechism of Architecture.* San Francisco: William Doxey, 1894.

Gebhard, David; Sandweiss, Eric; and Winter, Robert. *The Guide to Architecture in San Francisco and Northern California.* Rev. ed. Salt Lake City: Peregrine Smith, 1985.

————; Von Breton, Harriette; and Winter, Robert W. *Samuel and*

Joseph Cather Newsom: Victorian Architectural Imagery in California, 1878–1908. Santa Barbara: University of California, Santa Barbara, Art Museum, 1979.

Good Form: Cards, Their Significance and Proper Uses. New York: Frederick A. Stokes & Brother, 1889.

Harvey, David. *The Urban Experience.* Baltimore: Johns Hopkins University Press, 1989.

Heritage Newsletter. San Francisco: The Foundation for San Francisco's Architectural Heritage, 1974–present.

Hilton, George W. *The Cable Car in America: A New Treatise upon Cable or Rope Traction as Applied to the Working of Street and Other Railways.* Berkeley: Howell-North Books, 1971.

Hittell, John S. *A History of the City of San Francisco and Incidentally of the State of California.* San Francisco: A. L. Bancroft & Co., 1878.

———. *A Guide Book to San Francisco.* San Francisco: The Bancroft Co., 1888.

Issel, William, and Cherny, Robert W. *San Francisco, 1865–1932: Politics, Power, and Urban Development.* Berkeley: University of California Press, 1986.

Kirker, Harold C. "California Architecture and Its Relation to Contemporary Trends in Europe and America." In *Essays and Assays: California History Reappraised.* San Francisco: California Historical Society, 1973, pp. 91–108.

———. *California's Architectural Frontier: Style and Tradition in the Nineteenth Century.* Salt Lake City: Peregrine Smith, 1986.

Landmarks Preservation Advisory Board. Various case reports on landmarks officially designated by the City and County of San Francisco. In SFHR.

Landmarks Preservation Advisory Board, Vincent Marsh, project manager. *A Context Statement and Architectural/Historical Survey of Unreinforced Masonry Buildings Constructed in San Francisco from 1850 to 1940.* San Francisco Department of City Planning, November 1990. In SFHR.

Langley's *San Francisco Directory.* San Francisco, various years.

Levy, Harriet Lane. *920 O'Farrell Street.* New York: Doubleday & Co., 1947.

Lloyd, B. E. *Lights and Shades in San Francisco.* San Francisco: A. L. Bancroft & Co., 1876.

Longstreth, Richard. *On the Edge of the World: Four Architects in San Francisco at the Turn of the Century.* [Coxhead, Polk, Schweinfurth, and Maybeck.] Cambridge, MA: The MIT Press, 1983.

Lotchin, Roger W. *San Francisco, 1846–1856: From Hamlet to City.* New York: Oxford University Press, 1974.

Lowell, Waverly B., ed. *Architectural Records in the San Francisco Bay Area: A Guide to Research.* New York: Garland Publishing, 1988.

Matthews, Glenna. *"Just a Housewife": The Rise and Fall of Domesticity in America.* New York: Oxford University Press, 1987.

McDonald, Terrence J. *The Parameters of Urban Fiscal Policy: Socioeconomic Change and Political Culture in San Francisco, 1860–1906.* Berkeley: University of California Press, 1986.

Moudon, Anne Vernez. *Built for Change: Neighborhood Architecture in San Francisco.* Cambridge, MA: The MIT Press, 1986.

Muthesius, Stefan. *The English Terraced House.* New Haven: Yale University Press, 1982.

Newsom, J. Cather. *Picturesque and Artistic Homes and Buildings of California.* No. 3. San Francisco: 1890.

———. *Modern Homes of California.* No. 4. San Francisco: 1893.

Newsom, Samuel, and Newsom, J. Cather. *Picturesque California Homes.* No. 1. San Francisco: 1884–85. Republished with an introduction by David Gebhard. Los Angeles: Hennessey and Ingalls, 1978.

———. *Picturesque California Homes.* No. 2. San Francisco, 1887.

Norberg-Schulz, Christian. *Intentions in Architecture.* Cambridge, MA: The MIT Press, 1965.

Olmsted, Roger; Watkins, T. H.; and Baer, Morley. *Here Today: San Francisco's Architectural Heritage.* San Francisco: Junior League of San Francisco, Chronicle Books, 1968.

Olsen, Donald J. *The Growth of Victorian London.* New York: Holmes and Meier, 1976.

Olwell, Carol, and Waldhorn, Judith Lynch. *A Gift to the Streets.* San Francisco: Antelope Island Press, 1976.

Overland Monthly. San Francisco: 1883–1933.

Peixotto, Ernest C. "Architecture in San Francisco." *Overland Monthly,* vol. 1 (n.s.), May 1893, pp. 449–63.

Pelton, John Cotter, Jr. *Cheap Dwellings.* San Francisco: 1880.

Perrot, Michelle, ed. *A History of Private Life: From the Fires of Revolution*

to the Great War. Vol. 4. Cambridge, MA: Harvard University Press, 1990.

Powers, Susan. "Pacific Houses and Homes, I." *Overland Monthly,* vol. 2, October 1883, pp. 394–98.

Reps, John W. *Cities of the American West: A History of Frontier Urban Planning.* Princeton: Princeton University Press, 1979.

Ryan, Frederick L. *Industrial Relations in the San Francisco Building Trades.* Norman, OK: University of Oklahoma Press, 1936.

Salfield, David, and Kohlberg, Herman. *Modern Buildings of California.* San Francisco, 1890[?].

San Francisco Bulletin, 1855–1929.

San Francisco Call, 1856–1965.

San Francisco Chronicle, 1865–present.

San Francisco Department of City Planning. *Report on a Plan for the Location of Parks and Recreation Areas in San Francisco.* April 1954.

San Francisco Examiner, 1863–present.

San Francisco Municipal Reports, Board of Supervisors of the City and County of San Francisco, 1861–1917. In SFHR.

San Francisco News Letter, 1856–1928.

San Francisco *Real Estate Circular,* 1866–1921. In SFHR.

"The Savings Banks of California," *Overland Monthly,* vol. 11, no. 3, September 1873, pp. 267–72.

Scott, Mel. *The San Francisco Bay Area: A Metropolis in Perspective.* 2d ed. Berkeley: University of California Press, 1985.

Senkewicz, Robert M. *Vigilantes in Gold Rush San Francisco.* Stanford: Stanford University Press, 1985.

Sexton, Richard. *The Cottage Book.* San Francisco: Chronicle Books, 1989.

Shumate, Albert. *Rincon Hill and South Park: San Francisco's Early Fashionable Neighborhood.* Sausalito, CA: Windgate Press, 1988.

Shumsky, Neil L. "Tar Flat and Nob Hill: A Social History of Industrial San Francisco During the 1870s." Ph.D. dissertation, University of California, Berkeley, 1972.

Soulé, Frank; Gihon, John H.; and Nisbet, James. *The Annals of San Francisco.* New York: D. Appleton & Company, 1854.

Stevenson, Robert Louis. *From Scotland to Silverado.* Cambridge, MA:

Harvard University Press, 1966.

Symonds, R. W., and Whineray, B. B. *Victorian Furniture.* London: Studio Editions, 1987.

Teaford, Jon C. *The Unheralded Triumph: City Government in America, 1870–1900.* Baltimore: Johns Hopkins University Press, 1984.

Thernstrom, Stephan. *Poverty and Progress: Social Mobility in a Nineteenth-Century City.* Cambridge, MA: Harvard University Press, 1964.

———. *The Other Bostonians: Poverty and Progress in the American Metropolis, 1880–1970.* Cambridge, MA: Harvard University Press, 1973.

Truman, Ben C. *Homes and Happiness in the Golden State of California.* San Francisco: Crocker & Co., 1885.

Tygiel, Jules E. "Workingmen in San Francisco, 1880–1901." Ph.D. dissertation, University of California, Los Angeles, 1975.

Vail, Wesley D. *San Francisco Victorians: An Account of Domestic Architecture in Victorian San Francisco, 1870–1890.* Sebastopol, CA: Wabash Press, 1978.

Vance, James E., Jr. *Geography and Urban Evolution in the San Francisco Bay Area.* Berkeley: University of California Institute of Governmental Studies, 1964.

The Victorian Alliance. *Pocket Guide to San Francisco's Landmarks.* San Francisco: The Victorian Alliance, 1976. In SFHR.

Waldhorn, Judith Lynch. *Historic Preservation in San Francisco's Inner Mission.* Washington, D.C.: Department of Housing and Urban Development, HUD-361-CPD(2), October 1974. In SFHR.

———; Kirkeberg, Max; and others. *Haight-Ashbury Victorian Inventory.* San Francisco: San Francisco State University, Geography 699, Fall 1974. In SFHR.

———; Kirkeberg, Max; and others. *Eureka Valley Victorians.* San Francisco: San Francisco State University, Geography 699, Spring 1975. In SFHR.

———, and Woodbridge, Sally B. *Victoria's Legacy: Tours of San Francisco Bay Area Architecture.* San Francisco: 101 Productions, 1978.

Ward, David. *Poverty, Ethnicity, and the American City, 1840–1925: Changing Conceptions of the Slum and the Ghetto.* Cambridge: Cambridge University Press, 1989.

The Wave. San Francisco, 1891–1901.

Weber, Adna Ferrin. *The Growth of Cities in the Nineteenth Century: A Study in Statistics.* [1899.] Ithaca, NY: Cornell University Press, 1967.

Wolfe, George. "Our Architecture." *San Francisco Morning Call,* December 4, 1887.

Woodbridge, Sally B., ed. *Bay Area Houses.* New York: Oxford University Press, 1976.

———, and Woodbridge, John M. *Architecture, San Francisco, The Guide.* San Francisco: The American Institute of Architects, 101 Productions, 1982.

Work Projects Administration. *San Francisco: The Bay and Its Cities.* American Guide Series. New York: Hastings House Publishers, 1940.

Young, John P. *San Francisco: A History of the Pacific Coast Metropolis.* 2 vols. San Francisco and Chicago: S. J. Clarke Publishing Co., 1912.

Zunz, Olivier. *The Changing Face of Inequality: Urbanization, Industrial Development, and Immigrants in Detroit, 1880–1920.* Chicago: University of Chicago Press, 1982.

INDEX

ABOUT THE
WRITER AND THE PHOTOGRAPHER

About the Writer

Randolph Delehanty was born in 1944 in Memphis, Tennessee, and raised in Englewood and Tenafly, New Jersey. He holds degrees in history from Georgetown University, the University of Chicago, and Harvard University, where he was a University Prize Fellow. In 1970 Delehanty moved to Berkeley and began researching California history at the Bancroft Library. From 1973 to 1978 he was the first historian for The Foundation for San Francisco's Architectural Heritage. In 1983 he returned to Harvard for two years to study American social history. Among his other books are *San Francisco: The Ultimate Guide* (Chronicle Books) and *California: A Guidebook.* With photographer E. Andrew McKinney he wrote *Preserving the West,* a survey of landscape and architectural preservation in the seven western states, for the National Trust for Historic Preservation. Delehanty lives in San Francisco and is a city-planning and architectural consultant, lecturer, and convention speaker. He is currently working on an interpretive cultural, landscape, and architectural guide to California.

About the Photographer

Richard Sexton was born in 1954 in Atlanta, Georgia. He holds a bachelor's degree from Emory University, Atlanta, and also studied at the San Francisco Art Institute. He is the author of *American Style: Classic Product Design from Airstream to Zippo* and *The Cottage Book* (both Chronicle Books). Sexton is a commercial photographer, specializing in architectural and interior photography, and an occasional writer. His work has appeared in *Abitare, Designers West, Home, Interiors, Northern California Home & Garden,* and *Restaurant & Hotel Design,* among other publications. He resided in San Francisco for fourteen years and now lives with his wife, Rives, and his daughters, Adrianne and Claire, in New Orleans.

Randolph Delehanty and Richard Sexton are currently collaborating on a book about the architecture and cultural style of New Orleans, to be published by Chronicle Books.